painting
with
acrylics

Picnic with Two Figures by Roland Petersen, acrylic on canvas, 49" x 47½". Collection, The Joe and Emily Lowe Art Gallery. Courtesy Staempfli Gallery. Petersen primes the canvas with white acrylic. Over this, he blocks in passages of color with opaque acrylics to establish general shapes and composition. When he feels the composition is stabilized, he begins a process of overpainting with thick, transparent impastos. At this point, he mixes acrylic gel with dry pigments or with oil paint to produce a heavy, transparent paste.

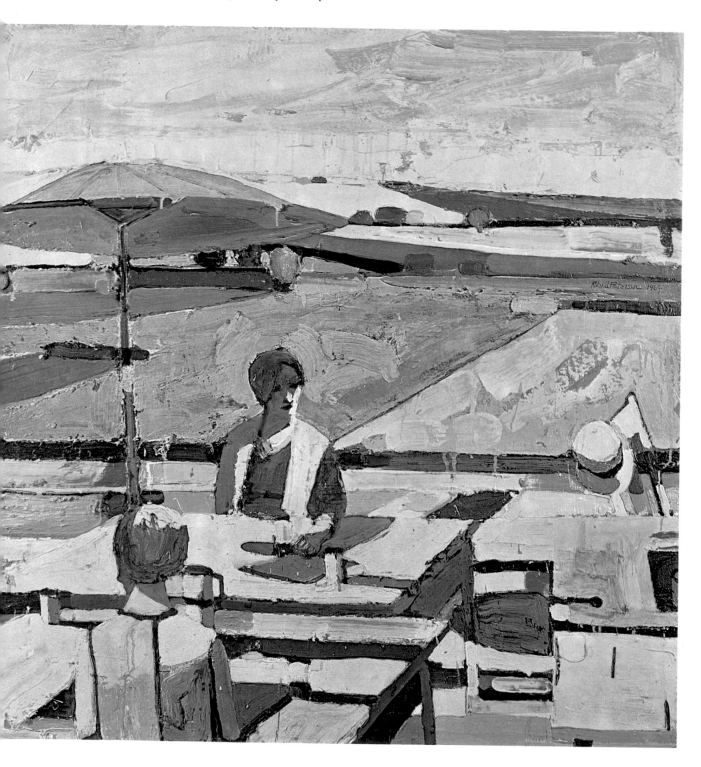

painting with acrylics

by José Gutierréz
& Nicholas Roukes

preface by
David Alfaro Siqueiros

with

acrylics

Watson-Guptill Publications New York

To Ruth and Glenna

Second Printing 1966

Third Printing 1968

Fourth Printing 1969

© **MCMLXV by Watson-Guptill Publications, New York, New York**
No part of the contents of this book may be reproduced without the written
permission of the publishers.
All Rights Reserved.
PRINTED IN U.S.A.
Library of Congress Catalog Card Number: 65-25309

"The nation's art-products and its scientific activities are not mere national property; they are international possessions; for the joy and service of the whole world. The nations hold them in trust for humanity."

Havelock Ellis

ACKNOWLEDGMENTS

The authors wish to thank the many artists and paint manufacturers who cooperated in providing information for this book. Special thanks are due to Leonard Bocour, Henry Levison, John Talucchi, Carol Cook, Don Gibson, Charles Dana, Ronald Hamm, Neil S. Estrada, Ronald Hayes. We also wish to thank the artists who participated in the demonstration sequences in this book: Jean Varda, Luis Strempler, Jonathan Batchelor, Robert Rishell, Romeo Tabuena, Leonardo Nierman, and Robert Elsocht. Special thanks to Donald Holden, Editor of Watson-Guptill Publications.

The authors are particularly grateful to Alma M. Reed, who has been an inspiration to so many Mexican painters for three decades.

preface

In 1930, I stated in a manifesto that art should extend beyond the bound-
aries of the museum, that it should go *to* the people and become part of
their environment. We, the Mexican painters who participated in this revo-
lution, decided to carry out our concept by making mural painting the fun-
damental form of our work; we decided to put art on exterior walls where
large masses of people could view it.

At the outset, the muralists met with a multiplicity of technical prob-
lems. It was necessary to search for teachers among our indigenous crafts-
men and have them teach us their techniques of painting. We found them
in the vicinity of Cholula. They taught us their methods, so pompously called
fresco since the beginning of Christian art. So, with the help of these simple
artisans, using a method dating back to the pre-Hispanic era, we were able
to create our first murals.

These first efforts of fresco were not entirely satisfactory, however.
We found that the time-honored methods of working in fresco — and also in
oil paint — were not suitable for surfaces exposed to the ravaging elements
of sun, rain, and constant climatic changes.

So it was that our Mexican artists moved from the methods of the
Cholula to the industrial knowledge of the United States. We sought to
modernize our techniques through consultation with laboratories which
were researching plastic materials.

In 1936, we organized the Siqueiros Workshop in New York. From many of the laboratories in the United States we obtained new products and chemicals; we began our experiments in developing paint media heretofore unknown to painters.

Out of these experiments were born the practical theories and formulas of José L. Gutiérrez, who, from the very first, had been aware of our technical distress. From then on, he gave us more and more enlightenment, not only to those of us Mexicans who were residing in the United States at that time, but to artists in Latin America, and elsewhere in the world, who came to consult and work with him in subsequent workshops.

Many years have passed since that workshop era. The proof of the validity of our efforts is in the tangible results: murals painted with synthetic media remain in excellent physical condition. The artist has been awakened to the rich possibilities of a new technology in paint formulation, with permanent results. Today, easel painters are reaping the harvest of those experimental years, and the plastic media are being continually refined.

This book, by Professor José L. Gutiérrez and Nicholas Roukes, will make a valuable contribution to the artist's vocabulary, not only by documenting the early experiments and formulas (which are still the finest to be compounded for the artist), but also by challenging the creative artist with the enormous possibilities of the revolutionary plastic paints.

David Alfaro Siqueiros

contents

Preface ... 8

Introduction 13

**1. The Development of
 Plastic Paints** 15
 The Dominance of Oil Painting 15
 The Need for Plastic Paints 16
 The Development of
 Plastic Media 17
 Characteristics of Plastic Media 18
 What are Plastic Paints? 20
 Testing the New Media 22
 Pioneering Plastic Paints 24

**2. Making Your Own
 Plastic Paints** 30
 A Note of Caution 31
 Formula #1: Emulsified Polyvinyl
 Acetate (White Glue) 31
 Formula #2: Vinylite 36
 Formula #3: Vinyl Chloride 40
 Formula #4: Ethyl Silicate, a
 Medium for Murals 42
 Formula #5: Acrylic Resins 46
 Formula #6: Polyacrylic Esters 48
 Formula #7: Pyroxylin 52

3. Mural Painting 56
 Preparing Masonry Surfaces 56
 Preparing Concrete Walls for 58
 Ethyl Silicate 58
 Plaster Walls 59
 Untempered Masonite, Celotex,
 Canvas, Wooden Walls 59
 Metal Surfaces 59
 Slick Surfaces
 (Glass, Tile, Etc.) 59
 False Walls of Masonite 62
 Notes on Painting
 Outdoor Murals 62
 Painting Murals with a
 Fresco Secco Technique 63

4. Pigments 64
 White 65
 Black 65
 Red .. 67
 Violet 68

Blue .. 70
Green .. 71
Yellow 71
Orange 74
Brown 74
Fluorescent Pigments 75
Metallic Powders 75
Alkalinity Test for Dry Pigments .. 77

**5. Commercially Prepared
 Plastic Paints** 79
 Aqua-Tec 80
 Cryla 82
 Hyplar 86
 Liquitex 89
 Magna 92
 New Masters 93
 Politec 96
 Polyart 99
 Reeves102
 Shiva104
 Weber106
 Additional Products....................110

6. Studio Tips113
 General Instructions113
 Brushes114
 Care of Brushes.........................115
 Knives and Tools........................115
 Supports and Grounds115
 Canvas117
 Papers and Cardboards...............117
 Plaster or Masonry Surfaces........117
 Masonite117
 Art Fabric117
 Metals118
 Palettes118
 Varnishing Plastic Paintings118
 Acrylic Fixative120
 Painting Techniques120
 Alla Prima120
 Watercolor Methods120
 Scumbling122
 Overpainting Methods.................122
 Glazing122
 Gouache Methods122
 Impasto Methods........................123
 Textures123
 Collage123
 Hard Edge Techniques123

"Combine" Painting Methods124
Painting Three Dimensional
 Sculpture124
Identification of
 Plastic Paintings124
Cleaning Plastic Paintings124
Restoration of Fresco Paintings....125

7. Painting a Still Life.................128
Preparation for Painting128
Preparing the Support for
 Painting a Still Life130
Beginning the Painting130
Developing Forms, Colors,
 and Textures130
Fluorescent Colors131
Final Painting131

8. Painting a Landscape.............137
Synthetic Media138
Preparing the Canvas138
Beginning the Landscape138
Applying Large, Flat Areas of
 Color139
Finishing Touches139

9. Painting a Portrait....................144
Palette of Colors145
Flesh Tones................................145
Brushes145
Preparing the Support.................145
Toning the Canvas146
Arranging the Pose146
The Basic Sketch.........................146
Painting in the Light
 Flesh Tones147
Dark Tones and Delineation of
 Detail147
Intermediate Stages147
Clothing....................................148
The Background148
Finishing Touches148
Highlight Flesh Tones148
Varnishing the Portrait149

10. Painting the Figure...................158
Palette and Studio Accessories159
Preparing the Canvas159
Palette for Figure Painting159

Beginning the Figure Painting159
Gesture Drawing161
Dark and Light Flesh Tones161
Intermediate Steps161
Finishing Touches162

11. Creating a Painted Relief........166
Preparing a Ground for a
 Painted Relief166
Sketching the Subject on
 the Panel167
Preparation of Acrylic
 Modeling Paste167
Application of Colored
 Modeling Pastes167
Making and Applying the
 Acrylic Paste Paint168
Glazing168
Varnishing.................................168

12. Creating a Collage....................174
Beginning a Cloth Collage174
Cutting and Arranging the Cloth..175
Transferring and Pasting the
 Fabrics.................................175
Finishing Touches with
 Plastic Paint.........................175

**13. Painting with Acrylic
 Lacquers**181
Studio Accessories for Painting
 with Acrylic Lacquers182
Preparing the Support.................182
Beginning the Painting182
Introducing the Acrylic
 Lacquers183
Stippling183
Perspective Drawing183
Masking and Painting183
Introducing Highlights185

Directory of Suppliers..................188

Bibliography................................189

Index ..190

LIST OF ARTISTS

Batchelor, Jonathan, 160
 (color)
Belkin, Arnold, 57
Benton, Thomas Hart, 84-85
 (color)
Betts, Edward, 108 (color)
Camarena, Jorge Gonzales,
 81 (color)
Coiner, Charles, 101
Colville, Alex, 88 (color)
Elsocht, Robert, 136 (color)
Gasser, Henry, 76
Gerszo, Gunther, 35
Gutiérrez, José, 105 (color)
Hayes, Richard, 72
Joysmith, Toby, 45
Kaish, Morton, 25 (color)
Kozlow, Richard, 109 (color)
Land, Ernest, 95
Louis, Morris, 32 (color)
Markos, Lajos, 50

Marshall, Fred B., 39
Merida, Carlos, 69
Nicholas, Tom, 66
Nierman, Leonardo, 180
 (color)
Orozco, José Clemente, 60
Petersen, Roland, 4 (color)
Pollock, Jackson, 14
Porter, Fairfield, 19
Rishell, Robert, 157 (color)
Roukes, Nicholas, 78
Shaw, Kendall, 73
Siqueiros, David Alfaro, 54,
 61, 112 (color)
Strempler, Luis, 173 (color)
Strisik, Paul, 51
Tabuena, Romeo, 129 (color)
Tamayo, Rufino, 28-29 (color)
Varda, Jean, 176 (color)
Zerbe, Karl, 23

introduction

In recent years, plastic paints have had a tremendous impact on the art world. They have been met with great enthusiasm by contemporary artists. In fact, plastic paints have caused a revolution. Plastic painting materials promise to be as important a contribution to art media in our own age as oil paints were in the Renaissance.

Easel painters, muralists, and illustrators, with an evergrowing consciousness of their technical means, are turning to the new media. Manufacturers are adding plastic paints to their lines of artists' colors. Museums and art galleries throughout the world are showing works executed in plastic. A great multitude of artists and art aficionados are eager to find out what these plastic media are and how to use them.

Painting with Acrylics, a working guide to synthetic art media, was written by artists for their colleagues: students, art educators, artists, and serious Sunday painters who are interested in the *what* and *how* of the new plastic paints. This book is an up-to-date account of creative activity in the field, including the history of experimentation, plastic painting materials and methods, and the ways in which contemporary artists are using and exploiting the new media.

In these pages, you will find a detailed analysis of the unique character of the new plastic media; instructions for those who wish to make their own plastic painting materials; descriptions of commercially manufactured plastic paints and instructions for their use; descriptions of the techniques of leading painters who use the new media; and step-by-step demonstrations by noted contemporary artists, revealing the extraordinary technical and expressive range of plastic paints.

This book was written in the painting research laboratory of the National Polytechnic Institute in Mexico City. Long noted as a pioneering force in the development of synthetic paint formulations, the laboratory has been host to hundreds of artists from all over the world, and has served as an authoritative source of technical advice to painters for over twenty years. Still under the original directorship of José L. Gutiérrez, the laboratory continues to serve as one of the world's unique research centers, dedicated exclusively to experimentation in developing new painting media and techniques.

José L. Gutiérrez
Nicholas Roukes
MEXICO CITY

Silver and Black Square #1 by Jackson Pollock, lacquer on canvas, 22"x22". Courtesy Sidney Janis Gallery. Pyroxylin lacquers, dripped and spattered over canvas, characterize the "action painting" methods of the late Jackson Pollock. (Photo, Oliver Baker)

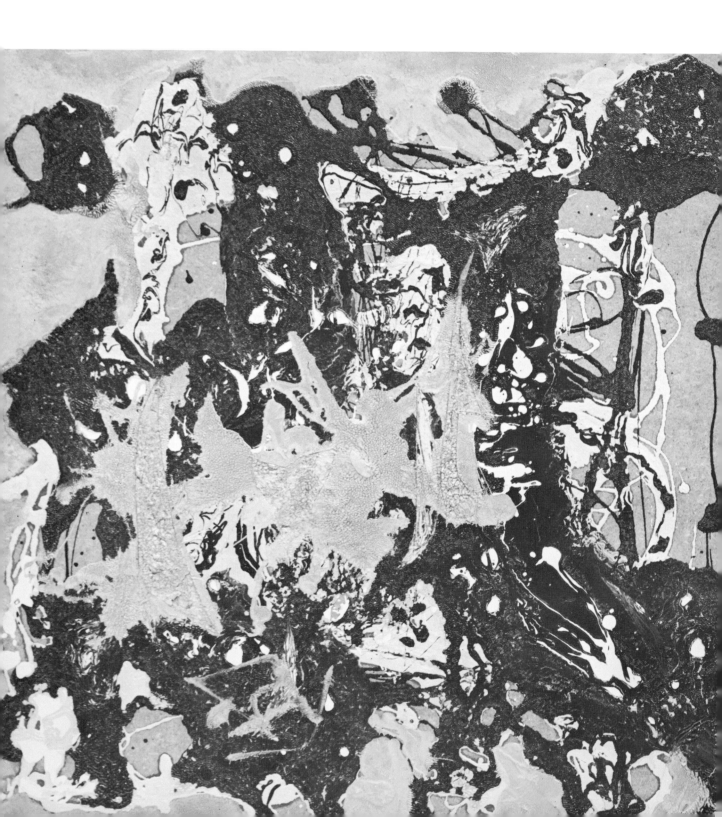

1
the development of plastic paints

Man's original pictorial expression was born of a functional necessity. Art was directly connected with the ritual of daily existence. Although prehistoric art is now enjoyed for its esthetic qualities, it evolved from a very practical need. For primitive peoples, the hunt was the principal means of subsistence; they used art as a direct aid in making their hunt successful. Prehistoric paintings and drawings of animals were a form of "magic" to help man slay the beasts he depicted.

With lards and greases, blood, berry juices, and albumin, early men developed basic paint vehicles. We are indebted to these unknown artists for the discovery of lime for fresco painting; for natural resins; for albumins; for animal glues used in temperas and varnishes; and for the chromatic vitrification of ceramic, porcelain, and mosaic materials.

THE DOMINANCE OF OIL PAINTING

From the dawn of history to the Renaissance, there is ample testimony to man's continual search for better colorants and vehicles for artists' paints. Fresco, encaustic, tempera, and varnishes, among other media, were widely and successfully used.

Not until the 15th century, however, with the emergence of oils, were great strides made in the technology of paint-making. From the time of the brothers Van Eyck — the great Flemish artists who are commonly credited

with perfecting the technique of oil painting in the 15th century — to the time of Picasso in the 20th century, oils remained the principal medium of the epoch.

In oil paints, artists seemed to have found a panacea for all their technical needs. In spite of scientific and industrial progress, no major advances were made after the Renaissance in the field of paint formulations for the artist.

THE NEED FOR PLASTIC PAINTS

Social needs sometimes impose technical problems which the artist must solve. For example, in Mexico, in the early twenties, the famous mural movement was born. Artists felt a responsibility to communicate to the mass of the people. This could best be done, they felt, through immense murals, public works of art.

Many murals were to be installed outdoors and artists found that the time-honored technique of oil painting presented many serious problems. They required an Art medium more capable of withstanding outdoor exposure. For a while, they returned to fresco, but found it technically limited and lacking duarability. What they needed was a medium with inherent characteristics of long life; resistance to atmospheric changes and oxidation; quick-drying characteristics; and ease of handling and application.

In their search for a new medium, the Mexican muralists rejected the old media. They found that the basic vehicle of oil paint — linseed oil — was impractical for murals. Previous work in oils was yellowing, cracking, oxidizing; clearly, oil lacked the durability required for large, outdoor works of art.

The problem of oil paint is the instability of linseed oil, which is a vegetable oil as the name suggests. Linseed oil — with which pigment is combined to make oil paint — is a complex compound of linoleic acids and their glycerides. As linseed oil dries, it changes from a liquid to a solid. Eventually, it changes to an entirely different substance, known as linoxyn. This dried oil film lacks adhesiveness; it becomes porous, brittle, and subject to cracking. This fragile film constitutes the body of an oil painting and continued chemical action within the film ultimately leads to the destruction of the painting. Hence the sad condition of so many great oil paintings in American and European museums.

What the muralists needed was a vehicle that remained completely stable: a painting medium that was not subject to further chemical change as it continued to dry. Their search turned to the laboratories of science, where they sought a man-made, *synthetic* paint vehicle, rather than a natural one.

THE DEVELOPMENT OF PLASTIC MEDIA

In the laboratory, plastics were found to offer what the artist demanded. Early paint formulations based on synthetic vehicles proved to be completely stable. Pigments mixed with synthetic media worked well horizontally, giving cohesiveness to the molecular ingredients; and worked well vertically, giving adhesiveness to the paint film on the painting surface to which it was applied. Once the drying action by evaporation was complete, no other chemical process took place within the paint film to crack or darken the painted surface. In compounding the formulas for plastic paint, artists sought the following characteristics:

1. Durability of color and paint film.
2. Covering characteristics: paint must be opaque, but become transparent when required by the artist.
3. Built-in drying characteristics: relatively slow, medium, or fast, as required by the artist.
4. Permanence: the vehicle should not decompose chemically.
5. Brushing quality: leveling or non-leveling, as required.
6. Chemical compatibility of one color with another.
7. No change in color from wet to dry state.
8. A completely clear binder, permitting maximum visibility of pigment.
9. Ease of application.

Plastic resins, derived from coal tars, had already been tested and used by industry. These industrial formulations provided a rich potential to the manufacturer of artists' paint. Plastics had served for many years as anti-corrosives; as water-proofing mediums; in the manufacture of such molded plastic objects as aircraft windows and domes; and for a multitude of household and industrial objects. From the laboratories of Rohm & Haas came the basic synthetic materials for compounding a variety of plastic emulsions. The paint researchers added pigments and various other chemical ingredients in seeking to perfect new media for the artist.

Formulas were developed and paints compounded. Many experimental paintings and murals were created both in the United States and Mexico. At first, many artists were reluctant to try the new materials. They were somewhat skeptical of plastic, a substance which connoted inexpensive, mass-produced articles. However, through laboratory testing and practical experiments by the artists themselves, the plastic paints were not only found to be permanent, but proved to have very desirable working characteristics. Today, 90% of the muralists in Mexico use the formulas

and plastic paints developed by Jose L. Gutierrez in his experimental work-shops. Almost all major manufacturers of artists' paints are making plastic painting materials for the artist.

CHARACTERISTICS OF PLASTIC MEDIA

In making plastic paints, raw plastic materials are obtained from the manu-facturer in either granular or emulsified form. Pigments, plasticizers, wet-ting agents, and other ingredients are added to produce the final plastic paint.

Although many of the new plastic paints may be used to "imitate" older media — such as oil, tempera, watercolor, or fresco — plastic materials should arouse the artist's interest as media that are important in themselves, with certain qualities and advantages that no other media possess. Many artists may find plastic paints more suitable to their temperaments, and may prefer their working properties to those of other media Art educators, in particular, should acquaint themselves with the plastic paints and present the new materials to their classes; students should be allowed to discover for themselves the exciting possibilities of synthetics.

Plastic paints may be used to "imitate" other media, but what else can they do? What are some of the distinctive qualities of plastic paints? What are some of the "honest" means of handling the material?

First, the most unusual and outstanding feature of the new medium is the vehicle itself, plastic. A plastic vehicle gives three distinct physical characteristics to paint: transparency, body, adhesiveness. Since plastic has a tendency to capture light and is completely transparent, glazing tech-niques are well suited to the new paints.

For example, by thinning the paint with water or with a plastic medium, the artist may apply thin, transparent glazes. He can build one glaze over the other, like layers of colored cellophane. Between the layers of paint, a clear plastic varnish may be applied to isolate each colored glaze and build up a thick paint film, which will serve to capture light, refract it with-in the picture, and create inner brilliance.

Second, the body of the plastic enables the artist to build up thick bodies of paint, called impasto. There is no need to worry about these heavy applications cracking or peeling. Because of the homogeneous quality of plastic paint and acrylic gesso, both can be safely mixed to produce a heavy, colored paste that may be applied with brush or palette knife.

The paints dry quickly, so there is none of the annoyance of waiting for a stubborn paint film to dry. Thus, work may be carried out in a direct, spontaneous manner, taking advantage of the inspired moment. The artist may use an *alla prima* technique, finishing a painting in one sitting, if he

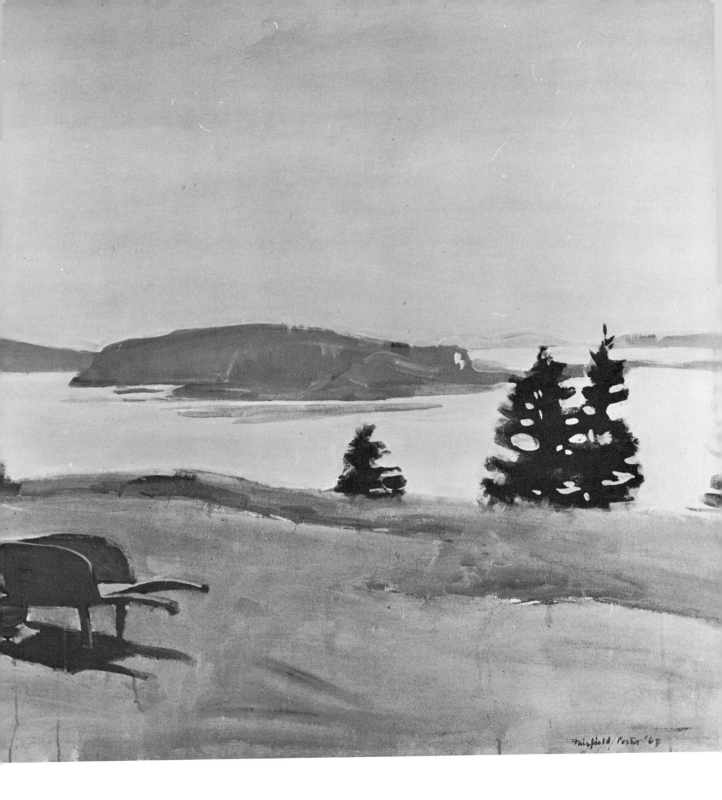

The Barreo Islands by Fairfield Porter, acrylic on canvas, 43" x 43". Collection, Mrs. Stephen Booke. Courtesy Tibor De Nagy Gallery. Porter makes maximum use of the fluidity of acrylic, applying his paint with a free, almost casual stroke which produces passages of great spontaneity. The paint is diluted to a consistency similar to gouache (opaque watercolor) and applied in a broad, flat manner, enlivened by scrubby textures, blobs, drips and other controlled "accidents." (Photo, Auerbach)

wishes. The viscosity and brilliance of the plastic paints suggest a direct approach. Flat color areas, "islands," and "mosaic" shapes of color are all well suited to the material.

Third, because of the adhesiveness of plastics, they are naturally suited to all types of assemblage and collage. Their stubborn resistance to the elements mark plastics as a logical paint medium for outdoor or semi-outdoor art, whether for a mural painting or for a swimming pool.

The artist, of course, must experiment with the plastic paints in order to discover his own personal methods of exploiting the material. Plastic paints are here to stay. The medium has become every bit as important as oil, watercolor, pastel, and graphics; its individuality is rapidly becoming recognized.

The purpose of this book is not to suggest that traditional media be replaced or eliminated. Its purpose is to arouse the interest of the artist in the vast possibilities of the new synthetic paints, and to urge him to enrich his technical means with these new materials, the industrial by-products of our age. The contemporary artist, in reflecting his time and his society, should concern himself not only with the esthetic concepts that mirror his age, but should also avail himself of the wealth of technical knowledge and invention which may bring more durability — and perhaps greater depth and insight — to his work.

WHAT ARE PLASTIC PAINTS?

Plastic paints are synthetic painting media produced entirely by scientific means, in contrast with traditional media, which are made from products found in nature. Science has created materials for the artist which not only rival, but in many cases surpass, materials provided by nature.

Recently, the acrylic plastic polymers have been found to produce many exciting vehicles for synthetic artists' paints. Today, leading manufacturers in America and Europe are using these resins in paint production.

Acrylic paints may be made from two types of raw plastic material. One type is solid resin crystal, such as the Rohm & Haas Company's Acryloid B-72 or B-82. These crystals are dissolved in Xylol and Toluene and then pigmented to produce an artists' paint (see formula, page 46). The raw plastic is also available in emulsified form, such as Rohm & Haas' Rhoplex AC-33, which produces a water-soluble painting material — soluble in its wet state, but insoluble when dry.

Almost all plastic paints now available are based on some kind of emulsion system. Essentially, there are two types of emulsions: those based on water; and those requiring more powerful industrial solvents, such as Xylol, Toluene, acetone, and denatured alcohol. The water based materials

— more convenient and less likely to be toxic — are most popular.

Union Carbide Corporation explains the term, emulsion, as follows:

It is common knowledge that oil, wax, or grease will not actually dissolve in water. It is possible, however, to prepare stable mixtures of such materials in water by incorporation of a surface-active agent called an emulsifier which keeps one liquid dispersed in the other. Two liquids which under normal conditions are insoluble in each other can thus be dispersed into an intimate mixture called an "emulsion" by the action of an emulsifying agent. Milk is an example of an emulsion in which the emulsifying agent is present naturally; in most industrial emulsions, the emulsifying agent must be added.

When an emulsion is examined under a microscope, it is seen to consist of a liquid medium in which minute droplets of a second liquid are suspended. When the medium is water and the droplets are oil, the emulsion is called the 'oil-in-water' type and is readily diluted with water. If the reverse is true, and the water is dispersed or suspended in the oil, it is a 'water-in-oil' type and can be further diluted only with oil.

Three essential ingredients compose an emulsion: the water-insoluble material, the water, and the emulsifying agent. To obtain such a fine division of the dispersed liquid, agitation is required during the preparation of the emulsion. The emulsifying agent... provides a film surrounding each particle, which prevents it from coalescing with other particles. The uniformity and stability of an emulsion, therefore, depend largely on the effectiveness of the emulsifying agent.*

In making plastic emulsions, the same basic principles hold true. With plastics, however, the emulsion is not liquid-in-liquid; it consists of fine, solid particles of resin suspended in droplets of water.

Paint manufacturers have found that artists favor plastic paints which need no other solvent but water. Most plastic paint mediums, therefore, are water emulsions of an acrylic ester polymer.

The term *polymer* refers to the chemical property of the basic material itself — the plastic — and its particular formulation. In this process, a number of small molecules are united into a single larger molecule of greatly enhanced strength and stability. Literally thousands of weak *monomers*

*Union Carbide Corporation, *Emulsions and Detergents*, 1961.

are joined together in a chemical union to form the tougher, more durable *polymer*. The monomer may be likened to a kind of molecular building block, by which the research scientist builds a chain. This chain, or polymer, develops the durable characteristics of the acrylic resin.

The paint manufacturer first orders his emulsions from the plastics factory. Then he adds pigments, fillers, plasticizers, chemical stabilizers, and other ingredients, according to his own particular formula, seeking to develop the best working characteristics for the artist.

One of the distinctive characteristics of the plastic vehicle is its great clarity. Although the liquefied plastic resin appears milky, it dries clear and colorless. Thus, plastic paints tend to be more luminous than other media. And since the plastic used as a binder is colorless, full color quality can be obtained from the pigments.

Another unusual quality of plastic paints is the kind of film they create. Acrylic paints, unlike traditional media, produce a film that is not continuous, but porous. This porosity allows for a kind of "breathing" that prolongs the life of the painted surface. Moisture passes through the paint film without endangering it; the film will not blister or peel, as happens with other media. This durable paint surface is formed as the water of the emulsion evaporates, permitting the resin particles to merge.

TESTING THE NEW MEDIA

In creating new media for the artist, reliable paint manufacturers subject their materials to a great number of tests before releasing them for use.

The paint manufacturer begins with his knowledge of the history of the material. Acrylic plastics had been used successfully in industry for twenty years before their discovery by artists. Developed by the Rohm & Haas Company, acrylics had already been tested and used for aircraft windows and domes, housings for electronic equipment, outdoor signs, and similar products, and had been found completely stable.

With this information about acrylic plastics, the paint manufacturer experiments with formulas for artists' paints, using acrylic as the binder or vehicle. Only through extensive research can he hope to produce a fine paint.

Acrylic emulsions are complex systems, and differ radically in formulation from traditional media. The manufacturer, in order to create a good synthetic paint, must ask himself these questions: 1) Are the emulsions stable during climatic changes? 2) Are the pigments, which are added to the emulsions, compatible and permanent? 3) Do the paints have a stable shelf life? 4) Does the packaging meet the artist's requirements?

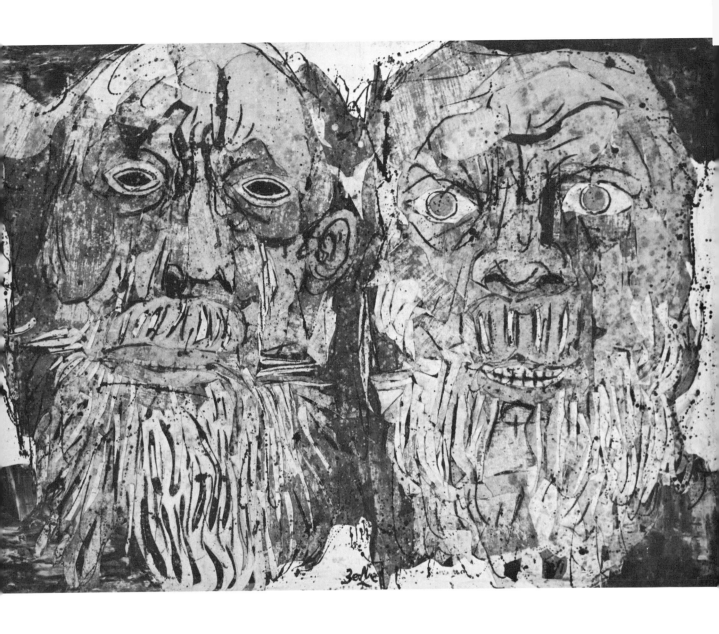

Two Bearded Masks by Karl Zerbe, collage and acrylic, 36"x 50". Courtesy Nordness Gallery. The artist makes use of the adhesive properties of acrylic by adding collage papers which he presses into the moist paint. Heavy textured areas are created by dripping and spattering acrylic paint. (Photo, Oliver Baker)

In his research laboratory, the paint manufacturer tests the life expectancy of the new media. Testing may be carried out in many ways. Paint samples — in full color as well as tints and shades — are placed in the sun, under arc lights, in the dark, out of doors. The paint samples are subjected to various climatic changes of humidity and temperature during a given period of time. The product is scientifically "aged" to simulate the passage of many years. Any changes in the materials are carefully measured with photoelectric and reflection meters.

As a supplement to laboratory testing, artists are called on as consultants. They are asked to experiment with the new media and to offer their opinions on the practical problems of painting with them.

Thus, the artist, the scientist, and the engineer join forces. The unmerciful testing given to the new plastic media assures the perfection of stable, lasting art materials.

PIONEERING PLASTIC PAINTS

Among the early researchers in the field of plastic paints were José L. Gutiérrez in Mexico City, Leonard Bocour in New York, and Henry Levison in Cincinnati.

Since 1934, José L. Gutiérrez has been exploring the by-products of industry for possible contributions to the development of new art media. Based on his research, pyroxylin lacquers were among the first industrial paints to be used as an art medium. With the help of research laboratories, Gutiérrez was able to compound some of the first synthetic paint formulations. From the Union Carbide Corporation, he received the basic information which led to the development of the Vinylite and ethyl silicate paint formulas. His compounds were later tested and approved by the Sherwin-Williams Paint Company.

During the period of the Works Progress Administration projects, many of Gutiérrez' formulas were tested in mural and easel paintings in the United States.

In 1945, Gutiérrez, with David Siqueiros, founded the experimental painting workshop at the National Polytechnic Institute in Mexico City. Created especially to study the new synthetic painting media and to compound others, the workshop drew students from all parts of the world. Many of these students used the new media to paint murals on the walls of the Institute. These murals are still in perfect condition today. Among the artists who consulted the painting workshop were Siqueiros, Orozco, Tamayo, Dean Cornwell, and other painters from both Mexico and the United States.

In 1955, research information was received from the Rohm & Haas Company in the United States which eventually led to the development of

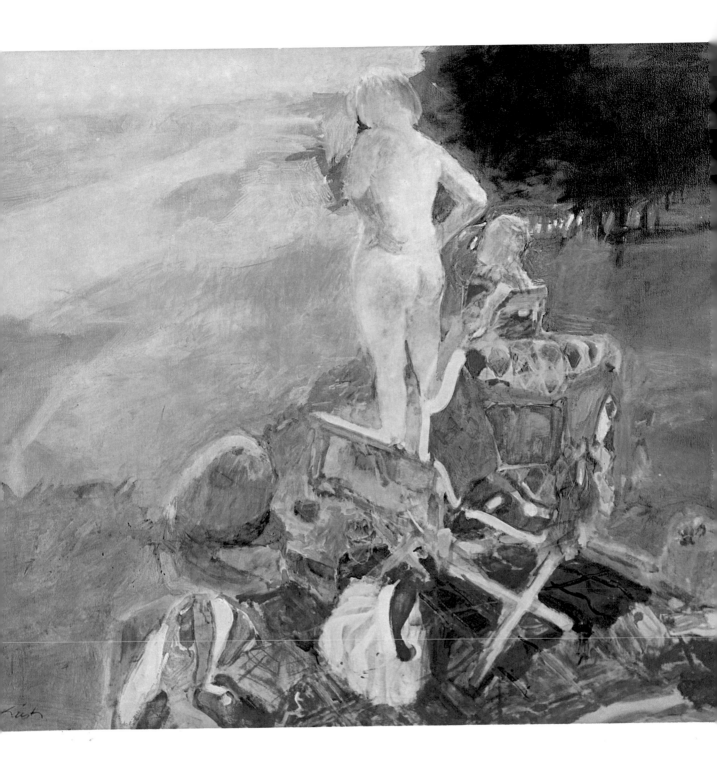

The Couple by Morton Kaish, acrylic on canvas, 50"x 60". Collection, Mrs. Jacqueline Schuman. Courtesy Staempfli Gallery. Applying acrylic thinly, with a seemingly random, scrubby stroke, Kaish makes maximum use of the glowing translucency of the medium. Quick drying layer is painted over quick drying layer; veils of color alternately reveal and conceal one another, producing subtle nuances of light and atmosphere.

an acrylic (water based) paint formulation at the Polytechnic Institute. This paint, perfected in 1956, was labeled Politec.

Meanwhile, Leonard Bocour, working in New York, developed an acrylic paint from the same plastic base, which he called Magna. In a letter to the authors, Bocour recalls the early experiments with plastic paints which led to the development of Magna, an acrylic for which turpentine is the solvent, rather than water.

"Right after the war, in 1945, an artist friend of mine brought me a jar of liquid that looked very much like honey, thick and viscous. This was an acrylic resin. He asked me to grind some white for him. At that time I had a small hand-grinding operation, and I proceeded to make him some white paint. There were many difficulties, and it was quite a mess, but we managed to get some paint that was brushable. The thing that amazed me was that it took to illustration board and paper without leaving the messy rings that oil does.

"This experience gave me the impetus to proceed; there followed months and months of experimentation and disappointment. The paint would crack and peel. Finally, after getting the proper stabilizer to put the acrylic and pigment into the proper suspension, we had a paint that was darn near perfect. Since then, we have made some minor improvements, and the list of artists who have used Magna reads like a *Who's Who:* Jackson Pollock, Mark Rothko, Morris Louis, Kenneth Noland, Helen Frankenthaler, Robert Motherwell, and many others."

Henry Levison, founder of Permanent Pigments, Inc., has always been interested in adapting new discoveries in paint technology to the field of art. In the course of research, he began to investigate acrylic plastics, and soon recognized their value for art materials — permanence, color stability, and freedom from deterioration. So began work on the line of water based acrylic artists' materials called Liquitex.

In an article in the *Rohm & Haas Reporter*, Levison discusses one of the major problems in the development of acrylic colors:

Liquitex is an alkaline medium. That means that some of the pigments that are perfectly good in oils or regular watercolors become unstable or unpredictable in alkaline mediums such as buon fresco, casein, or Liquitex. We can't leave out colors such as Alizarine or Viridian without providing something in its place...It wasn't until after many promising pigments had been tested in every aspect that a new Naphthol ITR Crimson was found to more than equal the reputable permanency of Alizarine...But mere substitution is not the only problem. This new medium is of a character

that invites the use of clear, brilliant glazes. It would be going against the nature of the medium not to use pigments inherently transparent wherever possible. This we have done...wherever a pigment has been proven permanent in the Liquitex medium and of value in hue to the artist.*

It is interesting to note that, working independently, Gutiérrez, Bocour, and Levison all perfected their acrylic paints at about the same time. Each one, using the same basic plastic, but slightly different formulas, developed a paint that has been widely accepted by artists throughout the world. Since these three researchers have entered the field, other leading manufacturers have joined them in producing plastic paints for the growing number of artists who are turning to the new materials. With the exception of Magna, virtually all commercially manufactured acrylics are water based.

*"A Modern Medium For Fine Arts," *Rohm & Haas Reporter,* September-October, 1957.

America by Rufino Tamayo, Vinylite on canvas, 70 square meters. Mural in the Bank of the Southwest, Houston. Color plate courtesy Crown Publishers. Painted in the artist's studio in Mexico City — using an early Vinylite formulation by José Gutiérrez — the canvas was rolled and transported to the bank for installation.

2
making your own plastic paints

Although most artists will find the commercially manufactured plastic paints entirely satisfactory for their needs, some painters will prefer to make their own materials. This chapter describes a variety of formulas which the reader may wish to try. However, before embarking upon such a project, the reader should carefully consider the section below: "A Note of Caution."

José L. Gutiérrez speaks on synthetic paint formulas: "I have been experimenting with synthetic paint formulations since 1934. Since the days of the Mexican muralists, who demanded a paint to withstand the rigors of outdoor exposure, we have been experimenting with the products of science, seeking new artists' materials that offer permanence, ease of application, stability, and brilliance of color.

"In many cases, the artist may wish to make his own synthetic paints. Raw materials are readily available from chemical and plastic manufacturers. There are many plastics that can be used — with the necessary care and precautions — to fabricate artists' paints. A number of them, however, present limitations to the home researcher; the chemical processes involved in preparing these paints may be too complex to be done in the artist's studio.

"The formulas in this chapter — using emulsified polyvinyl acetate, Vinylite, vinyl chloride, ethyl silicate, and acrylic emulsions — have been proven suitable for preparation in a properly equipped artist's studio. With these formulas, the artist may make his own synthetic paints, to be used directly or stored for use at a later time."

A NOTE OF CAUTION

The processes described in this chapter are intended for the serious professional artist and the advanced student, both of whom should have adequate studio or workshop facilities and equipment, and both of whom should be skilled in handling the materials recommended. These processes are *not* suggested for most students or hobbyists, who have neither the facilities, nor the time, nor the inclination to take the necessary care in compounding their own paints.

Bear in mind that a few of the materials listed are toxic, flammable, or otherwise hazardous. Many of those which are physically harmless are tricky to control and will yield reliable paints only when handled with skill and precision.

In mixing the formulas presented here, careful attention should be paid to instructions and precision in measuring. Manufacturers' recommendations should be strictly observed. Many of the solvents are toxic if taken into the body in large amounts, so normal precautions should be taken. Direct handling of solvents should be avoided; hands should be covered with protective cream or disposable polyethylene gloves. In spraying, use protective masks and keep the room adequately ventilated.

Although the formulas in this book have been tested by many artists and art educators and have been found successful, slight variations or miscalculations in formulation may produce results which are unsatisfactory in terms of handling characteristics or permanence. The authors, therefore, can assume no responsibility for defective paint formulations caused by miscalculations on the part of inexperienced artists or students.

In short, the reader who is not fully prepared to take the necessary care and precautions, who has neither the time nor the facilities for the painstaking work required, is urged to rely upon commercially manufactured plastic paints, described in Chapter 5. The commercial products are entirely safe, experimentally proven, and produced under controlled laboratory conditions rarely available to the student *or* the professional artist.

FORMULA #1: EMULSIFIED POLYVINYL ACETATE (WHITE GLUE)

The use of polyvinyl acetate emulsions as a base for artists' paint is fundamentally sound. These resins have the advantage of stability, require no catalyst, are extremely durable, and dry relatively quickly when applied. Furthermore, they are non-toxic. The vehicle is miscible with water and the paint film becomes insoluble to water after it is dried. As a paint film, it is comparatively immune to degradation from ultraviolet light, alkalies,

Blue Veil by Morris Louis, acrylic on canvas, 91-5/8"x 156". Collection, Fogg Art Museum. Color plate courtesy Guggenheim Museum. The late Morris Louis worked with acrylic thinned almost to the consistency of watercolor. Multi-colored translucent washes were floated onto absorbent canvas, where the various hues overlapped and intermingled to produce effects of extraordinary richness and subtlety. The color areas retain the character of free-flowing paint, yet are controlled with remarkable skill.

and the effects of oxidation. It is also a strong adhesive, making it useful as a paint for "difficult" surfaces.

Working Characteristics

The polyvinyl acetate copolymer is a film-forming substance that can be dispersed in water to form an emulsion. When the water evaporates from the emulsion, the resin particles of the polyvinyl acetate coalesce to form a continuous film. Pigment particles in this emulsion are bound within the film by a mechanism known as occlusion or envelopment. The polyvinyl acetate emulsions tend to be acidulous in the Ph value, rather than alkalescent as is the case of the acrylics. The paints form not only a tough, but a flexible film.

Chemical Properties

Vinyl acetate is an ester of an unsaturated alcohol and acetic acid. It is prepared industrially from acetylene gas and ethylene gas, and used principally for adhesives and coatings. At the present time, Neil Estrada, technical director of Reichhold Chemicals, Inc., reports that the polyvinyl acetate emulsions are probably the single type of emulsion polymer most widely used in industrial paint manufacture.

Chemical Ingredients

Manufacturers such as Borden's and Reichhold distribute fine polyvinyl acetate emulsions, which local paint manufacturers utilize, adding dry or paste pigments, dispersants, and other chemical ingredients in making paint for artists.

For many years, Don Gibson, a West Coast paint chemist, has researched the polyvinyl acetate copolymers as a vehicle in the manufacture of paint for artists. He makes the following recommendations for artists who wish to compound their own paint formulations from this emulsion: "The most readily available polyvinyl acetate emulsion is a white glue, such as 'sobo' or Elmer's Glue.' This is not recommended for use as a vehicle for making paint, however, as this white polyvinyl acetate glue was formulated with one purpose in mind and that was to make an excellent glue, *not* a base for artists' paint. The principal problem involved in using white glue as a painting vehicle is that it forms a brittle paint film."

The *recommended* copolymer polyvinyl acetate emulsion is one such as Reichhold's 40-120 Wallpol, available only in 55 gallon drums from the manufacturer. This emulsion may be available to the artist from a local paint manufacturer who uses the material in compounding a plastic paint. In this case, smaller amounts may be purchased through this source. An-

other recommended polyvinyl emulsion is Don Gibson's Polyart Clear, an emulsion prepared especially for the artist and available in pints, quarts, and gallon sizes from Gibson's Paints, Oakland, California.

INGREDIENTS FOR MEDIUM

Wallpol 40-120 or Polyart Clear .. 1 part
Water.. 4 parts

Mix the two ingredients in a glass jar. The medium will have a milky appearance, but this will change, becoming completely transparent when the paint film dries. Use this medium with the pigments listed in Chapter IV.

INGREDIENTS FOR PIGMENTS

Dry Pigment .. 1 part
Celite #281 .. 1 part

See Chapter 4 for recommended dry pigments. Celite #281, a diatomaceous earth, is a very fine, light weight, flour-like powder, refined and distributed by the Johns Manville Company. It is added to the dry color to give a final matte character to the paint, and is valuable for its effect on the quality of the colors.

Half fill a jar with Celite #281. Add dry color and shake until the pigment is thoroughly mixed. A complete range of dry colors may be prepared for future use. The Celite #281 imparts a matte surface quality and gives additional body to the paint. If you want a *glossy* surface, do not use the Celite. When the Celite powder is mixed with the dry pigment, the color tends to become grayish in tone. This condition will disappear when the glue medium is added.

Recommended Painting Surfaces

This medium is especially recommended for use on paper or illustration board, and is particularly well suited to class work. Other surfaces include canvas, untempered Masonite, and plywood.

Painting Technique

Use the medium as you would egg tempera. Dip the brush first into the glue and then into the pigment; then mix on a palette or directly on the canvas or painting surface.

If the artist chooses to mix the medium and pigments immediately and make a paint to be stored and used at a later date, here are the recommendations of Neil Estrada, technical director of Reichhold.

Paisaje de Papantla by Gunther Gerszo, mixed media on canvas. Unprimed canvas was prepared with two coats of acrylic gesso, sanded between coats. Underpainting was done with acrylic colors using a scumble technique. The artist used photo floodlights to hasten drying; he then applied thin glazes of oil paint over the acrylic ground painting. For final glazing, oil paints were thinned with copal painting medium, thinned with five parts of turpentine and five drops of dryer. Sable brushes were used for smooth, level brush strokes. As many as twenty thin coats of oil glaze were applied. Each coat was allowed to dry thoroughly before the next glaze was applied.

"Dry pigments should first be dispersed into a smooth paste by mixing them with about 2% of liquid soap such as Joy, and a household material such as Calgon. Both of these materials, which are mixed one to one, are added to the pigments and mixed thoroughly with a palette knife in a glass jar or can. They will act as dispersant and surfactant, and will yield a smooth paste. This paste is then added to the Wallpol 40-120 and further mixed. The proportions of Wallpol emulsion and paste should be approximately 25% paste to 75% emulsion. In no case should the total solids exceed 50% of the weight of the emulsion."

Many artists who wish to save themselves the trouble of making a paste pigment may purchase a wide variety of *universal tinting colors* which are compounded in paste form. These colors may be added to the emulsion in the same manner as described above.

FORMULA #2: VINYLITE

Working Characteristics

The Vinylite painting media will yield a fast-drying paint, suitable for creating textures, for "modeling" or shading, and for glazing. The use of denatured alcohol improves the brushing characteristics and facilitates the leveling of the paint film. Vinylite produces a velvety, clear surface. It does not require a surface varnish as protection and does not have a tendency to oxidize. Excessively porous surfaces may be prepared by sealing with one coat of clear Vinylite as a primer-sealer; manufactured under the trade name of Vinyseal by the Union Carbide Corporation, this material is available in soluble form, in gallon cans.

Chemical Properties

The Vinylite resins are available in either powder or granular form. They are colorless thermoplastics, non-toxic, tasteless, odorless, and very slow-igniting. Furthermore, they do not decompose with exposure to heat or light and are resistant to the action of mild acids and alkalies. (They are somewhat different from the vinyl chlorides, which will be discussed in the next section.) The Vinylite resins are soluble in most common solvents, except water.

One of the remarkable characteristics of Vinylite resin is its adhesiveness to almost any type of surface, rigid or pliable. Since it is also a very durable material, it is recommended for easel painting, murals, and decorative illustration on any surface. The medium is to be used with dry pigments, discussed on page 38.

The Vinylite resins AYAF and AYAT are two of the vinyl acetate resins produced under the trade name of Vinylite by the Union Carbide Corp.

Chemical Ingredients

Vinylite AYAF or AYAT (resembles white pearls) 100 grams

Industrial acetone ... 250 cc

Butonal... 20 cc

Carbitol .. 20 cc

Denatured alcohol ... As needed

Note that acetone is flammable and has a very low flash point. Handle with extreme care.

Equipment for Manufacture

Empty gallon can

Mixer (Electric drill with paint mixing propeller, or electric kitchen blender or mixer)

Empty quart size glass jar

Measuring beaker (500 cc capacity)

Because of the dangerously low flash point of acetone, a so-called "explosion-proof" electric mixer must be used.

Manufacturing Instructions

Pour the 250 cc of acetone into the empty gallon can. Add the Vinylite pearls slowly and begin to mix with the electric mixer until they are partially dissolved (about fifteen minutes). When the mixture has the consistency of honey, add enough denatured alcohol to thin the medium to a workable consistency. When the resins are completely dissolved, add 20 cc of Butonal and 20 cc of Carbitol, stirring them in well with a stick. (The Carbitol and Butonal are added to give better brushing characteristics and plasticity, and to retard drying.)

The Vinylite painting medium has a final consistency of syrup, is cloudy in appearance, and is fast drying. It will last indefinitely in airtight containers.

Denatured alcohol is the most common, least expensive solvent for thinning the medium and cleaning brushes.

Recommended Painting Surfaces

Raw duck canvas: Add titanium or zinc white dry pigment and Celite to Vinylite painting medium. (The amount of Celite should be about one fifth of the total volume.) Stir to a thick, creamy consistency. The mixture may be thinned by adding more medium or may be thickened by adding more Celite, depending on the type of surface you require. Heavy textures and stippled surfaces may be created with a pasty mix. Apply one coat to raw

canvas and wait until dry before you begin to paint (about twenty minutes). This method of preparing canvas is excellent for oil painting as well.

Untempered Masonite and plywood: First, sand the surface lightly, including the edges. Mix the medium, pigment, and Celite as you would for preparing canvas and apply to the surface.

Plaster, stucco, concrete, and brick walls: No undercoat is necessary. Clean the surface thoroughly, removing grease, oil, and loose paint. Avoid damp walls.

Paper, cardboard, chipboard, metal: No preparation is necessary.

Celotex and burlap: Coat these surfaces with acrylic gesso.

Painting with Dry Pigments

A list of recommended dry pigments appears in Chapter 4. Because pigments vary in weight, it is suggested that mixtures be made by volume. Ten to fifteen colors should give a wide range of variation for your palette.

Fill two-ounce jars two thirds full of dry pigment. Add Celite #281 to each jar, filling the jar to the top. Stir or shake the jar until the two ingredients are thoroughly mixed.

Using a muffin tin for a palette, pour a little prepared dry pigment into each section. Into a wide mouthed glass jar, pour a little of the prepared painting medium. Into a second wide mouthed glass jar, pour a quantity of denatured alcohol, for thinning paint and cleaning brushes.

Dip your brush first into the Vinylite medium, then into the dry pigment. On a second palette (non-porous — glass or porcelain) mix the pigment and the medium. Then apply the color directly to the painting surface.

Three kinds of brushes are recommended: bristle brushes of the kind used in oil painting; flat household paint brushes; and smaller sable brushes, for delicate work and fine lines.

Making Paints for Direct Use or Storage

Half fill wide mouthed, four-ounce jars with the prepared dry pigment. Add Vinylite medium until you obtain a syrupy paint consistency, stirring with a small stick or glass rod. Make up ten to fifteen colors for your palette. Paint directly from the jars, mixing on a glass or porcelain palette for intermediate color effects.

Handle this medium as you would handle oils, attempting blended effects or working with flat areas of color. Vinylite is especially effective in pointillistic or dry brush techniques. For textural effects, add any solid

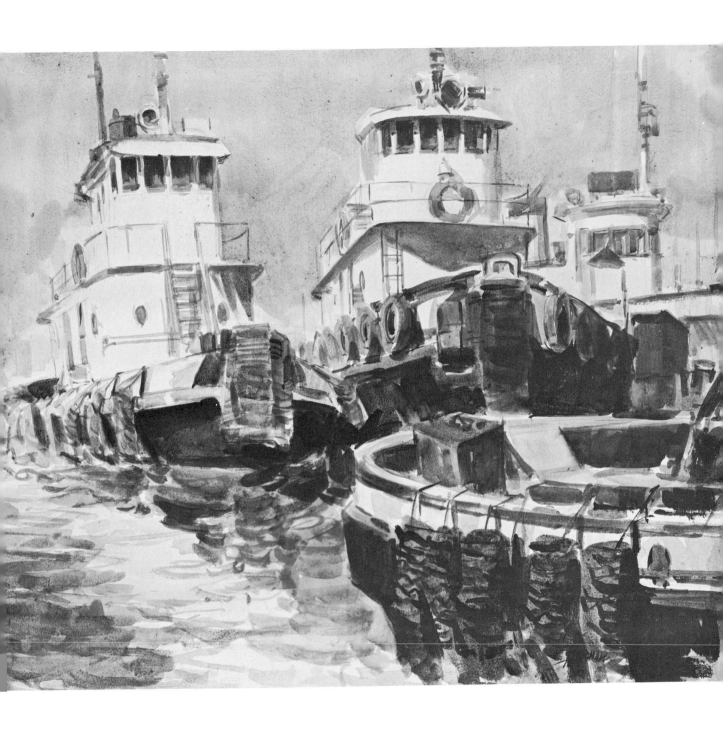

Seattle Tugs by Fred B. Marshall, acrylic on paper. Courtesy M. Grumbacher, Inc.
This scene is executed in a manner typical of transparent watercolor. Acrylic paints
were diluted with water and matte medium. Titanium white paint was used sparing-
ly for highlights. Mounted watercolor board was prepared first with a coating of
acrylic gesso.

thickening material and apply as an impasto with a palette knife. You can make interesting experiments with combinations of thin and thick techniques.

Although the final surface has a matte quality, you can create a shine by applying a clear acrylic varnish over it. To avoid cracking of heavy impastos, build high reliefs in a series of layers, leaving each layer to dry before adding another.

FORMULA #3: VINYL CHLORIDE

Working Characteristics

The inherent characteristics of this material lend it beautifully to easel or mural painting. It may be applied to a variety of surfaces, including canvas, paper, wood, plaster, concrete, and brick. Because of its unusual toughness and chemical resistance, it is especially recommended for outdoor or semi-outdoor mural or easel painting. It has been used successfully by many of the Mexican muralists, including David Siqueiros and Jose Clemente Orozco.

Chemical Properties

The vinyl chloride resins are manufactured in the form of white, fluffy powders, similar in texture to confectioner's sugar, but much harder. By varying the degree of polymerization and the ratio of vinyl chloride to vinyl resin, a great variety of resins are obtained for industrial purposes. Two types of vinyl chloride resins — vinyl chloride VMCH and VYHH — have been used with great success in the formulation of paints for mural and easel painting. They are products of the Union Carbide Corporation.

These thermoplastic resins are odorless, non-toxic, and non-flammable. They possess extreme chemical inertness, and are unaffected by alkalies, oxidizing agents, and most inorganic acids. Water, alcohols, grease, and fats have no effect upon them.

Chemical Ingredients

Vinyl chloride VMCH or VYHH (resembles confectioner's sugar)
Methyl Isobutyl Ketone (M.I.K. — solvent)

Recommended Solvents

Vinyl chloride resins may be dissolved by ketones, chlorinated hydrocarbons, and certain organic acids. Methyl Isobutyl Ketone (M.I.K.) is the chief chemical ingredient for dissolving the resin and for cleaning brushes. Caution: because the M.I.K. solvent has a strong odor and is toxic to a certain extent, it is important to work with good ventilation and to follow manu-

facturer's precautions. A good grade of lacquer thinner is another suitable solvent.

Equipment for Manufacture

Scale
Mixer (electric drill with paint mixing propeller, or electric kitchen blender or mixer)
Empty gallon can
Measuring beaker (500 cc capacity)

Manufacturing Instructions

Pour 500 cc of the liquid M.I.K. into the empty gallon can. Slowly add 100 grams of vinyl chloride powder. Stir with the electric mixer until all grains are completely dissolved (about fifteen minutes). If you want a thinner medium, add more M.I.K. For a thicker medium, add more vinyl chloride powder. (A ratio of about 40% vinyl chloride to about 60% M.I.K. is a good working proportion.) For a tougher vehicle — especially for outdoor work or projects subjected to moisture — mix the two resins, VMCH and VYHH, in equal proportions.

Recommended Painting Surfaces

Canvas, Masonite, cardboard, paper, Celotex: Prepare a mixture of vinyl chloride medium and titanium white dry pigment to produce a white paint as described below: "*Making Paints for Direct Use or Storage.*" Apply in the same way as suggested for Vinylite.

Inside or outside walls, new or old: Although cement walls are preferred, the medium may be used on any type of material, smooth or textured. First, clean off old paint, oil, and dust. Apply clear vinyl chloride medium as a sealer. Sketch your design on the wall and paint with any technique desired. When the mural is complete, you may obtain a shiny surface by applying a coat of clear acrylic varnish.

Aluminum and sheet metal: Prepare the surface by sanding lightly with fine emery paper. No priming is necessary. If a colored ground is desired for these metals, however, automobile priming lacquers may be used.

Painting with Dry Pigment

The medium may be handled in the same way as egg or casein tempera. Dip the brush first into the painting medium, then into the dry pigment, and finally apply to the painting surface. This method is recommended for easel paintings or for small decorative projects.

Making Paints for Direct Use or Storage

Using the prepared medium and a variety of dry pigments, you may prepare your own paints for use in your studio or school. Since powdered dry pigments vary in their absorptive capacity, no specific rule can be given for mixing medium and pigment. You will find it necessary to make adjustments in the amount of medium used with different dry pigments.

Start by mixing about 500 cc of medium with about 100 grams of dry pigment. Add to this about 20 grams of Celite, to impart a velvety, matte quality to the colors. Mix until homogeneous and test by brushing. If the paint does not have proper covering qualities, add more pigment. If it seems too thick and does not brush out properly, add more medium or M.I.K. solvent. In preparing large quantities of paint, use an electric mixer to make the paint properly homogeneous. The paints may be stored indefinitely in wide mouthed jars with airtight lids.

FORMULA #4: ETHYL SILICATE: A Medium for Murals on Masonry

As far back as the early 1900's, pure ethyl silicate was used in England to protect stone masonry from weathering. During this same period, the medium was also used by English artists for painting murals intended to imitate old tapestry.

Much later, in 1932, the Mexican artist, David Alfaro Siqueiros painted a mural with ethyl silicate in Buenos Aires. He used an ethyl silicate compound formulated by the German chemist, Kaim. This is believed to be the first use of this medium in fine arts in the Western Hemisphere. The Siqueiros mural is now over thirty years old, and is reported to be in good physical condition.

Working Characteristics

Ethyl silicate which is used in the formulation of a paint medium is not to be confused with potassium or sodium silicate (water glass).

Ethyl silicate is a colorless liquid with an agreeable odor, and is packaged in airtight drums. It sometimes may appear brownish in color, but this does not harm its working characteristics as a paint medium. The moment it is mixed with the other chemical ingredients in compounding the painting medium, it changes its color to that of a rich, light wine.

Chemical Properties

Ethyl silicate deposits silica in porous masonry as the medium hydrolyzes, thus making an excellent preservative for masonry. Naturally, it also makes

an excellent painting medium for the same kind of surface. Masonry surfaces which have been painted with ethyl silicate medium resist the action of decay, chemical fumes, and changes of temperature and weather as well. The medium does not darken nor change as it ages, and is especially well suited to outdoor painting projects.

Chemical Ingredients

Ethyl silicate (commercial grade)11 parts (or 100 cc)
Denatured alcohol (96 proof) or ethyl alcohol .. 3 parts (or 30 cc)
Tap water .. 1 part (or 10 cc)
Hydrochloric acid ... ½ part (or 5 cc)

Hydrochloric acid is a mild acid used generally for soldering purposes and available in most hardware stores and chemical supply houses.

Equipment for Manufacture

Measuring beaker, 500 cc capacity
One quart size, wide mouthed jar
One small tin or enamel funnel

Manufacturing Instructions

For best results, this formula must be prepared very accurately. Follow the directions carefully.

Pour ethyl silicate into a glass jar. Add the alcohol, water, and acid, in that order. Stir with a glass rod or tongue depressor just *once*. In five minutes, the mixture will begin to heat slightly (to about 38 C. or 100 F.) In fifteen minutes, test the mixture with thumb and index finger, as if you were testing dough. The mixture should now be slightly tacky.

If the formula does not heat, or if it does not become tacky, something has gone wrong during the process of formulation. It will be necessary to begin again, and to recheck measurements, accuracy of preparation, and ingredients. Be sure that the alcohol is of high quality.

After formulation, the ethyl silicate medium *may* be used immediately. However, for best results, it is recommended that the medium be allowed to stand for about twelve hours. Since this medium will have a tendency to gelatinize in about four days, it is not recommended that large quantities be made or that the medium be compounded into paint and stored. Do not shake or overmix the medium unnecessarily. For the medium to have its greatest strength, the gelatinization should be slow.

Painting Technique

Ethyl silicate should be used in much the same manner as egg tempera.

Using dry pigments, dip the paint brush first into the ethyl silicate medium, then into the dry pigment, then finally apply to the painting surface. While you are painting, keep the brushes moist with the ethyl silicate medium. Clean your brushes with water and detergent.

It is important to note that this medium should penetrate the masonry surface properly in order to be effective. For this reason, surfaces such as Masonite or canvas are not recommended. It is vital to pay strict attention to detail in mixing the formula. It is equally vital to pay scrupulous care to painting technique. Slight miscalculations in compounding the medium, or careless technique while painting, will not yield permanent results, nor exploit the inherent characteristics of this material.

Clean masonry surfaces to be painted with the ethyl silicate medium should *not* be primed with an undercoat of any type of paint. To be effective, the medium requires a clean, porous surface for proper penetration and crystalization. The large outdoor mural at the National Normal School in Mexico City, entitled *National Allegory*, was painted on concrete with ethyl silicate. Although the mural has lasted for seventeen years in an outdoor atmosphere of changing climatic conditions, it is now being restored. Unfortunately, the many "helpers" employed by the artist, José Clemente Orozco, were careless in their painting technique and were guilty of excessive overpainting, which caused some of the colors to peel.

From this unfortunate example, it must be emphasized that continuous "fussing" or overpainting with this medium will not yield permanent results, and constitutes a misuse of the material. This is to be considered an *alla prima*, or *one shot* painting medium. It is the *first* application of ethyl silicate — which fills the pores of the masonry — which counts; subsequent applications can no longer exploit the porosity of the virgin painting surface and the adhesion of multiple coats is doubtful. Up to three thin coatings may be applied, but more than three are not recommended.

Modeling techniques, glazing techniques, or other painting methods employing excessive overpainting are to be *avoided*. Excessive overpainting will pile up the crystals and will lead to impermanent results.

In the painting workshop of the National Polytechnic Institute at Mexico City, are two murals which were painted in 1947 and are in perfect condition today. To achieve these enduring results, the artists were extremely careful in their laboratory and painting methods. Flat planes of color were used; overpainting and glazing were avoided; and the medium was applied *thinly* to insure maximum penetration. A consistency similar to milk was used and colors resisting alkalinity were employed exclusively. These suggestions are crucial if you wish permanent results.

Once the ethyl silicate medium is mixed, it will last for only three to four days. At the end of this period, it will begin to gel and a new batch

Pyramid by Toby Joysmith, acrylic on Masonite. Acrylic polymer medium, mixed with water and plaster of Paris, provides the foundation for this polychromatic bas relief. The artist sets wood and fabrics into the paste to establish the sculptural effect of his work. Succeeding washes of thin acrylic paint build up a richly glazed surface of many colors.

will have to be mixed. Consequently the medium cannot be stored for future use, and must be mixed fresh for each painting period.

In addition to concrete, the painter may use brick, stucco, or asbestos sheeting for a painting surface.

FORMULA #5: ACRYLIC RESINS

Working Characteristics

Because of the clarity of the vehicle, paint made with a formula utilizing acrylic resins virtually glows with inner luminosity.

Although it is a fast-drying medium, acrylic does not dry quite as quickly as other mediums discussed, offering greater flexibility in handling. Because the solvents used with this medium are mild, there is no pick-up of previously applied paint. Its leveling quality is also excellent; flat areas, free of brush marks, are easy to obtain. Many noted artists have used acrylic successfully, including Rufino Tamayo, David Siqueiros, Juan O'Gorman, Arnold Belkin, Orozco Rivera, and Norberto Martinez. The latter two have done outdoor murals in tropical areas of Mexico.

The advantage of this medium is that *glazing* is easier to achieve, owing to the solvents used. Because the resin is also clearer than other media, the full tinting characteristics of the pigments may be exploited. Acrylic may be sprayed, rolled, brushed, or applied with a palette knife to both rigid and non-rigid supports, without danger of peeling or cracking.

Chemical Properties

Acrylic resins are thermoplastics derived from acrylic and metacrylic acids. They have the appearance of rock salt and are resistant to acids, alkalies, alcohol, and water. Their principal characteristics are transparency, adhesiveness, and resistance to alkalinity and ultraviolet rays.

Acrylic resins were discovered about 1901 by Dr. Otto Rohm, a German scientist. They were developed in Germany during the 1920's, and in the early 1930's were introduced in the United States.

In industry, the acrylics are used in the manufacture of dental plates, surgical instruments, plate glass, rugs and textiles, among other things. According to many sources, they are among the best plastics manufactured today. Acrylic resins may be liquified very easily with appropriate solvents and may be used successfully with dry pigments.

Chemical Ingredients

> Acryloid B-72 or B-82 ..400 grams
> Toluene and Xylol (solvents mixed 1:1)600 grams

Both of the acrylic resins Acryloid B-72 and B-82 may be used to make the paint medium, which is fixed with dry pigments to create acrylic paint, or used alone as a varnish. There is, however, a variation in the character of the two acrylics. The B-72 will produce a stable medium, whose particles will not stick or lump together. The B-82, however, becomes lumpy in temperatures above 38°C. Therefore, it is easier to mix the B-72, and the resultant medium is less likely to become lumpy in adverse temperature conditions.

Recommended Solvents

To thin the medium, add the solvents Xylol and Toluene, mixed 1:1. This mixture will serve to thin the medium, for general clean-up, and for cleaning brushes.

Equipment for Manufacture

Mixer (electric drill with paint mixer propeller, or electric kitchen blender or mixer)
Empty gallon can

Manufacturing Instructions

Pour the solvents into the empty gallon can. Add the acrylic resins, stirring with the electric mixer until they are completely dissolved and the mixture is of a smooth, uniform character. Average mixing time for small amounts is about half an hour. The consistency of the mixture should be like that of light honey.

The clear medium (formulated as directed here) may be used as a varnish for paintings done in other media, from the synthetics discussed in this book to oil, tempera, and watercolor. Apply this varnish with a light, direct brush stroke — do not scrub — because these powerful solvents *can* soften paint films.

Paintings containing aniline dyes should be varnished with care, since there is a general tendency for such dyes to bleed. If you suspect that colors have this characteristic, it would be best to varnish them with emulsified (water based) acrylic varnish.

Recommended Painting Surfaces

Acrylic may be used on almost any type of surface, because of the excellent tenacity and flexibility of the medium. Because of its resistance to light rays, acrylic is highly recommended as an outdoor painting medium. Among common surfaces well suited to this medium are canvas, burlap, Masonite (untempered), Celotex, plywood, metal, plaster, concrete, and certain types

of plastic. Because of the adhesive quality of the medium, it is excellent for making collages and mosaics.

Painting Technique

Mix the clear medium with dry pigments by dipping the brush from medium to pigment; then paint directly on canvas or other surfaces. Dry pigment containing Celite #281 will give a matte quality to the painting.

Paint may also be prepared in small, hermetically sealed jars for immediate or future use. Paint prepared in this way should be thoroughly mixed, and will have a shelf life of many years. If the paint thickens, thin with the Xylol-Toluene mixture.

One of the advantages of working with the acrylic resin medium is that it does not pick up color previously applied. Consequently, it is an excellent glazing medium. To glaze with acrylic resin paint, thin to a water-like consistency with the Xylol-Toluene solvent and apply with a soft brush. A rich, transparent quality may be obtained by overglazing many times.

The clear acrylic medium may be mixed with a variety of fillers to produce a paste or putty for creating high or low textures. Among recommended fillers are marble dust, sand, powdered Celite, glass beads, sawdust, metallic powder or filings, crushed class, and synthetic fillers (available where liquid plastic is sold). The textures produced with the medium adhere solidly to practically any surface, and dry to a rock-hard finish. Any type of paint may be applied to the textured surface — synthetic, oil, or water-base.

FORMULA #6: POLYACRYLIC ESTERS

Working Characteristics

These are emulsions possessing great adhesiveness, clarity, and flexibility. Paints may be compounded which will adhere to practically all non-oily surfaces. They are fast drying, water miscible, and yield a paint film which is virtually impossible to crack, even if the support is rolled or twisted. Although milky in color, the emulsion dries to a clear transparent finish.

Chemical Properties

Polyacrylic esters are AC-33, AC-34 and AC-55, all Rohm & Haas products. Only Rohm & Haas products are called polyacrylic esters. There is no odor. They are manageable with water; indelible when dry, with good adherence to all kinds of surfaces, except greasy ones; resistant to alkalinity and mild acids. They are co-polymers.

Chemical Ingredients

Rhoplex AC-33, AC-34, or AC-55
Dry pigments

Manufacturing Instructions

The emulsified, water base acrylics represent a great advancement in the field of synthetic materials. Unfortunately, the artist is faced with a great many problems in the preparation of the paint medium itself. The task requires special laboratory equipment and scientific know-how. Thus, the artist may choose to buy one of the good commercially prepared acrylic paints, or he may carefully prepare his own paints, using a commercially manufactured acrylic emulsion.

Excellent results may be obtained by mixing the emulsified acrylic resin — Rhoplex AC-33, AC-34, or AC-55 (manufactured by Rohm & Haas) — with dry pigment or universal tinting colors, available in paste form.

It is not recommended, however, that paint be mixed in large quantities or stored for later use, since the material has a tendency to produce foam when a great deal of paint is prepared. Since acrylic emulsions are slightly alkaline, it is wise to use only those dry pigments that have been proven lime resistant. See Chapter 4 on pigments.

Recommended Painting Surfaces

Most common surfaces — canvas, illustration board, untempered Masonite, plywood, prepared wall surfaces — are suitable.

Painting Technique

Paint as you would in the egg tempera technique. Dip the brush first into the medium, then into the dry color. Then apply to the painting surface.

Commercially Manufactured Materials

Although satisfactory results may be achieved with dry pigment and the acrylic emulsions, these mixtures are not as good as the commercially prepared artists' colors listed in Chapter 5. Such problems as foaming, wetting, dispersing, and plasticizing present technical difficulties which the artist cannot handle in his studio. However, manufacturers of acrylic paints have created one of the finest new mediums to be placed at the artist's disposal. The painter should investigate the various commercial brands available and decide for himself which one is suited to his particular needs.

Meditations by Lajos Markos, acrylic on canvas. Courtesy M. Grumbacher, Inc. The canvas was prepared with acrylic gesso, tinted slightly with a neutral gray-green acrylic paint. Preliminary drawing and shadow areas were painted with acrylic paint thinned with water and gloss medium. Middle tones, without white, were then painted and light tones and highlights were painted last by mixing acrylic color with white. Flat sable brushes were used throughout.

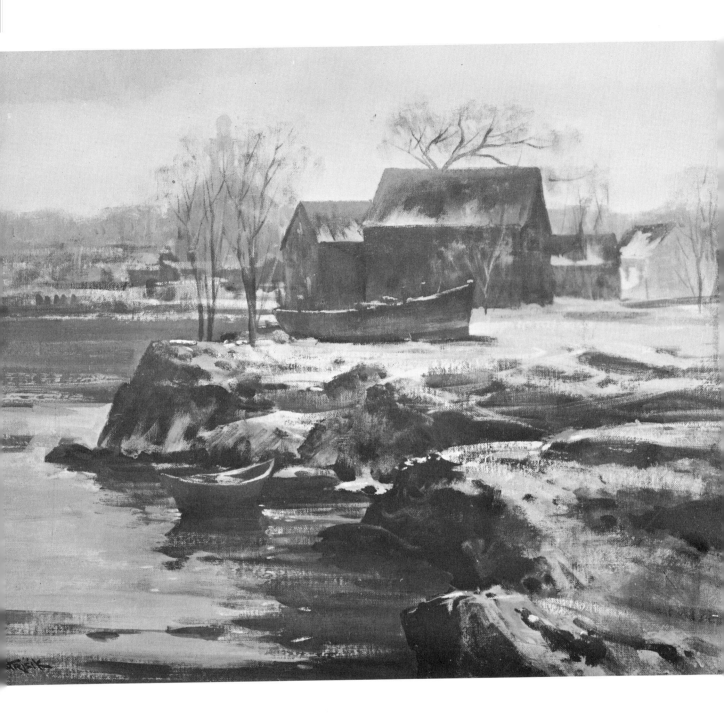

Boat Yard by Paul Strisik, acrylic on canvas. Courtesy M. Grumbacher, Inc. The canvas was primed with two coats of acrylic gesso, one coat in each direction; the final surface resembles linen. Preliminary drawing and modeling were done with raw umber thinned with water. In the final painting, acrylic colors were thinned with acrylic gloss medium; the medium was thinned with three parts water.

FORMULA #7: PYROXYLIN

Working Characteristics

Although it is not a plastic, pyroxylin is a synthetic material developed about the same time as the plastics; it has now emerged as a paint medium. Pyroxylin is by no means a new material; it has been used for many years in industry. However, it is only in recent years that new advances in its formulation have made it desirable as an art medium.

David Siqueiros, a pioneer in the use of pyroxylin, worked with it in the late 1920's. The medium was then in its infancy, and some of the early paintings have now darkened and cracked. Since that time, however, the material has been so much improved that the artist may use it with confidence for indoor mural and easel painting.

In 1936, in an experimental workshop in New York, methods and techniques were explored for using pyroxylin lacquers. Among the artists attending the workshop sessions were Pollock, Arenal, Berdesio, Basques, and Gutiérrez. The research was led by David Siqueiros. In the years before he died, the late Jackson Pollock painted exclusively with pyroxylin. Siqueiros has continued to use it and has found it highly satisfactory in mural painting.

Commonly known as Duco lacquers, and developed principally as automobile paints, the lacquers are brilliant in hue and are available in a wide range of colors. Although many brands are manufactured, the artist should use none but the finest available. The finer the lacquer, the less brittle it is, and the better the pigmentation.

Pigments used for the coloration of the lacquers are organic and inorganic; many are the same as those used in the formulation of oil and water base paints. According to current fashion trends, the industry produces hundreds of tints and shades, which vary from year to year. However, you need only select a few basic colors and mix them to produce the intermediate hues required.

The lacquers may be brushed, sprayed, or dripped. Since pyroxylin is extremely fast-drying (five minutes or less), retarders are of very little use. The painter must accustom himself to the drying qualities of the material and find his own way of working with the medium.

A note of caution: pyroxylin fumes are toxic. When you work with pyroxylin, make sure the room is well ventilated and handle the material according to the manufacturer's instructions. Solvents (lacquer thinners) are strong, can irritate your skin, and should be used with care. Avoid prolonged breathing of the vapors.

Chemical Properties

Pyroxylin (nitrocellulose) is extracted from cotton, and has bases of nitric and sulfuric acids. The compounds would be extremely difficult to produce in the studio, owing to the delicate and dangerous process of formulation. Therefore, if you wish to use the material, you should purchase it directly from your local paint dealer or automotive supply house.

Recommended Painting Surfaces

The best surfaces for lacquers are rigid ones, such as untempered Masonite, plywood, and sheet metal. Porous surfaces, such as Celotex and similar materials, may be sealed with a preliminary coat of a good automobile primer.

Painting Technique

Colors are prepared automobile lacquers, available at local paint dealers. In purchasing colors, select hues of deep color saturation, avoiding those of weak color intensity. Here is a suggested palette.

White	Deep maroon
Black	Brilliant red
Red oxide	Orange
Ochre	Hansa yellow
Green oxide	Phthalocyanine blue
Deep violet	Permanent crimson

Use a fine grade of lacquer thinner to extend the paint, to clean brushes, and to clean spray equipment. Note that two types of lacquer are available, one for brushing, another for spraying.

Use clear lacquer as a varnish for completed lacquer paintings. *Spray* on to avoid picking up previously applied color.

Thin, clear lacquer, with a consistency of light syrup, may be used as a medium to which dry pigments may be added. Lacquer may be thinned to work on such flexible materials as paper and canvas without danger of cracking.

Because of the leveling characteristics of lacquers, it is not necessary to use very fine sable brushes. Household paint brushes or bristle brushes used for oil paints are quite suitable. In glazing for transparent effects, however, you may dilute paints with lacquer thinner to a light, milky consistency, and use finer quality brushes. Apply colors lightly when glazing to avoid disturbing the undercoat.

Image of Our Time by *David Alfaro Siqueiros, pyroxylin lacquer on Celotex, 3'x4'. The texture of the head, which is ½" thick, is a mixture of lacquer and marble dust.*

For a matte surface, add Celite #281 (about one fifth by volume) to the lacquer.

To avoid cracking when you are painting thick areas, add castor oil; it serves as an excellent plasticizer and a mild retarder.

To create even textures, use untempered Masonite or plywood, pour a small amount of lacquer over the surface, and spread evenly with a palette knife or a small piece of cardboard. You may then sprinkle marble dust or sand over this wet surface and allow the lacquer to set for a few minutes; then shake off the surplus material to obtain a sandpaper-like surface.

To create uneven surfaces, mix a quantity of clear lacquer with marble dust, Celite, powdered cork, fine sawdust, ground glass, whiting, machine shop filings, or other similar materials to make a paste-like mixture in an empty can. This "putty" may be applied to a rigid surface in any irregular manner with a palette knife or trowel. The textures may serve as a surface preparation, or, if you wish, can be mixed with pigments for a direct painting medium.

To create high surfaces, make a powder by sawing or scraping Celotex and mix this sawdust with clear lacquer to form a putty. Relief shapes or textures may be built with this material.

In addition to using pyroxylin in a way similar to traditional oil painting methods, stencils and spray techniques may be used for flat colored areas.

With an airbrush or spray gun, modeled or flat color areas are easily created. Dilute the paint with a good grade of lacquer thinner to a milk-like consistency. Spraying low relief areas head-on — or from an angle — yields interesting effects. Be sure to work in a well ventilated room, use a spray mask, and follow the manufacturer's specifications.

You may get dramatic effects by "pooling," allowing colors to flow together, with or without the aid of lacquer thinner.

On a rigid surface of untempered Masonite or plywood, pour drops of color, adjacent to each other, until the entire surface is covered. In the center of each color area, while it is still wet, pour a smaller amount of a contrasting hue. Watch the effects of flowing color. By tilting the surface, you can produce unusual effects. Try pouring lacquer thinner directly onto the wet paint.

When a desired effect has been achieved and you do not want any further flow of color, set the paint by using infra-red lamps. You will find soup spoons very useful painting instruments in directing the flow of color. Effects achieved through these "created accidents" may be used as backgrounds for paintings or as paintings in themselves.

3
mural painting

Because of their exceptional durability *outdoors* as well as indoors, plastic paints have come to play an important role in contemporary mural painting. This chapter describes ways of preparing a variety of surfaces for mural painting and concludes with recommendations about actual painting technique.

PREPARING MASONRY SURFACES

Masonry surfaces (stucco, cement, brick) should be cleaned and given two coats of prepared cement, known as the *scratch coat* and the *final coat*.

Scratch Coat Ingredients

Marble dust (rice-like, granular quality)	3 parts
Portland cement	1 part
Hydrated lime	½ part
Cut hemp (use one inch lengths)	about ¼ cup per gallon of mix

Scratch Coat Directions

Combine the marble dust, cement, and lime; sprinkle in the loose hemp; and mix thoroughly. Add enough water to produce a heavy paste. Mix thoroughly by "kneading" with a trowel. Then apply the mixture directly to the wall. In order to achieve a good bond, dampen the wall slightly before applying the mix. The mixture should be "flicked" with force onto the wall with the trowel. Level the stuccoed wall with a large, smooth-edged stick,

Detail of Mural by Arnold Belkin, acrylic on cement, Child Welfare Building, Mexico City. Politec acrylic, mixed with Luzitron medium, was painted directly onto a concrete wall which had been primed with white acrylic paint.

working it up and down and moving it from left to right. The texture should be slightly rough, in order to provide a *tooth* for the final coat. Allow the scratch coat to dry thoroughly.

Final Coat Ingredients

Marble dust (granulated sugar-like quality) 2 parts
Portland cement...½ part
Hydrated lime ...½ part
Celite #281 ..1/5 part
Water ...As needed

Final Coat Directions

Add Celite to the other dry ingredients and mix thoroughly. Add enough water to produce a paste that will "stand" or hold its shape when applied to the wall with a trowel. The Celite gives a clay-like consistency to the mixture and helps to achieve a very smooth surface, if that is desired. When the wall has been treated with the final coat and is dry, examine the surface carefully to make sure that there are no cracks or hollows (caused by air bubbles). Hollows should be broken and re-stuccoed with the final coat formula. Cracks should be filled and the entire surface area given a final check to detect any further structural defects.

You may make the final coat either smooth or rough. If you want a smooth surface, use a steel trowel for the final finishing. For a rough surface, use a wooden trowel.

If a fresco *secco* technique is to be used for painting the wall, the surface should be prepared with a smooth finish. (The fresco *secco* technique using plastic paints is described later in this chapter.)

When other techniques are to be used, an additional process is needed in preparing the wall. The final coat should be primed with one coat of acrylic varnish and one coat of white acrylic paint, for a white, lustrous painting surace. To this surface, Vinylite, acrylic, pyroxylin, oil, casein, and other painting media may be applied.

PREPARING CONCRETE WALLS FOR ETHYL SILICATE

Two stucco coats are necessary to prepare a concrete wall for painting with ethyl silicate: the scratch coat and the final coat. (The formula for the ethyl silicate medium appears in Chapter 2.)

Scratch Coat

For the scratch coat, use the formula given for masonry surfaces and apply in the same way.

Final Coat Ingredients

Marble dust ..2 parts
Portland cement ..1 part
Celite #281 ..1/5 part
Water ..As needed

Final Coat Directions

Mix the dry ingredients in small amounts. Add enough water to obtain a pasty mixture. Apply to the wall (which has been dampened) with a trowel. Finish with a wooden trowel for a slightly "toothy" surface. You may begin painting as soon as the wall preparation is dry.

PLASTER WALLS

Plaster of Paris walls should be dampened slightly with a sponge and then given a coat of acrylic gesso or acrylic paste-extender, applied with a brush or trowel. The acrylic paste-extender may be textured with a variety of tools while still wet.

You may paint directly on the gesso treated wall. If a less porous surface is desired, however, paint the wall with one coat of acrylic painting medium, diluted 1:1 with water.

UNTEMPERED MASONITE, CELOTEX, CANVAS, WOODEN WALLS

With a household paint brush or roller, apply a coat of acrylic varnish-sealer, flat paint medium, or gloss paint medium. Then apply a coat of white acrylic paint.

On this surface, you may use any painting medium: plastic, oil, tempera, casein, or lacquer.

METAL SURFACES

Apply a coat of a good grade of industrial metal primer. Follow with a coat of flat or gloss acrylic paint medium.

SLICK SURFACES (GLASS, TILE, ETC.)

Prepare with the acrylic paste, Politec Plastilita, which has been tested for its ability to adhere to the most difficult surfaces.

Mural by José Clemente Orozco, Maria Isabel Hotel, Mexico City. Vinylite paints, prepared for the artist by José Gutiérrez, were applied over plywood panels. In-gredients for Vinylite paint are listed in the chapter, "Making Your Own Plastic Paints."

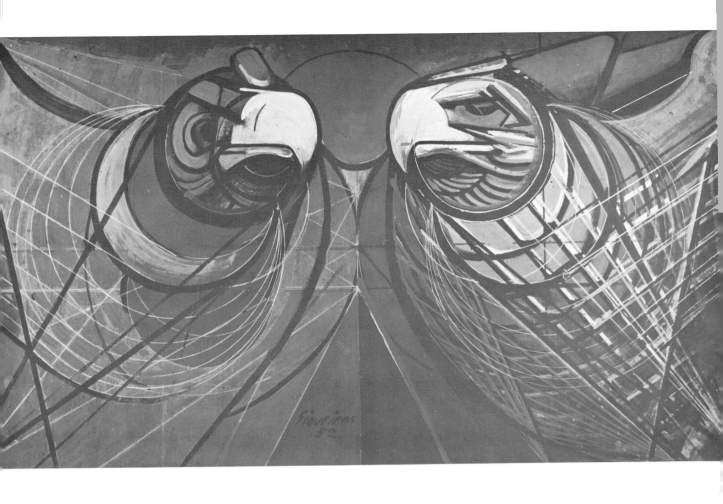

The Two Americas by David Alfaro Siqueiros, acrylic, 29½"x 47¼". Collection, Mr. and Mrs. Phillip A. Bruno. In this study for a mural, the artist has made use of the crisp, linear quality of acrylic to visualize the design of the final painting. Many brush lines were actually ruled against a straight-edge. The paint was thinned to the consistency of gouache. (Photo, John D. Schiff)

FALSE WALLS OF MASONITE

A false wall or "portable mural" may be made on 3/8" untempered Masonite, which is available in 4'x8' panels.

The back of each panel should be reinforced with wood strips (2"x2" pine), placed about 2 feet apart, which should be glued with a waterproof glue. Screws should be used, inserted from the front and countersunk. Do not use nails; they have a tendency to pop out later.

Where the panels are joined together, it is wise to run a strip of muslin dipped in commercial glue over the joint. The muslin should be cut approximately two inches wide.

Sand the surface of the Masonite lightly, to develop a *tooth*. Prime the entire surface with one coat of acrylic polymer medium (flat or glossy) and allow to dry. Follow with a coat of acrylic gesso. Fill the countersunk screws with acrylic paste and feather the edges of the joints.

Textures for the wall may be created by covering the entire surface with acrylic paste. Apply the paste with a brush or trowel. Use such tools as combs, sticks, broken saw blades, forks, etc., for an infinite number of textures. Although this is not essential, a final coat of white acrylic paint may be applied to make the painting surface less porous. Any medium may be used on this surface preparation: plastics, oils, tempera, lacquer, etc.

NOTES ON PAINTING OUTDOOR MURALS

The painting mediums discussed in this book are listed in this paragraph in the order of their resistance to outdoor exposure: ethyl silicate; acrylic resins; vinyl chloride.

Pigments recommended for outdoor exposure are: Mars black, ivory black, lamp black, ultramarine blue, phthalocyanine blue, chrome oxide green, phthalocyanine green, hansa yellow, yellow ochre, cadmium yellow, cadmium orange, cadmium red, red oxide, indanthrene violet, permanent violet, raw sienna, burnt sienna, raw umber, burnt umber.

Dark colors may be mixed with titanium white for lighter tints, although excessive mixing will adversely affect the permanence of colors.

Flat areas of full strength color are preferred. Observation of panels at controlled laboratory testing stations indicated that the tinting of colors by using white caused marked depreciation in permanence. Each color is a controlled system in itself; it will yield maximum permanence if not intermixed with other colors, or white. For example, instead of using red and yellow for making orange, use the prepared cadmium orange paint.

As many coats of the same color may be applied as necessary. However, be careful not to apply more than two different color *mixtures* on top of one another. This is an important precaution to avoid chemical incompatibility.

For greatest durability, modeling should be done with dry brush and glazing techniques, rather than by using an intermixture of color. Each color of the plastic paints is a complex system in its own right; consequently, for *maximum* permanence, straight colors should be used in mural painting outdoors.

For further protection of the completed mural, apply a final coat of clear acrylic painting medium or varnish.

PAINTING MURALS WITH A FRESCO SECCO TECHNIQUE

Traditional fresco techniques call for the artist to grind pigments in water and apply his colors directly to the wet plaster wall while the plaster is in the process of setting. The chemical action of the setting plaster (carbonic acid and lime) provides the bond between the pigment and the surface. In this way, murals must be done a small section at a time, and no correction or overpainting is possible. These disadvantages do not restrict the artist who works with acrylic paints; he may work in larger areas and correct mistakes whenever necessary.

When using acrylics in a fresco technique, first prepare the wall as described earlier. Draw a cartoon or final comprehensive outline in charcoal. A dark acrylic paint may then be used directly over the sketch, and modeling may be done in the same color, with thin washes, using a cross-hatch technique.

Dampen the wall slightly and continue to apply thin, transparent washes of color, using short strokes as in fresco style. You may overpaint with additional glazes in complete confidence, unlike the case of traditional fresco. The colors will not change in tone when dry; the artist can interrupt his work at any time without problems of color matching.

The finished mural may be left with a matte surface, or may be given a coat of acrylic varnish-sealer or varnish-medium for additional protection.

4
pigments

Many of the pigments used in formulating oil paint, watercolor, and other artists' paints may be used safely with the plastic paint formulations. This includes both organic and inorganic pigments. However, when an acrylic polymer medium is to be formulated, the principal problem lies in selecting pigments which resist alkalinity. This alkalinity is present in acrylic polymer mediums and also on such painting surfaces as concrete, asbestos, and lime. Aside from this consideration, *The Artist's Handbook of Materials and Techniques*, by Ralph Mayer, presents a logical approach to the problem of selecting desirable pigments in compounding paint formulations.

The requirements for a paint pigment, as recommended by Mayer, are as follows:

1. Should be a smooth, finely divided powder.
2. Should be insoluble in the medium in which it is to be used.
3. Should withstand the action of sunlight without change.
4. Should not exert a harmful chemical action upon the medium or upon other pigments with which it is to be mixed.
5. Should be chemically inert, unaffected by materials with which it is to be mixed, and unaffected by the atmosphere.
6. Should have the proper degree of opacity or transparency to suit the purpose for which it is intended.
7. Should be full strength and contain no added inert or loading ingredients.
8. Should conform to the accepted standards of color and color quality, and should exhibit all the desirable characteristics of its type.
9. Should be purchased from a reliable house which understands and

tests its colors, selects them from world-wide sources, and can furnish information as to origin, details of quality, etc.

The pigments listed below are obtainable in powder form and meet most of the aforementioned requirements, plus the additional requirement of resistance to alkalinity. They have been used widely in both easel and mural painting techniques, and have been found to be extremely hardy in resisting the effects of light and atmospheric impurities. They are recommended for use with the formulas described in Chapter 2.

WHITE

1. Titanium White

Extremely permanent, unaffected by all conditions which paintings are likely to undergo. Compounded of titanium dioxide (rutile). The particles are of round, or prismatic grains, giving excellent covering qualities. The pigment is the whitest of whites, inert, and unaffected by heat. Compatible with other pigments in producing tints. Avoid the use of whites in preparing glazes, as this will cut down the transparency of the other pigments.

2. Zinc White

Zinc white, of extremely fine grain crystals, is a pure, cold white. It is lightweight, and bulkier than white lead. Does not possess the hiding power of titanium white, but mixtures of both titanium and zinc whites produce paints which possess great brilliance, strength, and film flexibility, uncommon in either of the whites used singly.

Zinc white is recommended where white must be used as a translucent glaze. Zinc white may be used in dry powder form, mixed with the plastic paint vehicles, and used in a painting technique similar to fresco. However, it is not recommended that you use this pigment in compounding a paint to be stored.

The authors recommend a white mixed with both titanium and zinc whites in the following proportions: zinc white, 25%; titanium white, 75%.

BLACK

1. Ivory Black

Bone black. These black particles are irregular and coarse; are made of charred animal bone; and have a blue-black character. This black has a smooth texture, contains approximately 10% carbon, 84% calcium phosphate, and 6% calcium carbonate. It is highly favored by many artists, and

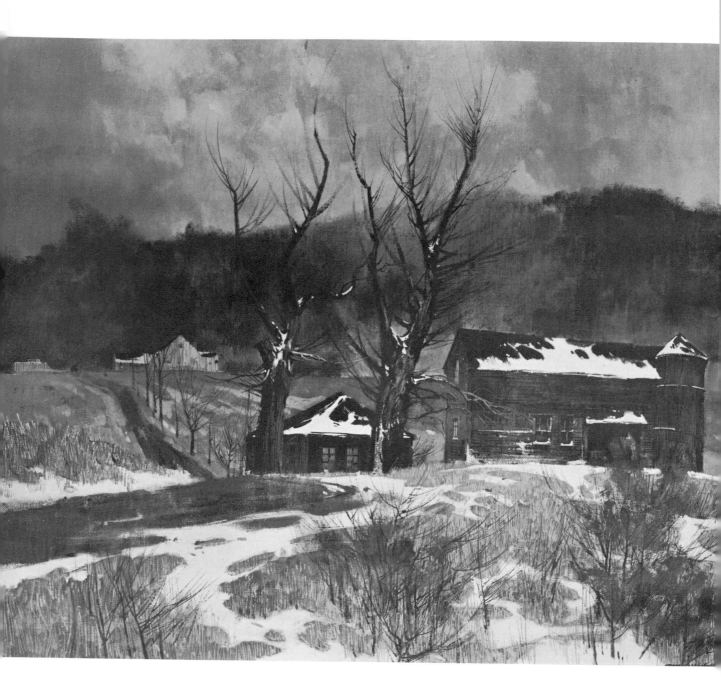

November Squall by Tom Nicholas, acrylic on canvas. Courtesy M. Grumbacher, Inc. The canvas was primed with several coats of acrylic gesso with a light sanding between coats. Thin, semi-opaque washes of color were applied with soft sable brushes. Matte acrylic varnish was used at the intermediate stage of the painting and subsequent colors of thicker viscosity were applied to establish the solidity of the buildings and trees.

is compatible in all vehicles. It possesses excellent covering characteristics and is the most intense of the black pigments.

2. Lamp Black

This black pigment is bluish and produces good neutral grays when mixed with white. Thinned, it produces excellent glazes. It is of very light, irregular particles and tends to create problems for the artist who wishes to mix the dry pigment with a vehicle to create a paint. Because of the buoyancy of the pigment, it literally floats on the surface of the vehicle and is somewhat difficult to make into a suspension. Consequently, special handling is required; you must employ wetting and dispersing agents. This black may be purchased in paste form, relieving the artist of such problems. In purchasing the paste lamp black, the artist has at his disposal a pigment which is already dispersed for either water, polymer, or other paint vehicles.

3. Mars Black

This is a pigment compounded of artificial oxides of iron. It is dense, opaque, and completely permanent in all plastic paint vehicles. It forms very strong films when combined with the synthetic paint vehicles and has a warm color quality.

RED

1. Red Oxide

Created of a synthetic iron oxide, this pigment possesses crystals of a minute character and is very opaque. It is permanent, stable, very bright, and yields an excellent paint film. It is recommended also for its good covering power, and will mix safely with all plastic paint formulations. Formerly derived from natural sources, it is now artificially produced. The iron oxide pigments have had a long and continuous use in paint formulation. Both the natural and the synthetic varieties of this pigment bear many trade names.

Red oxide possesses a red-maroon hue, and may be mixed with black to produce a coffee color. Mixed with white, it yields a brick color. Mixed with green oxide, it produces a forest green. Although it may be used for glazing, it does not produce completely transparent color.

2. Cadmium Red

Known as cadmium red, or cadmium red lithopone, or cadmium barium. Cadmium red is a cadmium sulfo-selenide, composed of cadmium sulphide and cadmium selenide. It is made in light, medium, or deep shades and is very permanent. It is bright, opaque, and has excellent covering character-

istics. The cadmiums are completely compatible with all plastic paint vehicles. Most new cadmium pigments also include barium sulphate and may be called cad-barium or cad-lithopone pigments. The latter are superior and more desirable due to greater inherent permanence.

The light, medium, and deep shades provide pigments that can be used in mixtures varying from a red-orange to a red-maroon hue. By controlling viscosity, the painter may use these pigments to glaze, to paint opaquely, or to create heavy, rich impastos. Cadmium reds mixed with white produce a great range of pinks; cadmium red and cadmium yellow may be mixed to produce a brilliant orange.

3. Naphthol Red

The new naphthol red organic pigments of light and crimson shades are permanent, and resistant to light and atmospheric chemical attack. They are brilliant pigments, and yield excellent transparent glazes in plastic paints. The ITR line of naphthol red colors is the only naphthol recommended for use in plastic paint formulations. The mixing characteristics are approximately the same as with the cadmium reds. Used by Permanent Pigments in formulating their naphthol ITR crimson, they belong to the general class of AZO type pigments. Naphthol red is designed to replace the alizarine crimson pigments.

VIOLET

1. Dioxazine Purple

This pigment is formulated of dioxazine carbasole and is highly favored as a choice in producing plastic emulsion paints. It produces an excellent glaze, and resists light and general exposure very well. It is a very deep purple and produces excellent tints when mixed with white. It is used in formulating the Liquitex purple.

2. Permanent Violet

This is one of the new developments based on very permanent lightfast vat dyes. Permanent violet is used generally in the paint trade as a tinting pigment for house paints, which require maximum lightfastness; it is a strong, organic pigment. The resistance to light in its pure tone is excellent. With white (as much as 1-100 parts) the qualities still remain good. These pigments originated in Frankfurt, Germany, a product of the Hoechst Company. Similar pigments are now manufactured in the United States and are available from the American Hoechst Corporation, Carbic Color Division, 270 Sheffield Street, Mountainside, New Jersey.

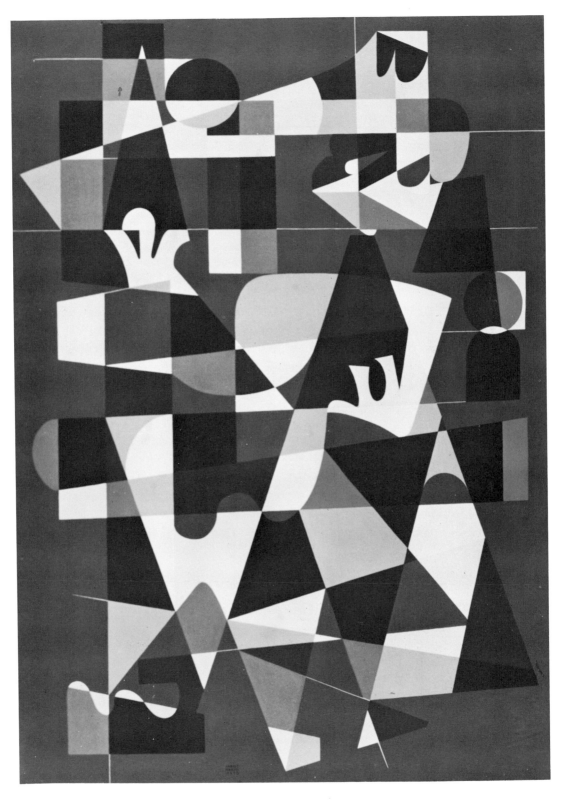

The Bird by Carlos Merida, acrylic on paper, 57" x 38½". The precise counterchanges of flat color are applied with soft sable brushes. Merida paints on a variety of papers and leathers, striving for a smooth, level application of color and mechanical precision of shapes and patterns. (Photo, José Verde O.)

3. Indanthrene Violet

Indanthrene violet R.H. is manufactured by the Hoechst Company. It belongs to the indanthrene pigment grouping and is of an organic nature. Resistance to light, permanence, mixture with other pigments, and dispersion in plastic paint vehicles, are all excellent.

BLUE

1. Cobalt Blue

Compounded of cobalt oxide, aluminum oxide, and phosphoric acid, this is a very stable pigment, highly resistant to sunlight. This is a "middle" blue, often regarded as essential to the artist's palette. The pigment forms an opaque film, with excellent covering characteristics. Cobalt blue does not possess the glazing qualities of phthalocyanine blue, but produces acceptable glazes.

2. Ultramarine Blue

Genuine ultramarine pigment was made by grinding the semi-precious stone, lapis lazuli. In recent times, however, an artificially prepared ultramarine pigment is produced by a complex chemical process and yields a pigment which is considered superior to the natural one. The pigment is semi-transparent and mixes well with other pigments in plastic paint formulations. It is affected to some extent by weak acids and has poor tinting strength.

3. Cerulean Blue

Compounded of cobalt and aluminum oxides, this pigment is a light "powder blue." It is opaque and permanent and of high luminosity. Cerulean is often used for sky effects.

4. Phthalocyanine Blue

This blue pigment is superior to Prussian blue, which it was designed to replace. It is compounded of copper phthalocyanine and alumina. A very permanent, intense blue of great tinting power, it produces excellent glazes and is considered to have twice the tinting strength of Prussian blue and 20-40 times the tinting strength of ultramarine. Mixed with white, it produces a tint similar to cerulean blue; added to yellow, it produces an intense green; mixed with reds and violets, it produces brilliant intermediate hues. Phthalocyanine blue is color fast, resistant to alkalinity, and is unaffected by the chemistry of other pigments.

GREEN

1. Chromium Oxide Green

This pigment is a chromium oxide compound, pale green, and rather weak in tinting power. It is, however, highly favored in landscape palettes and possesses an exceptionally strong and permanent paint film when mixed with plastic paint emulsions. Excellent for obtaining dark tones in portrait or figure painting. May be deepened with phthalocyanine blue or phthalocyanine green.

2. Viridian

Transparent chromium oxide. May be used with plastic resins and emulsions in powder form by dipping the brush into the emulsion and then into powdered pigment. Has long been used in fresco painting, with very good glazing properties. Not compatible with phthalocyanine colors, but mixes well with other pigments for intermediate hues.

3. Phthalocyanine Green

Compounded of chlorinated copper phthalocyanine and alumina, this is an intense green pigment of great tinting power, extremely permanent and resistant to light. It possesses excellent glazing characteristics and has good covering power. Yellow greens of extraordinary brilliance may be produced by mixing this color with cadmium or Hansa yellows.

YELLOW

1. Yellow Ochre

This is a natural pigment of clay, having the color of iron oxide. It is permanent, opaque, and possesses excellent covering power. Yellow ochre — or Mars yellow, below — are useful in flesh tones, thus important to the portrait painter.

2. Mars Yellow

Compounded of artificial oxides of iron. Depth of color may be controlled to produce an even graduation and tint, creating a more desirable color than the natural paint compounded of yellow ochre pigment. Mars yellow is permanent, resistant to alkalinity, lightfast, opaque, with characteristics similar to yellow ochre.

3. Cadmium Yellow

Available in light, medium, and deep. Cadmium-barium or cadmium-litho-

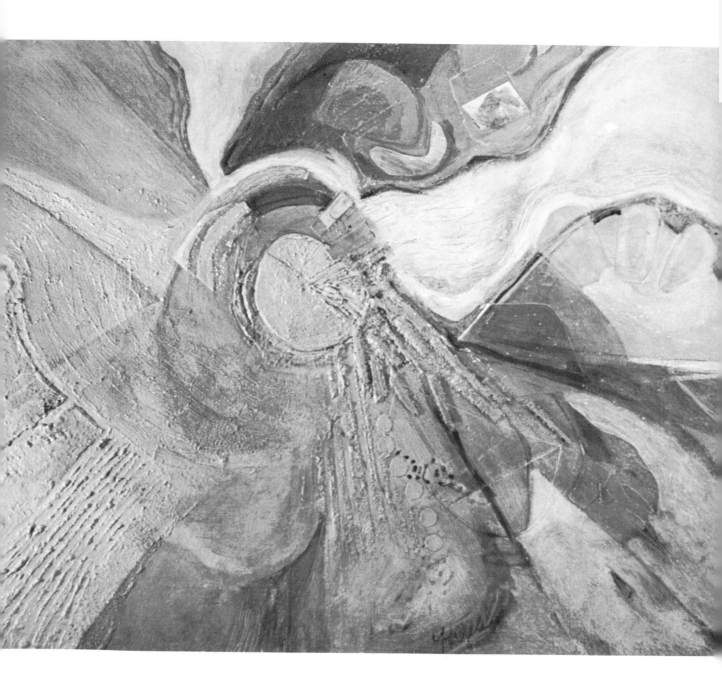

Landscape by Ronald Hayes, acrylic vinyl. The textured ground was prepared by using textured modeling paste, containing inert aggregate and copolymer binder. The copolymer paints were then applied over the textured ground.

Four at Bat by Kendall Shaw, acrylic on canvas, 68"x96". Courtesy Tibor De Nagy Gallery. In this type of hard-edged "pop art," acrylic has become particularly popular because the paint can be applied in flat, crisp, textureless areas, in much the same way as the traditional "designers' colors." Acrylic lends itself equally to precise handling or to free brushwork.

pones are cadmium sulphides co-precipitated with barium sulphate. These cadmium-barium pigments are superior to the older cadmium sulphides, colorfast, permanent, and compatible with plastic paint formulations. They may be readily mixed with other colors to produce predictable results, are excellent for glazing, and have good covering power for opaque films as well. Mixed with cadmium red, they will produce brilliant oranges. Mixed with phthalocyanine blue, they will produce a dark yellow-green, similar to Hooker's green.

4. Hansa Yellow

Compounded of the most permanent of the synthetic yellow dyes for making yellow lake pigments. The range of colors designated as Hansa 5g and 10g are used in the preparation of greenish-yellow lakes, and possess all the desirable characteristics for a pigment used in compounding plastic paint. It has excellent glazing characteristics. Transparent greens may be achieved by mixing Hansa yellow with phthalocyanine blue or green. Dynamic effects may be created by using this color in juxtaposition to darker hues.

ORANGE

1. Cadmium Orange

Compounded of cadmium-sulpho-selenide co-precipitated with barium sulphate. Has the same characteristics as other cadmium-barium pigments: permanent, light resistant, brilliant in hue, and of opaque covering character. This color is similar to one achieved by mixing cadmium or Hansa yellow with cadmium red.

BROWN (Earth Colors)

1. Raw Sienna

Raw sienna is natural earth color; it is clay containing iron and manganese. It is warmer than yellow ochre, permanent, color fast, mixable with other pigments and with plastic emulsions and resins. Raw sienna has excellent glaze characteristics and is favored by many portrait artists for mixing flesh tones.

2. Burnt Sienna

This earth color is of a very brilliant red-brown hue, and is the least "chalky" of the earth colors when mixed with white. Burnt sienna has excellent glaze characteristics. Dark flesh tones may be made by mixing burnt sienna with ultramarine blue.

3. Raw Umber

This is an earth color similar to raw sienna. It is a strong gray-brown with a slight greenish cast, an excellent glaze, and useful in portrait and figure painting.

4. Burnt Umber

This is a natural earth color made by calcining raw umber. It has the same general characteristics as raw umber, but is warmer in tone. Burnt umber is a good glaze, very permanent and resistant to light.

FLUORESCENT PIGMENTS

Fluorescent pigments are finely powdered organic pigments which produce brilliant fluorescence under ultraviolet light or daylight illumination. These pigments have no afterglow.

Ten brilliant colors are available from the Lawter Chemical Company: (1) pink (2) orange (3) green (4) medium orange (5) red (6) lemon yellow (7) cerise red (8) golden yellow (9) red orange (10) yellow orange. These colors may be obtained in powder form by writing directly to the manufacturer in Chicago; South Kearny, New Jersey; or San Leandro, California.

Prepared fluorescent paints, properly wetted and dispersed, may be obtained at most paint or artists' supply stores. These prepared paints may be purchased in the poster color line and may be mixed with polymer mediums or various water based acrylic resins.

In painting with the fluorescent colors, best results are obtained when the painting surface is first primed with a white undercoat. This allows for maximum fluorescence.

Fluorescent colors may be mixed with acrylic paints, and in so doing, the regular paints are intensified. For example, if you mix a fluorescent red with a cadmium red acrylic color, you produce a fiery red. The same may be accomplished by mixing fluorescent greens with green acrylic; yellow fluorescent with yellow acrylic, etc. Fluorescent colors may be used in all plastic paint formulations, including Vinylite, acrylic resins, and polymers.

These colors are intermixable among themselves as well. The great limitation of these pigments is their poor performance outdoors. Indoors, they are reasonably permanent; outdoors, they will gradually fade. Fumes and smoke have a tendency to blacken the paint surface.

METALLIC POWDERS

These pigments are metals in flake, powder, or paste form, and have the

Paris by Henry Gasser, acrylic on paper. Courtesy M. Grumbacher, Inc. Using a watercolorist's approach, the artist diluted acrylic colors with water to obtain a typical watercolor consistency. An ink spatter technique was used for the texture of the old buildings. The painting was finished with a coat of matte medium.

characteristics of the actual metal. Metallic powders offer excellent weather resisting properties and are being utilized by many manufacturers in the formulation of paints.

Metals Disintegrating Company of Elizabeth, New Jersey, has pioneered research and exploration in the metallic powders. These powdered pigments and pastes are now mass production items and are readily available for paint formulation.

Gold and copper bronze powders possess the remarkable durability of brass and copper, but are susceptible to tarnishing. Metallic films of this nature should be coated with a clear, water white acrylic varnish for protection.

Formulas for dispersion of these pigments are available from the Metals Disintegrating Company and include aqueous systems such as polyvinyl acetate and acrylic.

ALKALINITY TEST FOR DRY PIGMENTS

The pigments listed above have been tested for resistance to alkalies. Unknown pigments may be given the following test to determine their compatibility with synthetic paint mediums.

Mix two parts marble dust or fine sand with one part dehydrated lime. Add a small amount of water to form a thick paste; spread over a wooden or brick surface. Smooth the surface and allow the mixture to begin to set. While it is setting, apply the pigment, mixed with water, very lightly with a soft brush. If there is no noticeable change in hue after twenty-four hours, the pigment is considered alkaline resistant.

Landscape by Nicholas Roukes, acrylic on canvas, 12"x22". Heavy modeling paste was manipulated over unprimed canvas for a textural ground. Subsequent painting over the dried surface was done in a scumbling manner, emphasizing texture, and developing areas of brilliant color.

5
commercially prepared plastic paints

Although you may want to mix your own paints at first, you will often find quicker, more consistent results in using commercially prepared materials, which are products of skilled laboratory research. Now available at local art supply stores is a wide array of plastic paints, produced by leading manufacturers.

Commercially prepared plastic paints are made of acrylic resins or vinyl resins, or a combination of both. Paints described as copolymers are compounded of two types of resins; the desirable qualities of each — clarity and flexibility — are merged in one emulsion. All of the commercially prepared plastic paints are water soluble except for Bocour's Magna, which is soluble in turpentine. Products of different companies should not be intermixed, for each manufacturer uses a different formula, which may be incompatible with others.

In addition to paints, each manufacturer produces a line of mediums, which may be used for glazing or as a final varnish. Usually there are both a flat and a gloss medium. In some cases, a *gel* is especially made for achieving transparent glaze impastos. Also available are acrylic gesso and modeling paste. The latter is formulated with acrylic resin and marble dust, and is used for texturing.

Plastic paints are packaged in glass jars, metal tubes, and clear plastic squeeze bottles. They are available in quantities from two ounces to one gallon.

Aside from acrylic artists' paint, industrial paints are also being manufactured with a plastic base. These are not compounded especially for the use of the artist. Artists' colors are formulated with higher grade pigments and do not have the "chalking" or self-cleansing quality common to paints

used on houses or furniture. Consequently, industrial paints are not recommended for art purposes.

Descriptions of the commercially prepared paints in this section have been compounded from technical bulletins, brochures, and letters provided by the manufacturers of artists' paints. The reader should bear in mind that new products are appearing on the market in rapid succession. At the time of publication, the facts in this chapter were correct. However, as new information becomes available, this chapter will be updated in future, revised editions of this book.

AQUA-TEC

Manufactured by Bocour Artists Colors, 552 West 52nd Street, New York, New York 10019.

Aqua-tec employs as a medium and binder an acrylic resin of the same type as that used in the manufacture of the transparent plastics, Lucite and Plexiglas. Aqua-tec is mixed with water or an acrylic water based medium as you paint, but is waterproof when dry. It possesses the depth, brilliance, and durability which is inherent in plastic emulsions and which is characteristic of the acrylic paints. You may use Aqua-tec on such ordinary surfaces as canvas, paper, and gesso panels, as well as on china, glass, and plastic sheets. Its flexible paint film permits a variety of techniques, from heavy impasto to delicate brush delineations and transparent washes.

Products: Aqua-tec artists' colors; matte medium; polymer medium; matte varnish; gesso; molding paste.

Aqua-tec Artists' Colors are available in jars and plastic squeeze bottles. Since these water base colors dry by evaporation, paintings may be finished rapidly. Once the painted surface is dry, it is completely insoluble in water; you may begin overpainting immediately, without affecting the color beneath. Previously applied paint will not pick up. Water is used for thinning the colors and for general clean-up. When the surface is dry, it is not subject to further chemical change. The paint film remains permanent, durable, and flexible.

Matte Medium: Use matte medium to provide a flat, non-glossy painting surface, free of glare. Combine matte medium with polymer medium for intermediate gloss effects. The medium may be used to thin Aqua-tec colors for glazing or for thin applications of color washes. Matte medium is also an excellent adhesive for collage materials.

Liberation *(mural detail)* by Jorge Gonzales Camarena, acrylic on canvas. Instituto Nacional de Bellas Artes, Mexico City. Opaque, flat, and scumbled areas of color were glazed with acrylic paints which were diluted with water, creating a surface of unusual brilliance. This architectural mural was painted on canvas in four sections.

Polymer Medium: Mix polymer medium with Aqua-tec colors for a glossier surface quality. This medium may also be used to thin the paint when preparing glazes and, like the matte medium, may serve as a binder for collage materials.

Matte Varnish: Use this as a final varnish for paintings completed in Aqua-tec colors.

Gesso: This acrylic gesso may be used as a primer for painting surfaces and also to create a great number of textures and mild relief shapes. Since it is made of the same basic material as the Aqua-tec colors, the gesso may be intermixed with them to make a thick, viscous paint for use in heavy impasto techniques. Gesso is also useful in preparing picture frames.

Molding Paste is a viscous acrylic paste that may be used for building textures and high, heavy reliefs on paint surfaces or picture frames. The molding paste has useful applications wherever reliefs are needed — in paintings, maps, or models.

Painting with Aqua-tec

Aqua-tec colors offer a wide range of artistic possibilities. They may be applied with a brush in the same way as oil or tempera, or with a palette knife for textures or flat areas. The colors may be thinned with water or with the mediums for transparent washes. You may also use a scumbling or dry brush technique.

　　If you wish to experiment with mixed media, oil and acrylic paints may be combined in successive layers. The underpainting may be done with Aqua-tec, and subsequent glazing with transparent oil washes. Or, if you wish, oil paint may be used for the ground and the overpainting done with opaque or transparent Aqua-tec.

CRYLA

Manufactured by George Rowney and Company Limited, 10/11 Percy Street, London W. 1, England; U.S. distributor, Morilla Company, Inc., 43-01 21st Street, Long Island City, New York 11101.

Cryla polymer acrylic paints are manufactured and widely used in the United Kingdom and have been imported for distribution and sale in the United States as well. Cryla acrylics were the first plastic paints to be packaged in tubes and have a consistency similar to oil paint. Cryla is non-

yellowing, non-oxidizing, non-brittle and possesses color of extraordinary brilliance.

Like most other acrylic paints, Cryla colors are water miscible. They are not miscible with turpentine. Cryla colors dry in minutes through the natural process of water evaporation. Once the colors are dry, they produce a very tough, permanent, and yet elastic paint film.

They may be painted on most supports, i.e., paper, Masonite, hardboard, plaster, unprimed canvas, and other fabrics.

Since the colors act as their own ground preparation, no special consideration is necessary. However, Cryla white or Cryla primer are available for application to the supports mentioned above for initial preparation and can be applied with either brush, roller, or palette knife.

Products: Cryla acrylic colors; medium/varnish #1 (gloss); medium/varnish #2 (matte); primer.

Cryla Acrylic Colors have been used extensively in the United Kingdom. The flexible paint films they produce may even be rolled without fear of cracking. Marketed in tubes with the familiar consistency similar to oils, they dry to a semi-glossy surface sheen. This surface quality may be further controlled, however, by the additional use of mediums/varnish #1 and #2.

Cryla medium/varnish #1 (gloss) may be added to the colors to thin them without losing paint body or film strength. The use of this medium also gives the final surface a high gloss. The medium may be mixed with the paints while painting, or used as a final varnish over the completed work. To produce a waterproof paint film, this medium may also be added to poster colors, powdered dry colors, and other student watercolors.

Cryla medium/varnish #2 (matte) has the same characteristics as the acrylic varnish discussed above, with the difference that it imparts a flat, non-shiny characteristic to the final surface. In using either of the two mediums, variation may be obtained by using them with water, and combining the two mediums for an intermediate surface sheen effect.

Cryla primer is a pure titanium white acrylic emulsion paint, which dries in minutes and is used in the preparation of painting surfaces such as those indicated in the text above, plus plastics, and cement. It prepares practically any surface for an ideal painting ground, and is recommended especially where the artist wishes to use fine washes of color (the white ground enhances the brilliance of the colors). In other cases, irregular surface textures may be created by the use of knives, sponges, or other tools for

Independence and the Opening of the West by Thomas Hart Benton, acrylic on canvas, 19'x 32'. Truman Memorial Library, Independence, Missouri. The 495 square

foot mural was completed in 1961. Belgian linen canvas was used as a support. Primed with acrylic gesso, the canvas was attached to the wall with a polyester adhesive. Matte acrylic medium was used as a final protective finish for the mural.

impasto painting. This impasto will dry in about two hours.

Painting with Cryla

The artist may paint in a style suitable to his temperament, ranging from
an oil painting technique to that of watercolor. As Cryla paints have a great
adhesiveness, a palette of glass, formica, plastic, or tear-off paper is recom-
mended. To keep the color moist on the palette, spray some water on each
area of color on the palette from time to time during the painting session.

Brushes should be kept moist with water while painting. The palette
of color may be kept overnight if some protective device — such as Saran
Wrap or a jar or pot, which has been coated on the rim with some of the
color — is placed directly over the palette to exclude the air.

In using the colors, mix them with water to obtain proper brushability.
Mix the colors with the mediums to increase transparence for glazing. When
even the heaviest of impastos is used, these colors take only about three to
four hours to dry; thinner washes dry in minutes. The quick drying action
may be retarded to some extent by spraying water on the painting's surface.
All of the colors in the Cryla line are permanent and intermixable.

HYPLAR

*Manufactured by M. Grumbacher, Inc., 460 West 34th Street, New York,
New York 10001.*

Hyplar plastic colors and mediums are formulated with a high copolymer
plastic latex emulsion. This means that the water which forms the liquid
base of the medium has fine particles of a colorless synthetic resin sus-
pended in it. These particles form a clear film when the water evaporates.
The film is luminous, brilliant, tough, durable, and flexible. It is waterproof
as well as oil-proof.

Products: Hyplar artists' colors; gloss medium and varnish; matte medium
and varnish; modeling paste and extender; gesso; gel.

Artists' Colors: This painting medium can simulate the effects of any of the
aqueous or oil media. The use of a copolymer plastic binder, soluble in
water, produces qualities which are not usually associated with an aqueous
medium. There is very little change in the colors from the wet to the dry
stage. Once dry, the colors are extremely stable. Flexible supports — like
canvas or paper — may be painted in thin or heavy impasto applications,
even when these supports are to be rolled. The great adhesiveness of the

colors makes it possible to work on any non-oily surface: resin-free and sap-free wood, cloth, plaster, acetate, raw canvas, etc. Hyplar is packaged in jars.

Gloss medium and varnish is a high copolymer latex emulsion vehicle, which may be mixed with Hyplar artists' colors to increase their gloss, adhesiveness, and waterproof quality. When you wish a high gloss finish, it is an excellent final varnish for the plastic paintings.

Matte medium and varnish: This high copolymer latex emulsion is mixed with the colors to give a matte (non-glossy) quality to the picture surface. It also increases adhesiveness and waterproof quality. When either the gloss or matte varnish is first applied, it has a milky appearance, but becomes clear and transparent when dry.

Modeling paste and extender is a ready-to-use acrylic polymer latex emulsion compounded with ground marble. It dries rock-hard and is resilient and durable. While wet, it may be modeled, shaped, or textured. When dry, it may be carved, cut, or sanded. The paste should be used with adequate support. It is also suitable for many crafts projects, papier maché, collage, and to make printmakers' plates for printing on textiles or paper. Modeling paste-extender may be thinned with the Hyplar mediums or with water. When the paste is mixed with the Hyplar colors, the paints become more viscous and dry more matte. You may use almost all media over this material, including plastic paints, oils, watercolors, tempera, and casein.

Gesso: This is a ready-to-use painting ground material, containing titanium white pigment and acrylic polymer latex emulsion. The gesso is fast-drying, and resistant to oil, water, and alkali. Non-yellowing and adhesive, this gesso can be used to prepare painting surfaces without preliminary sealing. Apply with a brush or roller to any clean, non-oily surface. For a very smooth texture, thin the gesso with about one third volume of water, and apply several coats. Sand after each coat. For textured grounds, use the gesso directly from the can without diluting, and apply with a palette knife or brush. You may add Hyplar colors to the gesso to tint the painting ground.

Gel is mixed with the Hyplar colors for glazing and to increase paint transparency.

Painting with Hyplar

You can use standard brushes, knives, and other equipment associated with traditional media.

Skater by Alex Colville, acrylic on Masonite, 44½"x27½". Collection, Museum of Modern Art. Color plate courtesy Banfer Gallery and Cosmopolitan. Colville applies his color very thinly, in small, precise, form-following strokes, like the early masters of egg tempera. He makes little attempt to blend or fuse tones. The effect is similar to pointillism; the colors of the individual strokes mix in the viewer's eye to produce effects of great delicacy.

For a palette, use a glass or polyethylene surface, a disposable strip-palette, plastic ice cube trays, or foil muffin cups. To keep the paint from drying in open jars, cover them with aluminum foil. If you have established the color pattern of the painting, you may pre-mix the colors and store them in small glass jars.

For a watercolor technique, use all the ordinary brushes and tools associated with watercolor painting. Add a small amount of medium and some water to the colors. With Hyplar, watercolors may be executed on canvas, hardboards, or any suitable surface prepared with Hyplar gesso. You can employ transparent or opaque techniques.

For glazing, thin the colors with Hyplar medium or mix with Hyplar gel. Each layer is ready to be glazed over as soon as it is dry. You may apply any number of glazes, since underlying layers will not be disturbed by additional glazes.

Direct painting and impasto involve direct applications of color without any preparatory underpainting. You may use the colors as they come from the jar or thinned with water or medium. For heavier, textured applications, when you wish to use palette knife techniques or textural build-ups, the colors should be mixed with modeling paste-extender.

For novel textural effects, add clean sand, glass beads, or similar materials to modeling paste-extender. It is recommended that heavy impasto areas be built up one layer at a time, permitting each layer to dry before the next is applied.

In collage techniques, both the gloss and matte mediums and the modeling paste-extender may be used as adhesives to adhere a great variety of flat and dimensional materials.

LIQUITEX

Manufactured by Permanent Pigments Inc., 2700 Highland Avenue, Cincinnati, Ohio 45212.

An aqueous emulsion of an acrylic ester polymer is used as the medium for the pigments in Liquitex artists' colors. In simpler terms, it is a plastic (acrylic) resin, emulsified in water. The resin, in the form of very fine particles, is suspended in the water. These resin particles give the emuslion a milky appearance; but when the water evaporates, they flow together and join to form a clear film. The acrylic resin in Liquitex is of the same chemical nature as the transparent plastics known as Lucite and Plexiglass.

Although soluble in water as it comes from the jar or tube, Liquitex becomes completely insoluble as soon as the water evaporates. As a result, overpainting can proceed in a few minutes without affecting the paint be-

neath or the durability of the painting. The ground may be primed with Liquitex gesso, the painting completed with many layers of color, and the varnish applied, all in the same day.

Products: Liquitex artists' colors; polymer medium; matte medium; gesso; matte varnish; modeling paste and extender; gel.

Liquitex Artists' Colors: Packaged in jars and tubes, the colors are thick in consistency and brush easily. The tube colors approach the consistency of oil paints. Used directly, without any thinner, the colors are largely opaque and dry to a somewhat matte finish. To increase flow, thin the paint slightly with water or acrylic medium. To increase transparency, while maintaining full paint body, add polymer medium or gel, which will also increase the gloss. For a flatter quality, add matte medium. To vary the degree of gloss or flatness, vary the proportions of the two mediums.

Use only water and/or the Liquitex mediums to thin the paint. Do not mix with oil paint, other mediums or varnishes, or solvents used with oils. Use caution in thinning with water; too much water will produce too much mobility, and the paint will lack the cohesiveness necessary for control. There is also the danger of washing out the binder which holds the pigment. When paint must be thinned to a great extent, add some polymer medium to the water to preserve the film strength.

Polymer and Matte Mediums: The ways in which the Liquitex mediums are used with Liquitex artists' colors are described above. You may also use polymer medium or matte medium, or a combination of both, as a vehicle for dry pigments. In mixing dry color with the medium, rub the color up (with a palette knife) into undiluted or almost undiluted medium, using little or no water. In this way, the best color values and paint consistency are obtained, and the paint has sufficient binder to be properly durable. Liquitex polymer medium has excellent adhesive properties and is useful in making collages. It may also be used as a final varnish for a painting.

Liquitex Gesso is a liquid painting ground material which may be applied directly to canvas, with no preliminary sealing or sizing. The acrylic plastic resin fills the pores of the painting surface and protects the fibers. You may use Liquitex gesso just as it comes from the can, or it may be diluted with water (about 20%) and brushed on in two or three coats for a more even surface. Allow each coat to dry before applying the next. Heavy textures may be made with the gesso; such materials as sand and marble dust may be mixed with it to create a variety of surfaces. You can use the gesso as a primer for canvas, wood, plaster, masonry, and other porous surfaces,

and as a ground for encaustic paintings. Used on paper, it is an ideal base for silverpoint drawings.

Liquitex Matte Varnish: To give a painting a final protective film, you may apply a coat of matte varnish or polymer medium. You can vary surface gloss by controlling the proportions of varnish to polymer medium, mixing them together. If you prefer a matte finish, varnish first with polymer medium; when this is dry, apply a coat of matte varnish. Varnishing may be done as soon as the painting is dry. Use a flat, soft hair brush and apply the varnish with continuous strokes. Do not restroke over wet areas; wait until the varnish is dry to do any touching up. To thin the varnish, add water. When first applied, the varnish will have a milky appearance, turning completely clear when dry.

Liquitex Modeling Paste and Extender is an acrylic "putty" containing finely ground marble. It may be used to produce impastos, to build high relief surfaces, and to create three dimensional forms. Heavy applications of this paste should be made on stiff supports. Forms built with the paste may be painted or glazed with Liquitex colors to make a polychromatic relief. Liquitex modeling paste plus one-quarter to one-third gel medium makes an excellent, permanent sculptural or bas relief material. After drying for a short while, the modeling paste may be modeled like clay.

Gel is a pure, thickened, concentrated acrylic emulsion of the same vehicle used in the polymer medium. Gel is used with the colors for making heavy-bodied impastos of a transparent character; it may be used under, with, or over the Liquitex colors for creating dimensional effects. Gel sets up and dries more slowly than the other fluid media, mixed with the colors, when it allows for easier manipulation of the colors in obtaining blended effects.

Painting with Liquitex

Use bristle brushes, soft hair brushes, or stiffer and tougher substitutes like sabeline and high grade oxhair.

A flat piece of glass serves very well as a palette. To remove dried paint, submerge the glass in water for a short time and strip the paint from the surface. Color mixtures remaining on the palette may be placed in small, covered jars for future use.

When you set the palette, it is best to put out only as much paint as you will use during the session. Keep the colors on the palette to a minimum, adding colors when they are needed. Paints that have thickened may be made reworkable by adding a bit of water; but those that have hardened may not be reworked.

Keep your brushes wet while you are working; immerse them in water frequently, squeezing out excess liquid before dipping them into the paint, to prevent dilution. When you are finished working for the day, wash your brushes in soap and water. To clean brushes on which paint has dried, immerse them in Liquitex remover, an organic solvent for dried acrylic paint.

Any number of thin coats of Liquitex color, diluted with a medium, may be applied to a painting surface to build a glaze of any thickness and transparency. Before applying each new coat, allow the previous one to dry. Drying takes only a few minutes. One way of handling the glazes is to rub them over the surface quickly and lightly with the fingers or thumb, as is done with oil glazes. This should be done swiftly, however, because the film sets quickly, and may be rubbed off as it sets.

It is possible to do a limited amount of scumbling by means of rapid brush handling, using the color thinned with medium.

Before applying Liquitex to any aged masonry surface, loose or powdery paint must be removed by thorough wire-brushing. One or two coats of Liquitex gesso may be used as a primer, to seal the surface and provide a proper painting ground. Where you expect any degree of outdoor exposure, it is best to strengthen both the gesso and the paints with at least 25% of the polymer medium. Murals should be varnished with a coat of polymer medium or matte varnish (or a combination of both), to provide a protective surface.

Paintings done with Liquitex should be so marked on the back, indicating that only mild soap and water are needed to clean them. Never allow other solvents to be used in cleaning.

MAGNA

Manufactured by Bocour Artists Colors, 552 West 52nd Street, New York, New York 10019.

Magna colors, medium, and varnish are compounded with an acrylic resin that is completely compatible with linseed oil and turpentine, but *not* with water. The colors are fast-drying, with a consistency similar to that of oil paints. They are brilliant, intense, and like the other acrylics, remain unchanged in tone when dry. Laboratory tests using the quartz-lamp fade-ometer have projected a life of over two hundred years for the colors.

Products: Magna artists' colors; Magna varnish; Magna painting medium.

Magna Plastic Artists Colors: These fast-drying acrylic colors are unique among plastic paints because they are compatible with oil colors and with

linseed oil. They are not water-soluble; they may be thinned only with turpentine or the prepared medium. Unlike other acrylic water base paints, Magna colors may be reworked with turpentine after they have dried, so there is little waste. Used as they come from the tube, paints will dry within two hours; if they are thinned with medium, they will dry even more quickly. You can use Magna colors on such conventional surfaces as canvas, paper, and illustration board.

Magna Varnish: Magna paints dry quickly; however, excessive scrubbing while overpainting may pick up previously applied paint, especially when you use turpentine. To prevent pick-up, each layer of Magna color should be isolated with transparent Magna varnish. This is an excellent final varnish for paintings executed in Magna colors *or* in oils.

Magna Painting Medium is used for reducing or thinning Magna colors; the medium helps maintain the brilliance and film strength of the paint even in the subtlest of washes. It can also be used to hasten the drying of Magna colors, and of oils as well.

Painting with Magna

Magna colors may be used alone or in combination with oil colors. Any ordinary painting surface will do: canvas, paper, plaster walls, gesso panels, etc. Since the viscosity of Magna resembles oil paint, an oil painting technique may be employed. However, unlike oil paints, Magna will dry quickly, allowing work to progress faster.

Use a palette knife for impastos; thick areas may be built up safely and will dry quickly, especially if medium has been mixed with the paint. For watercolor effects, thin the paint with turpentine. Use turpentine for cleaning your brushes.

Magna paints may be used for overpainting oils. Conversely, ground painting may be done with Magna and overpainted with oils.

NEW MASTERS

Manufactured by California Products Corporation, New Masters Fine Arts Division, 169 Waverly Street, Cambridge, Massachusetts 02139.

New Master Fine Arts Materials are compounded from a formulation of acrylic-vinyl copolymer emulsions. This kind of emulsion is a compound of many fine particles of solid copolymer suspended in water. Drying takes place as the water evaporates, allowing the particles to coalesce. The film

thus formed is adhesive, non-yellowing, and permanently flexible, with a smooth, non-porous surface.

Products: New Masters artists' colors; New Masters illustrators' colors; matte and gloss mediums; gesso; modeling paste.

New Masters Artists' Colors are high viscosity paints, packaged in plastic tubes, similar in appearance and handling to tubed oils. Full strength pigments are dispersed in the acrylic-vinyl copolymer emulsion vehicle. Drying period is about four to six hours. Thinner layers dry in thirty minutes. The paint film may be kept workable by adding water periodically. Water is used to thin the paint. Soap and water are used to clean brushes and tools.

 Because of the high viscosity of the colors, the artist can create textures and heavy impasto areas without delay in drying and without eventual cracking of the film. Once the paint is dry, it is unaffected by water or atmospheric changes. The surface is insoluble, so successive paint layers may be applied in any thickness and sequence. The film surface is durable and clear; there is no chalking or flaking of the paint film. Color values will not change, fade, or yellow upon aging. There is no muddying when colors are intermixed.

New Masters Illustrators' Colors, available in plastic squeeze bottles, have the same features as the artists' colors, but are more fluid and will dry to a soft matte finish. They are non-bleeding and fast-drying, well suited to reproduction and commercial applications. They may be used in combination with New Masters artists' colors and with the mediums for a variety of techniques, brilliant glazes, and variations in surface gloss.

New Masters Mediums are designed as thinning and glazing vehicles for the artists' and illustrators' colors. They are available in two forms. *Matte medium* reduces surface gloss for flat surface effects; by varying the proportion of medium to color, you can achieve varying degrees of gloss. Gloss medium increases the surface gloss. Either medium may be used as a final varnish for paintings done in watercolor, casein, gouache, tempera, and plastics.

New Masters Gesso is a liquid, ready-to-use painting ground. It dries quickly to a brilliant white, permanently flexible surface. The gesso is also a copolymer emulsion, which may be used to prepare surfaces for painting with acrylics or oils.

Attic Treasures by Ernest Land, acrylic on Masonite. Courtesy M. Grumbacher, Inc. The Masonite panel was primed with three coats of acrylic gesso with a light sanding between coats. The preliminary sketch, to establish the composition, was rendered with charcoal pencil. The painting was executed in two stages: underpainting, using solid, basic colors; and glazing. Acrylic colors were thinned with matte acrylic medium for obtaining transparent glazes. The artist glazed objects farthest away in the composition first, gradually working towards the front planes of the composition. Final varnishing was done with gloss acrylic medium, thinned slightly with water.

Modeling Paste: This is a completely inert, light material, available in paste form, to be added to the colors for obtaining heavier viscosity, or for treating painting surfaces prior to painting. The modeling paste is packaged in pint and quart containers. In addition to the modeling paste, the manufacturer also offers the artist a dry aggregate, packaged in 8 oz. squeeze containers. This is the same inert aggregate in powder form, to be mixed with any of the colors or mediums in the New Masters line, or with plastic paints made by other manufacturers.

Painting with New Masters

Use any of the tools employed with oil paints — sable, bristle, fitch, and nylon brushes, as well as palette knives.

Glass, plastic, or well-oiled wood palettes are recommended. Paper and non-oiled wooden palettes should not be used; the porosity of these materials will cause them to absorb water from the paints.

When you begin to paint, pour out only enough paint for about two hours' work; the paint is fast-drying, and larger amounts may dry hard on the palette. (Small amounts of water, added to the colors from time to time, will keep them workable longer.) Thin the colors only with water or with the mediums. They are not compatible with oils or with the solvents used in oil painting.

For brilliantly clear glazes, mix four parts of medium to one part of color.

For painting on paper, colors may be thinned with water (about 60% paint, 40% water) for transparent, watercolor effects. Excessive thinning with water has a weakening effect on the paint film; if too much water is added, some medium should be used to increase the film strength.

You may use the colors directly on masonry, plaster, and wood surfaces. A minimum of preparation is necessary. On masonry and plaster, repair the major cracks; remove old paint and oil; sand the surface and prime with two coats of New Masters gesso.

Use the mediums as an adhesive for collage materials of any sort: transparent or opaque papers or textural substances.

Dried paint surfaces may be cleaned with mild soap and water. Do not use solvents or strong detergents. Paintings finished with acrylic resin should be so labeled on the back.

POLITEC

Manufactured by the Politec Company, Tigre 24 (Actipan), Mexico 12, D.F., Mexico. U.S. distributor: the Politec Company, 425 14th Street, San Francisco, California 94103.

Formulated by an artist for artists, Politec was developed in response to demands by the Mexican muralists, who required a paint that would dry quickly, last indefinitely, and offer brilliance of color and ease of handling. Developed at the laboratory workshop of the National Polytechnic Institute in Mexico City, Politec products are now being used by artists in Europe, Asia, and the Americas.

Politec paint is made from acrylic emulsions. The acrylic resin is suspended in the water in tiny particles; when the water evaporates, these particles merge to form a film which is highly resistant to light, oxidation, and climatic changes. The acrylic vehicle is perfectly compatible with the pigments, forming a homogeneous paint. The paints may be freely intermixed to form intermediate colors; they are thinned with water.

Products: Politec 100 (acrylic ester paint); Politec 300 (acrylic base tempera); varnish-sealer; Luzitron varnish-medium; Plastilita Extender.

Politec 100: This paint, formulated with a 100% acrylic ester base, is wetted, dispersed, plasticized, and ground to extremely critical specifications. It offers a wide range of uses and great flexibility, rivaling oils and watercolor in certain ways, and producing its own particular luminous, brilliant effects. Politec 100 dries to a velvety, matte surface which is unusually resistant to exposure and climatic changes.

Politec 300 is acrylic tempera, especially formulated for the use of schools, hobbyists, and commercial artists. It is suitable for posters, textiles, decorating papier mache, sculpture, plaster, etc. A water soluble medium, Politec 300 has an acrylic base, which makes painted surfaces permanent. It is especially recommended for paper and cardboard surfaces, but it will adhere to almost any non-greasy surface, rigid or pliable, including many types of plastics and glass. The paint retains its brilliance when dry. unlike many temperas, which dull upon drying. Politec 300 contains a 50% acrylic base and pigments which contain fillers that give the paint plasticity and superior covering characteristics.

Varnish-Sealer is a water based acrylic emulsion, used with Politec paints as a thinner for glazing or as a final varnish for paintings. For most varnishing operations, use varnish-sealer diluted with about one third volume of water. Apply with a flat sable brush in one or more coats. One coat will produce a satin-like surface; more applications will make the surface glossier. Although it appears milky when first applied, varnish-sealer dries clear and transparent in minutes. The varnish-sealer may also be used as a vehicle to be mixed with dry pigment. Using much the same method as you

would use in egg tempera techniques, dip the brush first into varnish-sealer, then into pigment, and then apply to the painting surface.

Luzitron Varnish-Medium is a completely clear, non-yellowing acrylic resin, which has been liquefied for use as a final varnish over paintings done in plastics, oils, and other media. It is the only medium in the Politec line that is not water soluble; use lacquer thinner for cleaning brushes, and thin the medium itself with Luzitron Thinner X-T. This thinner is a mixture of equal amounts of the chemicals Xylol and Toluene. Luzitron may be added to Politec paint to increase film strength; if this is done, paint is no longer water soluble, and requires the X-T solvent. Luzitron may also be used as a vehicle; mixed with dry pigments and thinned with X-T solvent, it produces excellent results. *Caution:* Luzitron varnish-medium has a slight solvent effect on plastic paints. Before applying it as a varnish to paintings done in plastic, isolate the surface by carefully applying a coat of Politec varnish-sealer. Use care in the application of the Luzitron on plastic paint films. (This precaution is not necessary in varnishing oil paintings.)

Plastilita Extender Paste is prepared with silica and marble dust of a flour-like consistency. It may be used on rigid or pliable surfaces. Although the Plastilita dries to an extremely hard surface, it maintains its flexibility and does not become brittle. For very thick textures, the plaste should be built up in several layers in order to avoid cracking. Plastilita may be mixed with Politec paints and applied with a palette knife in an impasto technique. It may also be used in making bas-reliefs, for texturing frames, and for other craft activities. When the paste is used as a ground surface preparation, a variety of media may be painted on it, including plastics, oils, tempera, lacquers, and metallic colors.

Painting with Politec

Because surfaces may not have an even porosity, it is suggested that a coat of varnish-sealer be applied to all painting surfaces, to provide an evenly porous painting ground. When you are preparing canvas, unbleached muslin, or burlap, a coat of white Politec 300 is recommended, in addition to the varnish-sealer.

For a palette, use a piece of flat glass, a plastic sheet, muffin tins, plastic ice cube trays, or a disposable paper palette. Dip out only enough paint for use in the painting session; when acrylic paints have dried on the palette, they cannot be reworked. Dampened blotting paper, Saran Wrap, of aluminum foil placed over the palette will help prevent paint from drying out.

For watercolor technique, stretch ordinary watercolor paper in the usual way. Dilute Politec paint with water and apply to the dampened paper,

using traditional watercolor techniques. This medium offers a great advantage to watercolorists, for acrylic paints will not pick up with subsequent overpainting. Paintings may be given a glossy surface with a coat of varnish-sealer, and may be exhibited without glass.

Since the acrylic paints are fast-drying, glazing may be started immediately. Dilute colors with water and apply washes of color over the painting. Repeat with various tones until you achieve the desired build-up of transparent color.

Because of their excellent adhesive qualities, both Luzitron varnish-medium and Plastilita paste are recommended for use in collage and mosaic projects.

For painting and decorating textiles, use Politec 300 mixed with varnish-sealer that has been diluted with a 10% volume of water.

Keep the lids screwed tightly on the jars. While you are painting, brushes should be kept moist with water. If paint dries solid on brushes, soak them with lacquer thinner or Luzitron Thinner X-T.

To retard drying of Politec colors, use a few drops of glycol in the paint. After each painting session, a few drops of water should be added to each jar of paint to replace the moisture lost by evaporation.

POLYART

Manufactured by Gibson Paint Company, Polyart Division, 1199 East 12th Street, Oakland, California 94606.

Polyart colors are formulated in a copolymer polyvinyl acetate base. These colors are not to be confused with *Politec*, an entirely different type of plastic paint which has an acrylic base and which is described above in the text. Polyart colors are water miscible paints: finely dispersed pigments in a milky emulsion of polyvinyl acetate. The milkiness clears as the painting dries, providing a clear film. Designed particularly for schools, the medium has a wide range of possibilities from thin watercolor techniques to heavy sculpture applications.

Products: Polyart colors; Polyart clear; retarder; remover; paste extender.

Polyart Colors: These permanent colors dry to a rich matte finish. The colors are of heavy consistency and may be intermixed for intermediate tones. The polyvinyl acetate base for the colors gives them a strong adhesiveness to many surfaces: paper, illustration board, Masonite, canvas, masonry surfaces, etc. They possess the working characteristics of tempera, poster paint, watercolors, casein, or oil paint. The colors are miscible with water, but become water insoluble when dry, yet retain a flexible paint film.

Thin, opaque areas dry within minutes; a half inch impasto of color will become surface dry within fifteen minutes to an hour. The colors may be painted directly on the surface chosen, with no primer necessary. Polyart products are packaged in glass and plastic jars.

Polyart Clear: This is an unpigmented polyvinyl acetate medium. It is milky in appearance and is used with colors for obtaining glossier surfaces and for obtaining thin glazes. The clear medium is also recommended as a vehicle for mixing with pigments or with universal tints in formulating additional colors, and may be used as an adhesive for making collages.

Retarder: This medium, when added to the colors in very small amounts, will retard their drying time.

Remover: This is a solvent used for removing *dried* colors and any of the mediums.

Paste Extender: This is a heavy polyvinyl acetate paste, used for mixing with colors for impastos, for a base in assemblage, for collage, or for mosaic techniques. It may also be used over papier maché or wire screen for making three dimensional sculpture. On Masonite, heavy impastos may be treated with various tools for textures. It may be applied with a trowel to surfaces for creating preliminary textures prior to painting.

Painting with Polyart

The colors and mediums may be used as painting mediums with characteristics similar to those of tempera, watercolor, casein, and oil.

In painting with Polyart colors, reduce the consistency of the paint with water and apply in thin, opaque layers. Thinner, more transparent washes may be obtained by further diluting the colors with additional water. If a gloss transparency is desired, add Polyart clear to the water to obtain the desired surface sheen. Thick color impastos may be achieved by using the color directly from the jar, applying it with a brush or palette knife. The heavier, clay-like consistency of paste-paint may be achieved by further mixing the colors with the paste extender. Polyart adheres to styrofoam plastic; therefore, it may be used as both an adhesive and surface paint for styrofoam.

Polyart clear may be used as a vehicle for paint formulation with tinting colors or with dry pigments. It may also be used in a number of additional ways: used with pastels or chalk, it transforms pastel drawings to paintings; mixed with extender (1:1) it makes an excellent grout for mosaics. Diluted even further, the same mixture may be used to saturate paper or

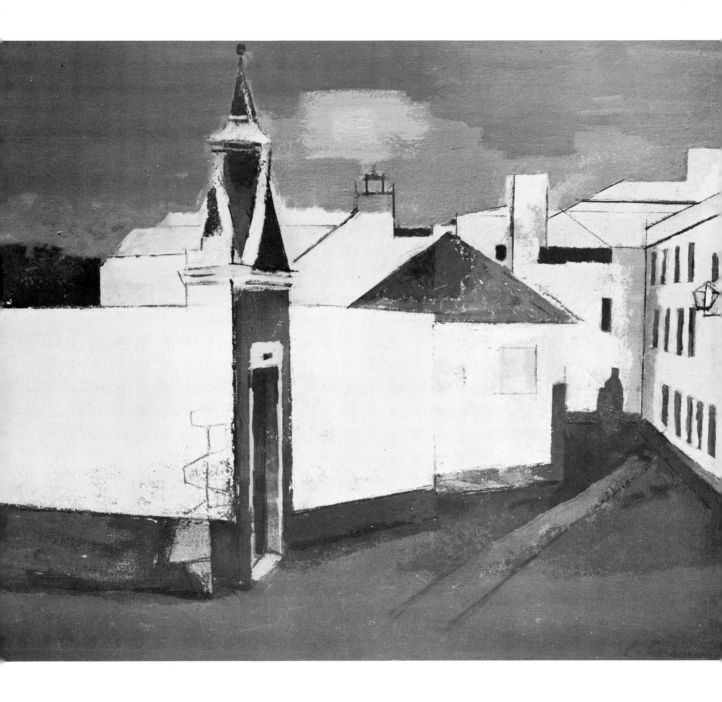

Street in Portugal by Charles Coiner, acrylic on panel, 24″ x 30″. Courtesy Midtown Galleries. In this carefully designed cityscape, the angular, geometric shapes of the walls are defined by crisp lines, then softened by rough, scumbling strokes which render the texture of the moldering surfaces. Applied with a scumbling motion, acrylic lends itself especially well to broken color effects.

cloth for making sculpture. The saturated material may then be draped over armatures or arranged on base boards. When dry, the surface can be painted with Polyart colors. Aggregates and fillers such as sand, sawdust, paper chips, and vermiculite may be incorporated into the paste.

In painting with the colors, keep your brushes moist with water. Brushes should be washed with mild soap and water when you clean up. Use the remover to recondition brushes which have dried paint on them, or to remove dried paint from clothing. A good palette for mixing colors may be made by using a piece of cardboard or Masonite and sealing the surface with Polyart clear. For permanent palettes, glass is recommended.

Polyart clear, mixed with two parts water, produce a waterproof papier maché medium, suitable for making rigid sculptures of paper.

Paper strips saturated in this mixture may be placed over an armature and successive layers built up, in the typical papier maché method. One layer at a time should be applied, allowing each to dry before applying the next. This sculpture may be painted with the colors or treated with paste extender, which may be used as it comes from the jar (white) or colored with Polyart colors.

REEVES

Manufactured by Reeves and Sons Limited, Lincoln Road, Enfield, Middlesex, England; Reeves and Sons (Canada) Limited, 16 Apex Road, Toronto 19, Canada.

Reeves polymer colors and mediums are used widely in the United Kingdom and in Canada. These colors are water miscible, quick drying, and create a tough, yet flexible paint film. Canvases painted with the colors may be rolled safely without danger of cracking when dry. The colors are formulated in an acrylic polymer emulsion, are permanent and non-yellowing. They may be applied to surfaces and grounds such as paper, board, canvas, fabrics, metals, stones, wood, plastic, and glass. Water or the acrylic mediums may be mixed with the colors to produce thin watercolor washes and glazes. Heavy impastos may be applied by using the paints directly from the tubes.

The Reeves colors are packaged in transparent polyvinyl tubes which are designed to collapse as the colors are used. This particular feature excludes the possibility of air remaining in the container to harden the unused paint. Brushes, painting knives, and tools typically used with other art media may be employed with the Reeves polymer colors.

Products: Reeves polymer colors; polymer painting medium; polymer varnish; polymer primer.

Reeves Polymer Colors are available in a wide spectrum of hues, and are particularly resistant to light. Painted on non-greasy surfaces, they manifest a brilliance typical of the acrylic colors. Colors are safely intermixable, and may be thinned with water or the acrylic mediums. Used straight from the tube or diluted with water, the colors will dry to a soft matte finish. The addition of polymer medium will give a glossier quality to the final work.

Reeves Polymer Medium is an acrylic vinyl emulsion, milky in appearance, which will dry to a clear transparent quality. It may be used to make colors more transparent without changing their viscosity, and facilitates the flow of color. This medium is designed to be used as a glaze, or for any technique where a semi-gloss finish is required. Artists may also use this medium with dry pigments in compounding plastic paint.

Reeves Polymer Varnish: Also milky in appearance, this varnish dries to a clear, transparent quality. Paintings may be varnished with the polymer varnish immediately when they are dry. This imparts a brilliant sheen to the painting surface.

Reeves Polymer Primer: Designed for preparing painting surfaces for use with the plastic paints, this primer dries rapidly to a white, hard, flexible surface. It may be tinted with Reeves polymer colors if a toned ground is desired. Application may be with brush or palette knife. Two coats of primer are recommended.

Painting with Reeves Polymer Colors

Techniques of glazing, scumbling, overpainting and gouache methods may be employed quite readily. Watercolorists, designers, commercial artists, or fine artists may use this material in a style to which they are accustomed from transparent to impasto methods. Collage techniques may be achieved by using the polymer medium or varnish as an adhesive for paper or fabrics. Particularly effective is the method of painting wet-into-wet paint, or the alla prima method. Clean, brushless characteristics may also be achieved by working on canvas grounds or Masonite. Flat sable brushes will impart an even paint film, free of the characteristic brush stroke.

Because of the excellent hiding power of the paint film, the technique of scumbling, or using broken areas of color, is also recommended. Scumbling with either brush or palette knife is effective. Dragging stiff mixtures of color over surfaces of color previously applied, or the use of light colors over dark and the reverse, will yield effects which exploit this medium to advantage.

The hiding power of the paint film makes overpainting easy, with no threat of uneven paint film or of sub-strata bleeding.

It is suggested that for impasto painting, some of the acrylic color be squeezed out on the palette and allowed to dry for a few minutes to thicken the paint. This thicker paint may then be applied to the canvas or support with palette knives or painting knives.

SHIVA

Manufactured by Shiva Artists Colors, Shiva-Rhodes Building, 10th and Monroe Streets, Paducah, Kentucky 42001.

Shiva acrylics utilize pure pigments mixed with an acrylic plastic medium emulsified in water. They are water soluble, dry to the touch in thirty minutes, and are then ready for further coats. Paints may be applied to virtually any grease-free surface; however, if there is any doubt about adhesion to a particular surface, the acrylic gesso should first be applied as a primer. The paint film produced by Shiva acrylics is durable and flexible and has been proven not to yellow, fade, chalk, crack, or peel.

Products: Shiva acrylic colors; gloss medium; matte medium; liquid gesso; modeling paste; polymer remover and brush cleaner.

Shiva Acrylic Colors have been subjected to at least eighteen months of tests designed to exceed the normal requirements of an artist's color. They have been alternately frozen, baked, subjected to acids and alkalies, and exposed to the elements. Shelf stability has been checked to insure that these tube colors will remain in usable condition in the dealer's storeroom and the artist's studio months after the day of manufacture.

Gloss Medium is mixed with the colors for thinning paint, making transparent washes, imparting a glossy surface, and preserving film strength. For intermediate gloss effects, mix gloss medium with water or with matte medium. Gloss medium is an excellent adhesive for collage papers.

Matte Medium: To obtain a flat surface quality and to preserve film strength, mix matte medium with acrylic colors. Both mediums increase the waterproof characteristic of the final paint film, and may be used as a varnish for acrylic paintings.

Liquid Gesso: A ready-to-use white painting ground, this gesso may be used

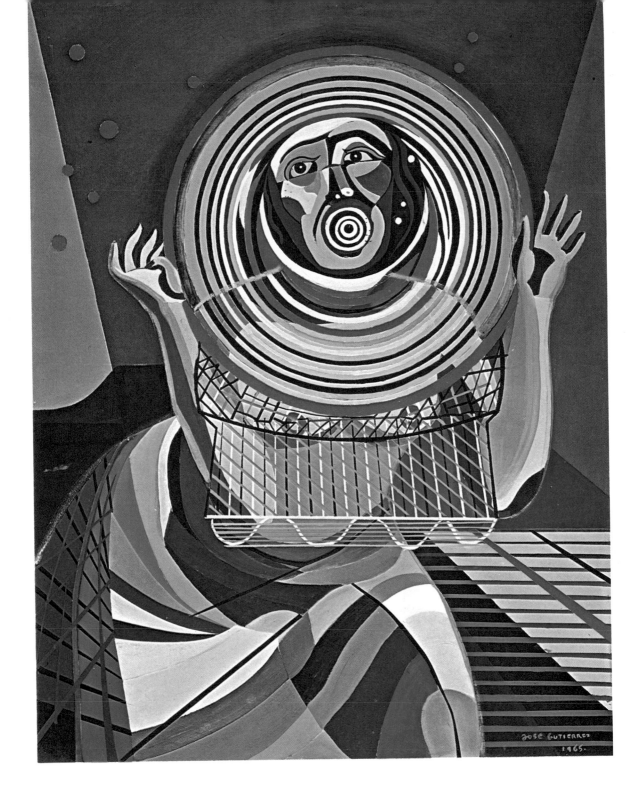

The Scream by José Gutiérrez, acrylic on Masonite, 29½" x 39½". On a ground of white acrylic paint, the lines of the composition were first drawn in charcoal, then incised with an ice pick. Politec, an acrylic formulated by the artist, was applied directly to the luminous white ground for maximum clarity and intensity of color.

just as it comes, thinned with water, or mixed with the paints for making colored impastos. It provides a painting surface that is flexible, non-absorbent, and waterproof.

Modeling Paste is a high viscosity acrylic paste that dries quickly to a hard finish. It may be used for textures, bas-relief, or in combination with colors for making impastos. When dry, it may be carved or sanded. Thinned with water, gloss or matte medium, this acrylic paste has a multitude of applications, from easel painting to the preparation of picture frames.

Polymer Remover & Brush Cleaner is used to dissolve paint film, recondition brushes filled with dried paint, and for general clean-up of dried acrylic. While you are painting, use this solvent for experimenting with techniques: you may purposely dissolve the dried paint film, allowing layers below to reappear.

Painting with Shiva Acrylics

Paint directly with techniques similar to those used with oils. Use palette knives for impasto; the paint should be used as it comes from the tube or thickened with gesso or modeling paste.

Mix colors with water or with the mediums for transparent, brilliant glazes or color washes. When these acrylics are used in a gouache technique, there is no pick-up of previous layers of color.

Keep brushes wet while painting. Use a palette of plastic, glass, aluminum foil, or paper.

Shiva colors are packaged in roll-up metal tubes; you can squeeze out only the amount of paint desired. In addition, these tubes prevent the entrance of air, so there is less chance of paint thickening.

WEBER

Manufactured by F. Weber Company, 1220 Buttonwood Street, Philadelphia, Pennsylvania 19123.

Weber artist's latex polymer paints are pigments dispersed in a medium of plastic resin emulsified in water. When the water evaporates, the resin particles form a clear, homogeneous film which becomes a completely insoluble binder for the pigments. Possessing the depth and brilliance characteristic of the plastic resin emulsion, these paints are permanent and will intermix cleanly and crisply. They are water miscible and dry quickly, depending on thickness of application. In thin watercolor applications, they will dry in minutes; in impasto applications, they dry in two or three hours.

Products: Weber latex polymer colors; latex polymer medium #1; fast drying matte latex polymer medium #2; slow drying latex polymer medium #3; Aqua/Gel painting medium; Permalba latex gesso; Univar varnish.

Weber Latex Polymer Colors: Prepared in a buttery consistency and packaged in metal tubes, the colors may be mixed directly with water, or with the mediums. Dried colors remain the same as when painted wet, with no lightening or change. Complementary colors may be mixed to produce a rich black, and may also be used with white for producing warm or cool tints of gray. The paints adhere to most painting surfaces and will remain flexible when dry. Supports such as paper, illustration board, canvas, Masonite, gesso, metal, glass, ceramics, leather, fabrics, plaster, masonry, and most plastics may be used.

The paint drying characteristics may be controlled — from fast to relatively slow — by the addition of the appropriate mediums. The colors dry with a soft gloss surface.

Latex Polymer Medium #1: Used for transparent effects, without losing the body of the color, this medium may be used with water to obtain desired brushing characteristics.

Fast Drying Matte Latex Polymer Medium #2 may be added to colors to thin them and to accelerate drying time. It may also be used as a final varnish. It is particularly useful to hasten the drying of heavy impastos.

Slow Drying Latex Polymer Medium #3 is an additive to colors for retarding the drying time on the palette or on the support while painting. It will allow for a longer painting period, which may be desirable in portrait painting or in paintings done outdoors in a warm climate.

Aqua/Gel Painting Medium: A heavy, buttery medium or colloidal dispersion, this medium may be added to the latex polymer colors for a heavier consistency. In painting impastos, brush strokes are retained. A wet-in-wet technique is particularly effective with this medium.

This is one of the few mediums that may also be added to oil paints. If the artist uses Aqua/Gel with oils, he may thin the resultant paints either with turpentine or turpenoid (an odorless turpentine substitute made by Weber) or with water. Clean-up may also be done with water. The Aqua/Gel will not affect the normal drying time of watercolors or oil colors with which it is used.

Permalba Latex Gesso is a ready-to-use latex gesso, designed for preparing

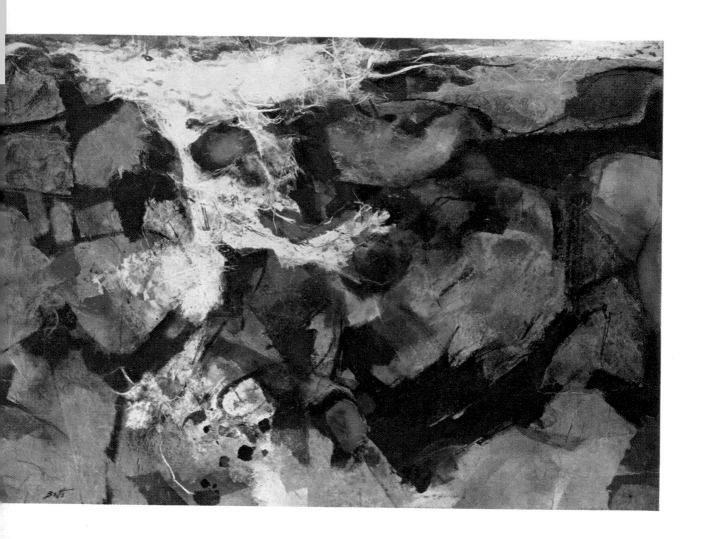

Rocks and Surf by Edward Betts, acrylic and collage on Masonite, 23½" x 33½". *Courtesy Midtown Galleries. On a gesso ground, the artist paints random, intuitive shapes, then adds collage materials, cemented with acrylic medium. As the painting progresses, a variety of mixed media may be added: inks, crayons, and other drawing materials. As layers are built upon layers — transparent, semi-opaque, and opaque — the various strata are isolated with polymer medium, thinned with water. Ultimately, an image based upon nature begins to appear. The painting begins as an abstraction and ends by evoking memories and associations of the visible world.*

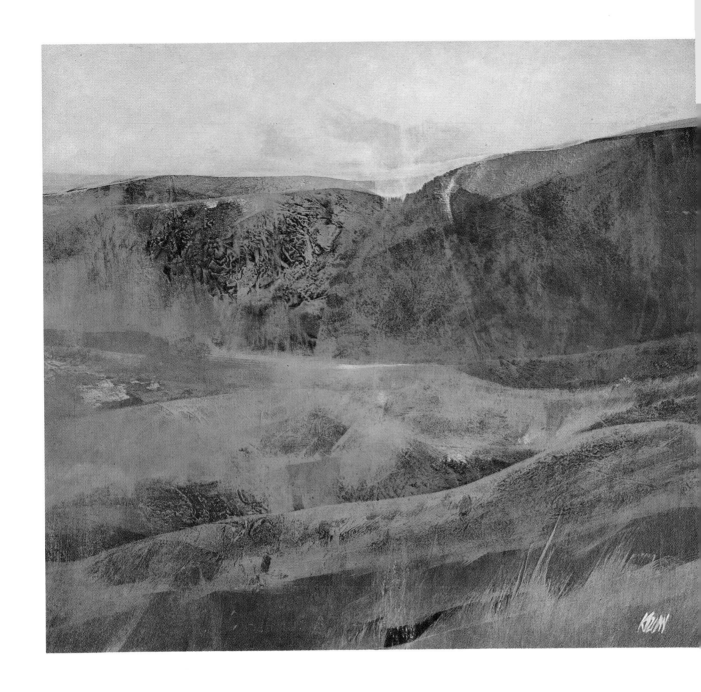

Formentor by Richard Kozlow, acrylic on Masonite, 27" x 30". Courtesy Frank Rehn Gallery. A luminous glow is imparted to the succeeding layers of transparent colors by the brilliant ground: Masonite primed with opaque white acrylic paint. Kozlow attaches crumpled, torn tissue and newsprint to the surface for texture. Close, sensitive tonalities of greens and ochres characterize this landscape, which has a misty, remote quality that exploits the subtle translucency of acrylic.

painting surfaces. The binder of both the gesso and the Weber artists' colors is related, making a desirable painting ground because of the homogeneous quality of paint and painting surface. The gesso may be used on surfaces such as canvas, hardwood, Masonite, cardboard, and other types of panels. It is very adhesive and is an intense white. It may be used directly — without sizing the support — acting as its own sealer. Suggested method of application is to thin slightly with water for brushability, and to apply several thin coats, rather than one heavy coat.

Univar Varnish is a permanent water clear varnish, packaged in spray cans, and insoluble to most solvents. Univar will add a degree of gloss to the final painting. Repeated sprayings will achieve a glossier finish. Many applications will create a gloss like ceramic tile.

Painting with Weber Latex Polymer Paints

Use only as much color as needed during a painting period. The addition of a drop of water over each swirl of color on the palette will serve to keep colors moist. By adding a small amount of Aqua/Gel or medium #3 to each color on the palette, you can lengthen setting up time and give the paint a heavier consistency. To re-use the following day, the palette may be covered with a layer of plastic to keep out the air.

Any degree of matte or shiny finish may be achieved by adding the appropriate painting medium. In addition, the drying time of the latex paints may be slowed by the addition of medium #3, the retarding agent. Typical techniques suggestive of oil, watercolor, and gouache, may be employed. A unique medium made by Weber is the Aqua/Gel, which may not only be used with latex colors, but also mixed with oil paints, making them water soluble. The mediums may be used with other colors, such as poster paints and watercolors, and may also be employed as adhesives in making collages.

ADDITIONAL PRODUCTS

There are many firms other than those listed who are manufacturing plastic paints locally, or are planning to manufacture them in the near future.

Talens and Sons, Inc., of Union, New Jersey, plan to introduce their Rembrandt Acryl Colors shortly; more complete information on this product will be introduced in subsequent editions of this book.

Craftint Manufacturing Company, 18501 Euclid Ave., Cleveland, Ohio 45212, makes Un-Art-Co (Universal Colors) which may be mixed with un-pigmented oil, casein, water, or plastic bases. The Un-Art-Co colors are available in a wide range of hues and may be mixed with Craftint's Un-Art-Co plastic base for excellent results. Colors are available in tubes; the un-

pigmented bases in tubes, pints and quart containers.

Dana Colors, Inc., 1833 Egbert Ave., San Francisco, California 94124, makes an acrylic paint which is available in a range of twenty colors, labeled Acrycolor. These are acrylic latex polymer colors with a fairly heavy body and matte finish. They also distribute a gloss and matte medium to be used with the colors, and a gesso for priming surfaces to be painted. Acrycolor is distributed in California, Washington, Nevada, Arizona, and Utah; the manufacturer has plans for national distribution. These colors are available to artists by writing directly to the manufacturer.

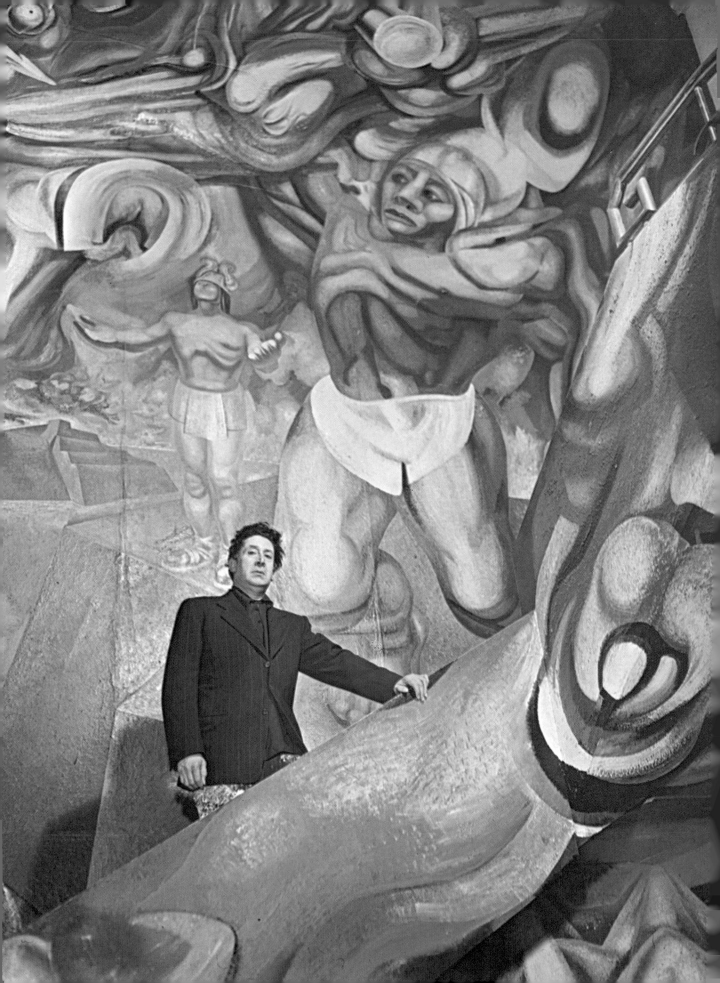

6
studio tips

GENERAL INSTRUCTIONS

There are two basic types of commercially available plastic paint: water based, the most commonly available; and oleo acrylic, which requires organic thinners (turpentine, etc.) for dilution and clean-up.

The remarks in this chapter pertain to the plastic paints of an aqueous character. However, when special handling of the oleo acrylics is required, this will be noted.

It is a good idea to keep brushes moist while painting. Remember that although the aqueous paints are water soluble when wet, they become insoluble in water after they have dried. This is one desirable characteristic of the paints, but you must maintain good housekeeping procedures to preserve the life of your equipment and brushes.

Do not mix organic solvents, such as turpentine, into the aqueous plastic paints; the only thinner necessary is water. To control the surface shine of the paints, add either the matte or gloss medium, which are also water miscible. To control viscosity, use inert fillers such as Celite #281, or add heavier bodied acrylic paste extenders. Although water is used to dilute the aqueous plastic paints, the addition of too much water will weaken the paint film. It is a good practice to add either the matte or gloss medium when you use thin washes of color.

Squeeze out only the amount of paint which will be necessary for a particular painting session. If you use the paint prepared in metal tubes, keep the tubes rolled up to exclude the air. In removing plastic paint from jars, use a palette knife, a disposable wooden spoon, or a tongue depressor. The jars should not be left open for long periods of time; the water in the

Cuauhtemoc Against the Myth *(mural detail) by David Alfaro Siqueiros, pyroxylin lacquer on Celotex, 24 square meters, installed at the Unidad Tlalteloco, Mexico City. Brilliant automotive lacquers were applied over a Celotex support. The surface was sealed with a preliminary coat of automotive primer. Bristle brushes were used with thinned color for modeling and blending.*

113

paint will tend to evaporate. Some artists prefer to remove the jar lids and then substitute temporary lids of aluminum foil while painting. Colors may also be mixed in disposable paper cups or TV dinner trays. Small glass jars with a vacuum sealed lid — such as those used for baby food — are ideal for mixing and storing colors.

To keep the plastic paint from hardening on the palette while you are painting, add a few drops of water to each swirl of color on the palette from time to time. Some artists have contrived ingenious devices for adding water to their colors: eye droppers, sponges, atomizers, fixative sprayers, and window spray bottles. After each painting session, add a few drops of water to jars of aqueous plastic paints to replace the water which is lost through evaporation. Some manufacturers make special retarders which can be used to slow down the drying time of the paints.

However, the artist must understand and accept the inherent characteristics of the medium; fast drying *is* one of the principal characteristics (whether you consider this an advantage or a disadvantage) and it is worthwhile to exploit this quality of the plastic paints.

The addition of a few drops of Glycolin (Glycol) to aqueous plastic paints will retard drying to some extent, making them more suitable for obtaining blended effects, and encouraging "leveling" of the paint film.

In building heavy impastos with either paint or paste extender, it is not a good practice to do this in a single operation. To achieve a relief quality on a painting, it is wiser to build successive layers, allowing each to dry, thereby avoiding the possibility of cracking.

BRUSHES

Most brushes normally used for other media may also be used in painting with plastics. This includes brushes made of hog bristle, fitch, sable, sablene, and nylon, all of which are available in a variety of shapes and sizes, either flat or round.

The selection of the proper brush depends on the area to be painted, the type of support, and the brush quality desired. For example, flat bristle brushes may be used for covering large areas of canvas or porous grounds. Flat sable brushes are used in obtaining "brushless" paint quality, and for glazing and final varnishing. Sables may also be used for blended effects in portrait painting. The stiffer bristle brushes are used where the brush mark is to be an obvious part of the character of the painting.

A. Langnickel, Inc., 115 West 34th Street, New York, New York 10001, manufactures heavy duty white bristle brushes, shaped to a chiseled edge. These brushes are developed especially for use with acrylics and casein, and are designed to withstand heavy usage.

CARE OF BRUSHES

Besides keeping brushes wet while painting, proper attention should also be given to them after each painting session. Clean brushes with soap and water, making sure that all of the plastic paint has been removed. For additional maintenance, brushes may be moistened with Glycolin before putting them away (Glycolin is a preparation of hydrocarbons, extensively used as a retarder for plastic paints).

If plastic paint has dried on the brushes, they may be reconditioned by using the manufacturer's recommended solvent for removing dried paint film. Some of the solvents employed are: X-T solvent for Politec paints, which is a combination of Xylol and Toluene; rubbing alcohol for New Masters; and in some cases, a good grade of automobile lacquer thinner.

KNIVES AND TOOLS

Palette knives and painting knives with flexible steel blades are available in many shapes and sizes. Good, inexpensive painting knives are the trowel-shaped palette knives. Firm, rigid blades are preferred over the very flexible ones. The artist may use a mason's trowel for applying paste extender to walls in preparation for mural projects. Other knives that may be employed are: glaziers' putty knives, printers' knives, as well as some household knives.

The paint and acrylic pastes may be applied directly, swirled, patted, and imprinted with the edge of the knife. The knife may also be used in scumbling or scraping methods, as in the demonstration chapter by Robert Elsocht. Other special textures and effects may be created with the heavy bodied paste extended by using tools such as combs, saw blades, kitchen forks, and notched spreaders. Textured burlap, sponges, etc., may be used to press and transfer textures to the paint and to the extender pastes.

SUPPORTS AND GROUNDS

The various grounds that can be used for plastic paints have already been discussed in this book. In general, the artist can use the traditional grounds and supports designed for other art media. Most of these are suitable for use when painting with plastic paints; however, the artist should not use oily or greasy supports, and generally should not use canvas primed with an oleo base material. Porous grounds should be primed with an acrylic medium or gesso, or both. This will keep the paint from being absorbed into the ground too readily.

Watercolor washes: *Diluted with water, plastic paints may be used in methods similar to classical watercolor. Watercolor brushes and papers are used. Unlike watercolor, however, the first coat of paint makes a waterproof surface; subsequent paint applications do not "pick up" previously applied color.*

Scumbling plastic paints: *By applying plastic paints with bristle brushes and a scrubbing motion, you may apply either light or dark passages of opaque paint, allowing previously applied paint to show through. Rich surfaces are obtained by painting many passages of color which reveal the passages beneath.*

Alla prima or wet-into-wet: *Using bristle brushes, colors are painted into one another while still moist. The artist must accustom himself to the fast drying properties of the plastic paints and work accordingly. A few drops of Glycol may be added to the acrylic paints to slow the drying time.*

CANVAS

Unprimed linen or cotton is recommended over the commercially primed canvas, unless the latter has been primed with a latex paint. Although it is possible to paint over this oleo primed canvas, it is wiser to use an unprimed canvas and to prepare it with an acrylic gesso. In this way, a homogeneous bond is created between the layers of paint and the ground. Generally, two thin applications of acrylic gesso are better than a single heavy coat.

PAPERS AND CARDBOARDS

Since paper and cardboard are absorbent materials, the artist should first prepare the surfaces by using one of the acrylic mediums, diluted with approximately three parts of water. This medium, applied to the surface of paper, will make it less porous. With the addition of a greater proportion of medium, the paper will be waterproofed as well.

If you wish to use a watercolor technique in working with plastic paints, no priming is necessary. However, after the first application of thin acrylic paint and medium, the surface will dry to an insoluble state, and no further "pick up" will be possible. There are great advantages in using acrylic paint as a watercolor medium on paper. Unlike conventional watercolors, the previous paint layers do not pick up, and the surface will dry waterproof. Furthermore, no glass protection is required if acrylic medium is applied as a final varnish.

PLASTER OR MASONRY SURFACES

It is a good idea to prime a plaster or masonry surface with polymer medium, followed with a coat of gesso. This will seal the surface and facilitate subsequent brushing on of color.

MASONITE

The untempered type is preferred and does not require priming. The plastic paint serves as its own primer. However, to obtain a white ground or to create special textures before painting, it will be necessary to give the Masonite two coats of thin gesso or to treat it with paste extender for textural effects.

ART FABRIC

Minnesota Mining and Manufacturing Company has introduced a new product which they call Art Fabric. This material is not a paper but a porous,

non-woven fabric that allows for considerable flexibility in usage, ranging from watercolor methods to palette knife techniques. A unique feature of this support is that paint does not adhere as a thin layer on the surface of the material, but penetrates and becomes part of the fabric.

METALS

Acrylic paints adhere well to grease-free aluminum, which should be roughened slightly to increase adhesion.

PALETTES

When using aqueous plastic paints, smooth, non-absorbent palettes are preferred. These include glass, plastic, and formica, which may be easily scraped with a palette knife to remove the paint after each painting session. Disposable cardboard or wooden palettes may be used if you prepare the surface with a coat of acrylic medium to make them non-absorbent. Disposable paper palettes, used in oil painting, are not suitable for aqueous plastic paints — the paper absorbs moisture from the paint — although they work well with the oleo acrylics.

Palettes covered with wet color may be kept overnight if they are covered with plastic, such as Saran Wrap. Some artists keep their palettes fresh by covering them with a shallow pan, placed face down, and by brushing some acrylic paint around the edges to serve as a seal.

Paint that has dried on a glass palette may be loosened by submerging it in water. Raymond Jonson, of Arizona, used this dried paint film in a unique process for making "tessarae" for plastic mosaics and colages. The loosened, dried paint film is subsequently cut into various shapes and attached with polymer medium or acrylic paint to a canvas support.

VARNISHING PLASTIC PAINTINGS

Plastic paintings executed in aqueous emulsions may be varnished as soon as they are dry. Use a flat, soft hair brush, either sable or nylon, and give the painting several thin applications of the matte or the gloss medium. Rather than one heavy coat, it is recommended that several thin, evenly applied coats be given to a painting. Allow each coat to dry before applying the next. These mediums may be mixed with water: one part medium to three parts water. By using a combination of water, matte medium, and gloss medium, the artist may create an acrylic varnish that will give the desired surface shine. In varnishing an *oleo* acrylic painting, either the

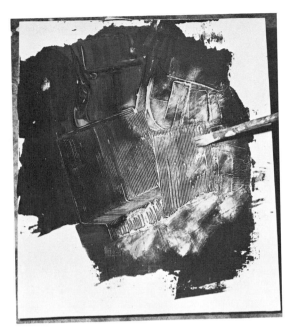

Acrylic modeling paste is applied over a Masonite panel with a palette knife. Many textures may be created with the palette knife, combs, sawblades, forks, etc. The acrylic paste, which is water miscible, dries hard in one to four hours, depending on thickness of application and climatic conditions. In the photograph, black acrylic paint was added to the modeling paste; the textured surface is given additional interest by scumbling light acrylic paint over the coarse surface.

Masking tape is used to create clean edges for paintings requiring a "hard-edged" quality. Acrylic paints may be applied with a soft sable brush to obtain "brushless" paint surfaces.

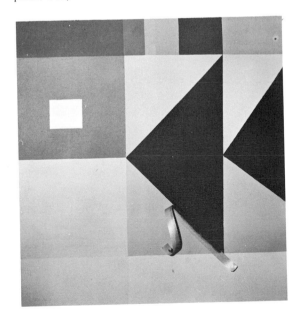

aqueous acrylic mediums or the oil painting varnishes may be used. Weber's Univar spray varnish is designed for both oleo and aqueous acrylic paintings.

ACRYLIC FIXATIVE

In preserving drawings, pastels, or watercolors, the artist may use diluted polymer mediums, either flat or glossy. This medium may be applied with an atomizer or fixative sprayer.

PAINTING TECHNIQUES

Throughout this book there are detailed descriptions of a variety of painting techniques. The possibilities for the creative artist using plastic paints are limitless. Briefly described below are a few of the principal methods of working with synthetic media.

ALLA PRIMA

The alla prima method is the technique of working wet-into-wet. In this manner, spontaneous mixing of color is achieved. The water miscible plastic paints lend themselves well to this method of painting, and may be used either indoors or outdoors. In most cases, the plastic paints are used as they come from the tube or jar; however, the viscosity of the paint may be adjusted by the addition of the polymer mediums.

The artist will have to become accustomed to the fast drying characteristic of the synthetic paints and he must take this into account when painting. Acrylic paints may be retarded in drying, to some extent, by the addition of a few drops of Glycolin (Glycol).

Bristle brushes, which are designed for use in oil or casein painting, are recommended for this method.

WATERCOLOR METHODS

Plastic paints thinned with water produce washes similar to those of the watercolor media. Paper usually used with watercolors is also suitable for plastic watercolor methods. Paper should be stretched before using to prevent buckling. To aid the flow of colors into one another, absorbent papers may be "primed" with water before the application of the colors.

Classical watercolor techniques can be followed; however, the artist will find that the plastic paints do not "pick up" after they are dry. Dried areas of color are waterproof. "Wiping out" color must be done while the

Collage papers *may be made by applying plastic paints over white drawing paper. Acrylic colors are available in a wide spectrum for making collage paper. Politec acrylics are available in fluorescent and metallic colors as well. Weber also makes metallic colors.*

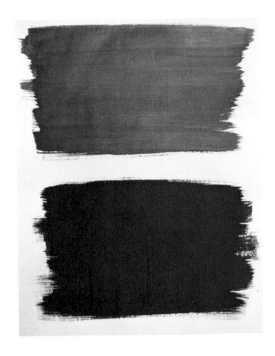

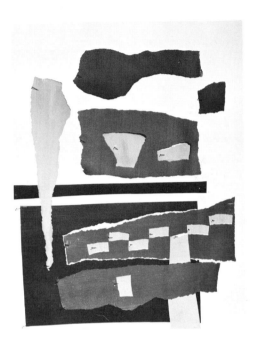

When papers are dry, *they may be cut or torn to the desired shapes and arranged over a suitable support. The photograph shows the torn papers arranged and pinned temporarily in place.*

Polymer medium *is used as an adhesive; the backs of the torn papers are given a liberal application of the plastic medium, using a sable brush. As the plastic colors are waterproof, polymer medium may also be painted over the colored surface for maximum adhesion without danger of smearing the paint.*

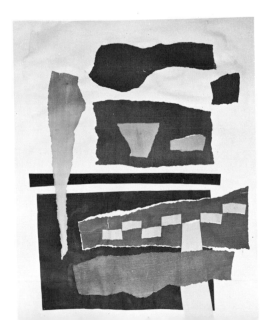

paints are still moist. Soft sable brushes and watercolor brushes are generally used in this method.

SCUMBLING

The scumbling method of painting is very popular with many contemporary artists who are using synthetic paints. Scumbling refers to the application of color (usually opaque) over previously applied color. Light or dark colors are applied with a brush in a scrubbing motion. In this manner, the artist obtains surfaces of broken colors and textures. In another method, the artist may drag a brush charged with paint over heavily textured surfaces, depositing color on high spots. Coarse bristle brushes, which can take some abuse, are recommended for this painting technique.

OVERPAINTING METHODS

The artist is allowed great flexibility in painting with the synthetic media, especially in overpainting, when he may wish to paint a light color over a dark one, as well as dark over light. Plastic paints possess great "hiding power;" consequently, single applications of color, either thin or thick, cover previously applied paint. For "brushless" effects, fine sable brushes are used to apply plastic paint, which may be thinned slightly with water. For coarser brush strokes, bristle brushes are used with thicker paint. Palette or painting knives may be employed in applying the plastic paint, which may be thickened by mixing it with plastic paste extenders.

GLAZING

Thin, transparent washes of color are obtained by mixing plastic paint with water or with the plastic painting mediums (gloss, matte, or gel). Layer over layer of these fast drying washes of color may be applied in rapid succession. The physical characteristics of the plastic vehicle are clearly evident in this manner of painting. With successive applications of glazes, an inner brilliance appears in the painting. This trapping of light creates a paint surface quite unlike that of other painting media.

Heavy, transparent impastos are obtained by mixing acrylic gel medium with acrylic plastic paints.

GOUACHE METHODS

In gouache painting, white paint is used rather than water, for obtaining

lighter tints. This method lends itself readily to plastic paints as well, and is practiced by many artists.

IMPASTO METHODS

Thicker impastos may be created by squeezing plastic paint onto a paper palette, which absorbs water readily. The palette absorbs water from the paints, which thus become firmer and more viscous; subsequently, the paint may be applied with either bristle brush or painting knife. Another method used to create thicker-bodied paints is for the artist to mix paste extenders with the plastic paints. The resultant paint may reach a consistency approaching clay. These thick paste paints should be applied to a painting surface in *several* applications to prevent cracking.

TEXTURES

Thickened plastic paints may be treated with a variety of tools and gadgets to obtain interesting textures. Combs, saw blades, notched tools, etc., may be employed to comb, criss, cross, or manipulate the think paint or the plastic media on a variety of paint surfaces. Sponges, coarse fabrics, wire screen, etc., may be used to press and transfer textures to the paint as well. Loose materials such as marble dust, sand, Celite, filings, etc., may be incorporated into the paint or mediums for creating textures.

COLLAGE

The plastic mediums, such as the polymer gloss or matte mediums, make excellent adhesives for use in collage. Transparent or opaque papers or cloth may be attached to many surfaces with these water miscible mediums. Many contemporary artists create their own collage papers by painting lightweight paper with acrylic paints. These papers are cut or torn to desired shapes when dry, and subsequently glued to supports with the acrylic mediums.

HARD EDGE TECHNIQUES

Precision edges may be created by using masking tape to temporarily shield specific areas of the support while painting. By repeated maskings, elaborate, hard edged patterns may be created. Plastic paints possess "leveling" characteristics and artists who demand the combination of flat surfaces and hard edges find plastic paints very desirable.

"COMBINE" PAINTING METHODS

Three dimensional objects may be added to a painting by using acrylic paste extender. Into this material, foreign objects such as beads, mosaic tessarae, or other "found materials" may be pressed. Acrylic paste extender is usually applied to rigid surfaces with palette knives.

PAINTING THREE DIMENSIONAL SCULPTURE

Plastic paints may be applied over plaster, cement, clay, metal, wood, or plastics in creating polychromatic sculpture. The paints adhere well to most surfaces which are grease-free. In painting over smooth surfaces such as metal or plastic, slight sanding with light carborundum paper is recommended for better adhesion.

IDENTIFICATION OF PLASTIC PAINTINGS

So that a prospective client will know how to care properly for work done in a plastic medium, the medium should be identified on the back of the work, accompanied by instructions for cleaning.

CLEANING PLASTIC PAINTINGS

Cleaning does not pose much of a problem for paintings executed in plastic paint. These paintings require little care because the paint vehicle is water clear, non-yellowing, non-cracking, and non-oxidizing.

For mild cleaning, most plastic paints may be cleaned with a soft cloth, moistened with tap water. The painting should be dusted first, however. Organic solvents should not be used on the aqueous acrylic paintings, as they may adversely affect the paint film.

To remove heavier encrustations of foreign material from the painting, a mild detergent soap, mixed with water, may be used. After such cleaning, the surface should be wiped clean with a soft cloth moistened in water, and then dried with another soft, clean cloth.

The principal threat to plastic paintings is physical damage by careless handling. On the other hand, there is the possibility that short-lived paintings will be created by the artist who indiscriminately mixes materials which are chemically incompatible. For this reason, the authors have stressed the use of *homogeneous* techniques; this means using the same type of plastic from prime coat to final varnish, and refraining from intermixing different brands of commercially produced paints.

RESTORATION OF FRESCO PAINTINGS

Acrylic paints of the aqueous type may be safely used to restore fresco paintings. The artist may work in *fresco secco* manner, and may give the restored fresco a coat of acrylic medium as a final protective coat.

Fine marble dust *is sifted into wet areas of polymer medium for achieving sandpaper-like surfaces. When dry, the loose marble dust is shaken off and the surface is ready for further painting.*

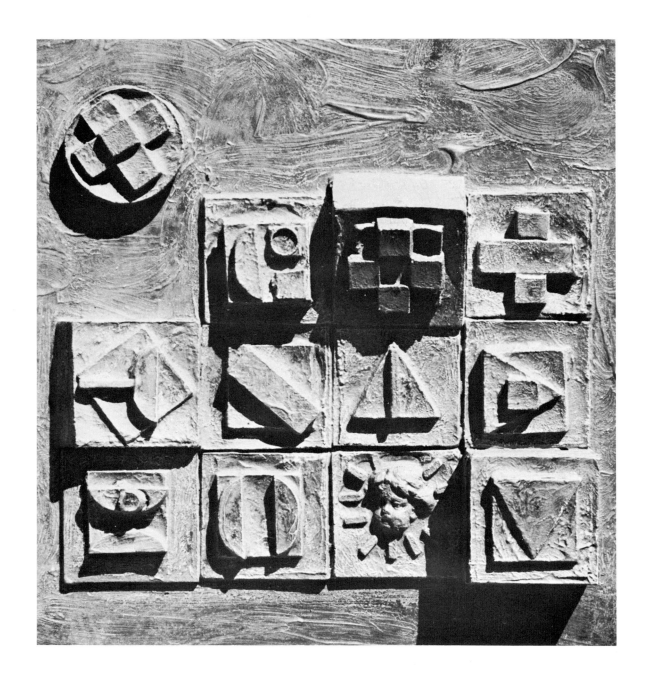

Assemblage reliefs: *The small blocks were cast of polyester resin. This resin, mixed with a catalyst, was poured into damp pottery clay which had been depressed with a variety of wooden blocks and forms. The polyester resin becomes hard in approximately an hour, at which time the cast forms are removed. The final assembly surface is a panel of Masonite, primed with a thick coating of acrylic paste; the cast polyester forms are pressed into the wet paste and allowed to dry. The entire assemblage is later coated with acrylic gesso.*

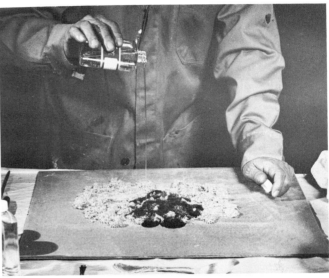

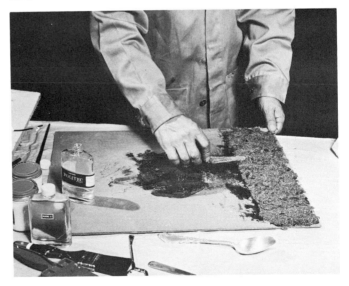

Creating coarse textures: *Celotex shavings are produced by scraping the board with a saw. Politec Luzitron (or another liquefied acrylic resin) is poured over the shavings and mixed to produce a heavy paste. Using the palette knife, the coarse paste is troweled to the appropriate areas and allowed to dry.*

7
painting a still life

Romeo Tabuena, of San Miguel de Allende, Mexico, demonstrates his method of working with acrylic paints. Mr. Tabuena, originally from the Philippines, has lived in Mexico since 1955.

In painting a still life, I prefer to work free of restricting conventions. Academic ideas regarding perspective, color, and rendering seem to make a painting look too rigidly contrived. The important aspects of artistic intuition and subjective inspiration must be allowed full play in order for the artist to create a valid work of art. The still life objects on the table before me — a musical instrument, a bowl of fruit, a wedge of watermelon, and an apple — these are simply visual references from which I shall derive the structural elements for my work. The identity of the objects does not interest me. However, certain aspects — such as shape, color, and the inter-relationships of the objects — do interest me. These are the things that may be translated into painting terms.

In the past I have worked with oil and tempera; however, plastic paints offer a new horizon of creative challenges. The still life painting I did for this demonstration was executed in Politec acrylic, an extremely durable, flexible, and versatile medium.

PREPARATION FOR PAINTING

I start by making several preliminary sketches in black and white. I make use of poetic license and conjure up other shapes as I go along, seeking the ultimate composition for my painting. I also take several photographs of the still life from different angles in black and white. The object is to explore

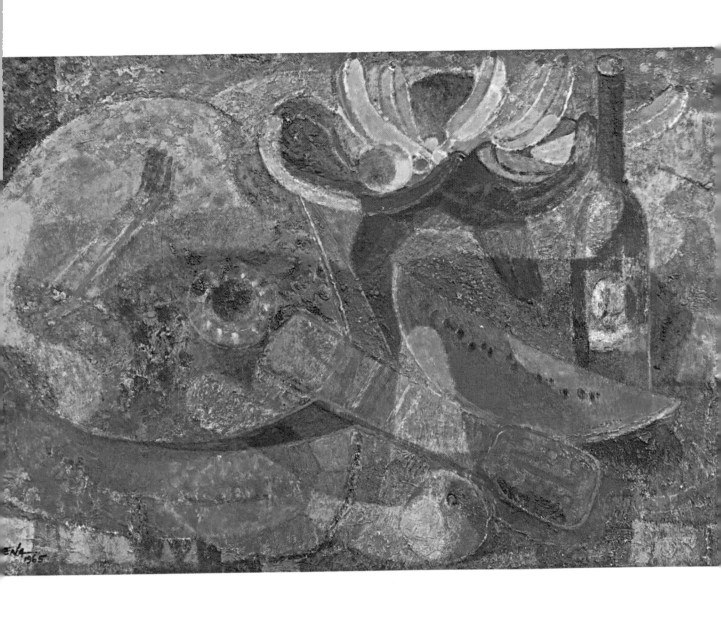

Still Life *by Romeo Tabuena, acrylic on Masonite, 25" x 37".*

the still life from many viewpoints until an interpretation and synthesis of the composition is established in my mind's eye. When I am satisfied, the still life is dismantled because I no longer need it.

PREPARING THE SUPPORT FOR PAINTING A STILL LIFE

For the support, I use untempered Masonite, primed with white acrylic paint. I paint the surface with five coats of titanium white Politec. This process takes about an hour, from the application of the first coat to the drying time of the fifth. In priming the support, I deliberately make the brush strokes uneven, applying the titanium white in uneven thicknesses. This creates an interesting textural surface. To make the painting surface less porous, I paint over the priming with one coat of acrylic medium (Politec varnish sealer). To further treat the painting surface, I apply with a palette knife some Politec paste extender, Plastilita. To this paste, I also add fine marble dust to create a coarser texture at various places. Eventually, the painting surface becomes an intricately wrinkled, scratched, rough texture.

BEGINNING THE PAINTING

In the first stage of my painting, I use black acrylic paint, thinned with water to delineate the basic objects of the still life. I use a worn bristle brush for this purpose, which gives the outlines a sketchy quality.

 I paint with the sketches and photographs in front of me. The composition is still nebulous at this stage, although I have retained the essence of the theme in my mind. The absence of the subject prompts me to recapture its impression, to mentally reorganize its lines, colors, shapes, and textures. Certain areas of the sketch are treated with a dry brush quality, others with a wash effect. Although I am working only in black and white, the imagery of color is already felt at this point.

DEVELOPING FORMS, COLORS, AND TEXTURES

Acrylic paints dry quickly and paint films may be applied over one another in quick succession. My method of applying paint is to scumble it on, applying thin films of color over one another until a scintillating surface is achieved. As the painting progresses, the forms evolve, and the character of the painting slowly reveals itself. Since the colors I have used are predominantly opaque, and the underlying areas are heavily textured, my main concern in finishing the painting is to create interesting surface light.

FLUORESCENT COLORS

To achieve a surface light, I use fluorescent colors on my painting at this stage. Politec acrylic fluorescent paints are applied with a dry brush method over some of the textured areas to heighten the color. The fluorescent colors are used sparingly. Fluorescent red, over a previously painted red, makes it fiery; fluorescent yellows over light colors create an amazing brilliance. The use of the fluorescent paints is for emphasizing brilliance in *selected* areas only; when used indiscriminately, fluorescent colors can dominate the painting.

FINAL PAINTING

The final painting is given a coat of polymer medium (varnish-sealer) as a final varnish. *Still Life*, measuring 25" x 37", took about a week to complete, with two hours a day of actual working time. The qualities of oxidized metals, discolored surfaces, old brick walls, etc., are reflected in the interplay of color and textures in the final painting. The final surface was left matte.

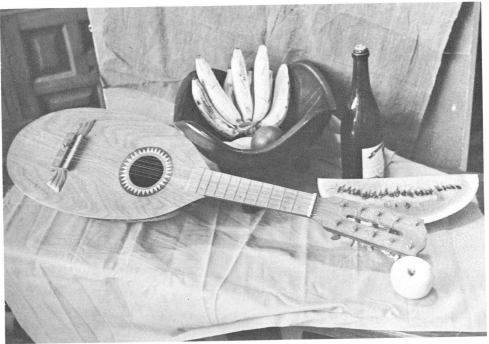

Tabuena sets up the still life. He uses five objects, which he arranges carefully and views from many angles. The still life is also photographed for further study. Many possible views of the still life are carefully considered as the artist strives for a synthesis, rather than an academic copy of the subject.

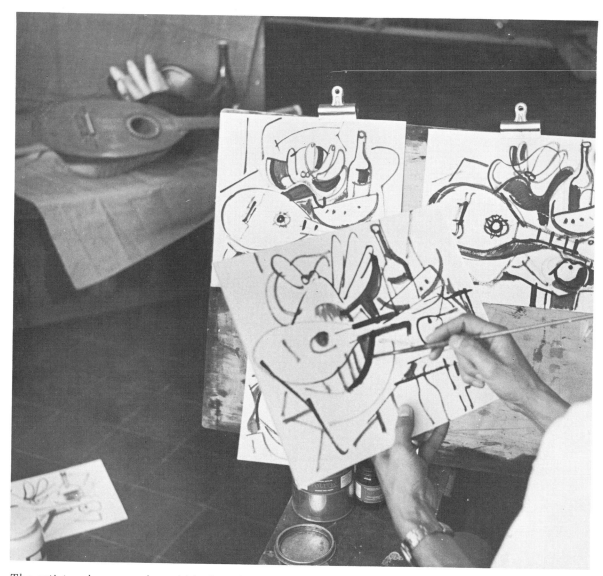

The artist makes a number of black and white drawings, consciously disregarding rules of perspective. Along with the black and white photographs, the sketches are scrutinized carefully. When the artist is satisfied with this exploration, the still life objects are dismantled and put away, to prevent interference with the artist's intuitive ideas when the actual painting is begun.

Tabuena prepares untempered Masonite by priming the surface with five coats of Politec white acrylic paint. The water miscible paint dries quickly, and successive coats are applied in rapid succession, the entire process taking approximately an hour. Brush strokes are uneven, creating a textured surface.

Acrylic paste extender is applied over the white primed surface to create further textures. The paste extender is mixed with marble dust and applied with a palette knife.

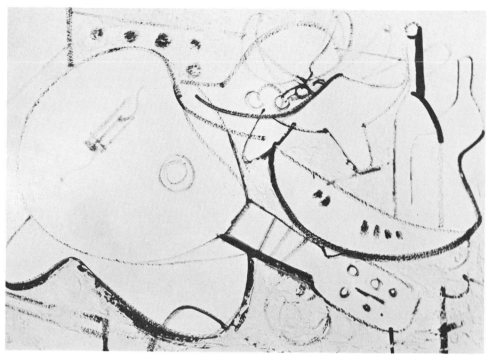

Using black acrylic paint thinned with water, Tabuena sketches directly on the prepared Masonite panel. Photos of the subject and black and white drawings are used for reference purposes. The absence of the actual still life prompts the artist to recapture its impression as he strives to organize lines, colors, and textures. Using a worn bristle brush, he deliberately keeps the sketch simple. Bold, sweeping lines suggest the eventual composition.

In the preliminary underpainting, acrylic colors are scumbled into forms and background shapes. The artist uses a thin, opaque paint film and scrubs the colors into the textured surface.

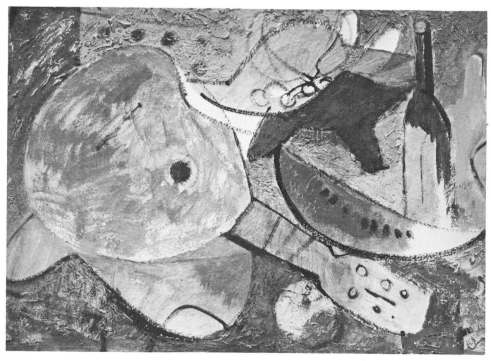

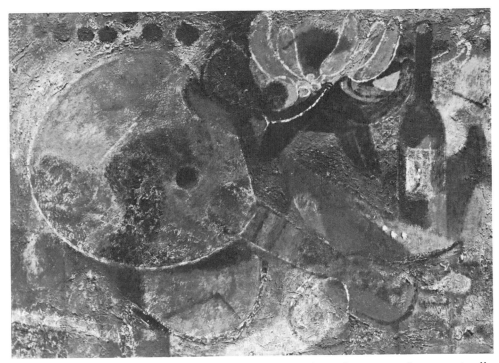

Continuing with thin, opaque colors, Tabuena scrubs color over color, eventually creating a scintillating surface of paint textures. Using the edge of a bristle brush, he suggests contours and edges with delicate lines of opaque acrylic paint.

Final applications of fluorescent acrylic paint create a "surface light" in selected areas, heightening the brilliance of the color. Tabuena seals his painting surface by applying one coat of thin acrylic medium (Politec Varnish Sealer).

Forest Glen by Robert Elsocht, *polyvinyl acetate on canvas, 30" x 34".*

8
painting a landscape

Robert Elsocht, of Oakland, California, demonstrates his use of polyvinyl acetate paint with his favorite painting tool, a three inch putty knife. The landscape was completed in three hours.

My intention in painting is to capture that first, fresh, perceptive glance: the initial confrontation of nature, before the mind has had the opportunity to intellectualize on what the eyes have seen. I want to preserve that spontaneous quality in my painting, combining the objective and subjective aspects of my subject matter. I want to eliminate the overly detailed, and to emphasize instead the bold passages of color and light, the interplay of light and dark forms and the colors between them.

In order to accomplish this, I work swiftly, trusting my initial responses, and work with painting tools suited to my temperament. I find the palette knife is the ideal instrument which allows me to apply broad, sweeping passages of paint; the knife can also be used later for the detail.

Although I have worked with a variety of palette and painting knives for over ten years, I have come to prefer the common putty knife, or glazier's knife, which I used in the demonstration painting, *Forest Glen*. Using the three inch putty knife, I am able to apply thick impastos of color; scrape paint to reveal color previously painted; "print" fine lines using the edge of the tool; scratch lines through the paint film for a sgrafitto technique, etc. The paint may be scumbled, pressed, textured, or applied in a variety of other ways.

SYNTHETIC MEDIA

During the past ten years, I have explored a variety of synthetic materials for use in painting. Among them, I have worked with lacquers and polyesters. At one time, I developed a technique of working with polyester and dry pigments. This proved fairly satisfactory but it was a nuisance to have to mix a great number of chemicals and it also had an unpleasant odor which permeated the studio.

The demonstration painting was painted with Polyart, a water base, polyvinyl acetate paint manufactured in Oakland, California. This thick paint is perfect for palette knife painting and has no unpleasant odor. In working with this material, I added polyvinyl acetate paste extender to the colors to produce a thicker paste paint for the demonstration.

PREPARING THE CANVAS

I usually work on a good grade of raw linen canvas which I seal and prime with two or three coats of Pabco P.V.A. Wall Sealer. This is a white latex paint, well suited for this purpose, and dries in about three hours. The viscosity of the primer is about right as it comes from the can; no thinning is necessary.

BEGINNING THE LANDSCAPE

I plan the composition of my canvas on a sketch pad, developing the general light and dark patterns with a felt tipped pen. At this stage I work only with the general shapes and the basic rhythms of the composition. Once the sketch is made, I put it away, so that it will not interfere with my direct approach in the painting which is to follow.

PREPARING THE PALETTE

I work on a plate glass palette, with white paper underneath. On this surface, I spread the full palette of colors for my painting. The colors include yellow ochre, cadmium red, ultramarine blue, chrome oxide green, cadmium yellow medium, burnt umber, burnt sienna, violet, white, and black. The paste extender, also a plastic medium, is used to thicken the paints.

BEGINNING THE LANDSCAPE

Using a three inch putty knife, I begin the painting by laying in bold sweep-

ing lines of burnt umber, which suggest the general form of the composition. The idea is to break up the area of the canvas into interesting shapes, with no attention given to detail.

APPLYING LARGE, FLAT AREAS OF COLOR

In the next stage, I mix polyvinyl acetate paints with the paste extender to produce heavy paste paint. Bold, massive areas of color are applied with the large putty knife. Some colors are applied directly to the canvas; others are mixed on the glass palette for intermediate tones and then applied. As the plastic paint dries quickly, subsequent areas of color are overpainted in a matter of minutes. In some cases, the putty knife is used to scrape the paint film, revealing the color underneath, which was applied previously.

In continuing the painting, color areas become smaller, and are applied using the corner of the putty knife. Areas of the painting that appear too busy are overpainted, or scratched away.

FINISHING TOUCHES

Small amounts of brilliant color are applied with the putty knife. Cadmium red, yellow ochre, light blues and greens are applied with the corner of the putty knife. These color accents work throughout the painting. White is also applied in the final painting to obtain contrast and to maintain a fresh, spontaneous quality.

The edge of the palette knife is used to carefully "print" some final delicate lines, which clarify the edges of the trees and suggest branches. Foliage is suggested by applying small areas of greens, ochres, and intermediate tones with the corner of the putty knife. In viewing the completed painting at very close range, it appears as a myriad of color islands, with a mosaic-like character. The passages of color, of course, fuse in the spectator's eye as he steps back to view the work.

The polyvinyl acetate paint dries to a matte finish, and needs no final varnishing. Although there is a clear medium available for applying a final gloss finish, I decided to retain the flat surface, and did not apply the plastic varnish. Entitled *Forest Glen*, the landscape measures 30" x 34".

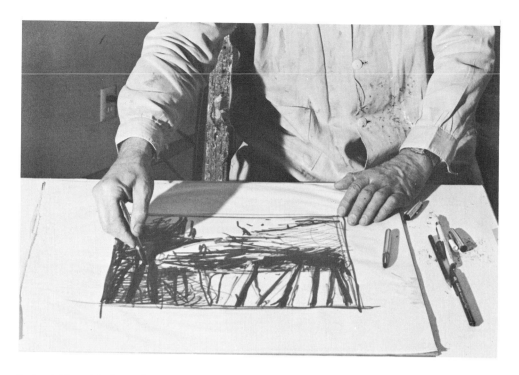

Robert Elsocht plans the general composition for his painting on a sketch pad, using felt tipped pens. The division of space and the black and white patterns are worked out. Once the general nature of the composition has been decided, the sketches are put away, in order not to impede the spontaneity of subsequent painting.

Elsocht's palette is a large piece of plate glass, placed over a white surface. His painting medium is "Polyart," a polyvinyl acetate paint. Although several knives are shown in the photograph, most of them are used to mix colors on the palette and also for mixing paste extender with the paint to obtain a heavier paint body. Only the 3" putty knife is used to paint the landscape, Forest Glen.

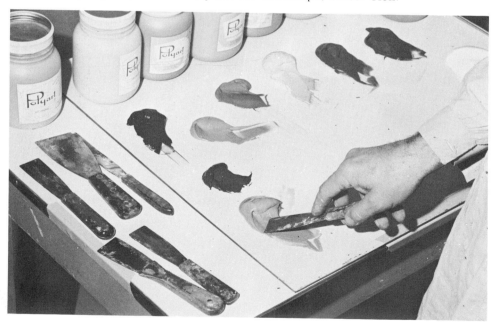

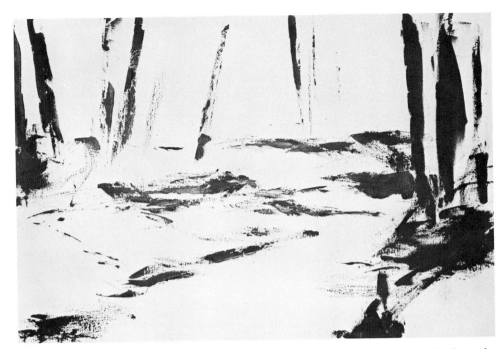

The artist begins by laying in large, sweeping lines and movements, dividing the space and suggesting the general nature of the composition. Burnt umber is applied with the putty knife. No attention is given to detail at this stage.

Large areas of color are introduced with the putty knife. Colors are applied thickly and with bold gestures. The plastic paint has been thickened to some extent by the addition of paste-extender, a polyvinyl acetate thickener. The entire canvas area is treated with various tints and shades of color. The polyvinyl acetate paints dry quickly, and some areas are overpainted in minutes with smaller notes of brighter color.

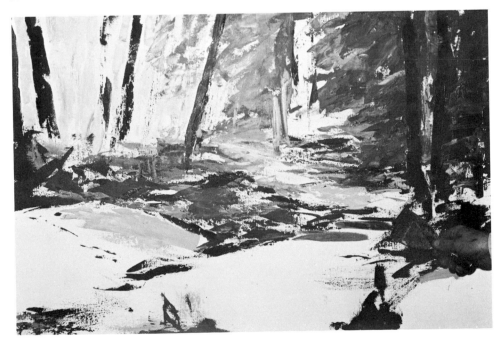

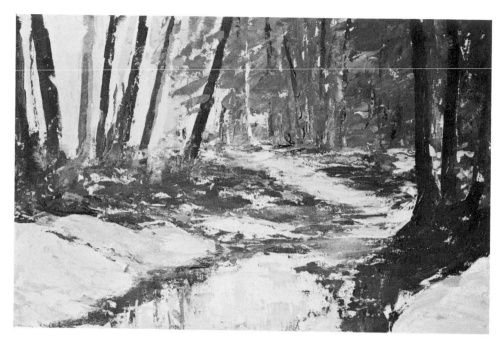

As the painting continues to develop, Elsocht uses various techniques in painting with the putty knife. He uses the flat, broad surface of the blade to apply large impastos; scrapes surfaces to expose previously applied paint; and uses the bottom edge of the knife to "print" lines and establish forms. Smaller accents of color are introduced over the larger masses. These accents — which suggest foliage, branches, highlights, or reflected light — are applied with the corner edge of the putty knife in quick, spontaneous motions. Brilliant dashes of cadmium red, light blues, ochres, and greens are applied in the final stage. The painting maintains a mosaic-like character, with islands of color which suggest rather than delineate the subject.

Close-up of a small section shows the bold application of paint with the putty knife. Variations in color were obtained by overpainting, and by scraping away paint film, revealing previous layers of color underneath.

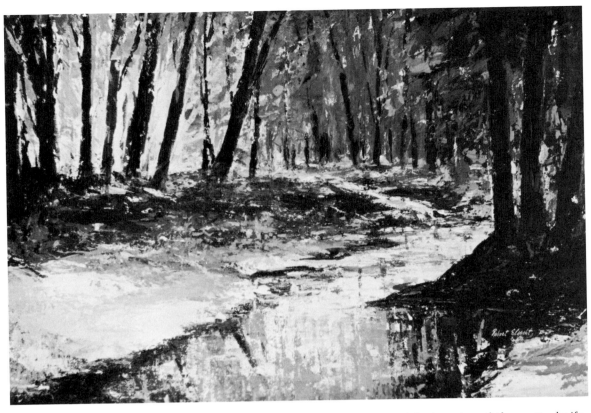

The artist "prints" delicate branches and foliage with the edge of the putty knife, providing the final touches. Areas which become too busy are overpainted or scraped away. White paint is scraped over the foreground to suggest reflected light in the water.

9
painting a portrait

Robert Rishell, San Francisco bay area artist, demonstrates his method of painting a portrait, using acrylic paints.

The characteristics of the new acrylic paints should challenge the imagination of any creative artist. They are designed for fast handling, they dry quickly, yet they offer flexibility in a variety of directions, including the art of portraiture.

With these materials, I find that I can finish a portrait in one sitting, just a few hours. The time element — waiting for each stage of the work to dry and for the next stage to commence — is compressed into a fantastically short period. The artist may get on with his work quickly; he is not plagued with the agonizing wait demanded by slow drying material. Although there is a different "feel" to acrylics in comparison to that of oils, there are many characteristics which are the same; I found it fairly easy to adapt my oil painting methods and attitudes.

Because I had been using oil paint for my portraits in previous work, I selected an acrylic which had physical properties similar to oils. For the demonstration painting, therefore, I chose to work with Liquitex acrylic, which is available in metal tubes and possesses a viscosity similar to that of oils.

In addition to the colors, I used the Liquitex gel medium, an acrylic extender which is heavy in viscosity and which dries transparent. This

medium was used to slow the drying time of the colors, thus allowing for a partial blending of colors. The gel also makes the colors transparent without losing their tube viscosity.

For a palette, I used a large piece of plate glass, squeezing out small amounts of acrylic paint along the top edge. The remaining area of the palette was used for the subsequent mixing of colors. It is necessary to prevent the colors from drying out too quickly while they are on the palette; for this purpose, I used an atomizer filled with water. From time to time during the painting session, I sprayed the colors remaining on the palette with the water in the atomizer, and in this way replaced the moisture that was lost through evaporation.

PALETTE OF COLORS

In painting the portrait, I selected the following colors for my palette: cadmium yellow, cadmium red light, raw sienna, indo orange red, burnt sienna, acra violet, naphthol cerulean blue, thalo green, green oxide, ultramarine blue, titanium white.

This constituted my full palette, which I used for the light and dark tones of the head, hair colors, clothing, and background.

FLESH TONES

For the light flesh tone colors, I used titanium white, raw sienna, and a touch of indo orange red. For the shadow areas of the head I used burnt sienna, green oxide, ultramarine blue, and cerulean blue. Burnt sienna was used as a base, and into this I mixed a touch of blue or green. As the painting progressed, I modified the light and dark flesh tone colors by intermixing them, which produced tones which served to relate the contrasting areas of color.

BRUSHES

Three short haired bristle brushes were selected: #2, #6, and #12. For fine lines and details, I used a pointed #3 sable.

PREPARING THE SUPPORT

I selected a linen canvas, double primed with an acrylic latex primer. After assembling the stretcher bars and checking them for squareness with a large square, I attached the canvas to the bars with the aid of canvas pliers and a staple gun. The taut canvas was now ready for toning, using a raw umber and acrylic medium.

TONING THE CANVAS

On the glass palette, I squeezed out an amount of raw umber acrylic, which I thinned slightly with matte acrylic medium. This was applied to the canvas with a wide brush. This toning is an important step in my technique, because it puts the canvas in a neutral value relationship to the subsequent flesh tone colors, which will be both light and dark.

ARRANGING THE POSE

I do not make preliminary sketches of the subject, preferring to sketch and paint directly on the canvas. However, before work is begun, it is important to consider the pose the subject is to take. I arrange this carefully, considering many different angles and positions. When the pose seems right, I create the studio lighting by using two incandescent bulbs. A strong 150 watt spot is used as a key light, which is placed approximately at a 45° angle and above the subject. A fill light is placed on the opposite side. For this I use a 100 watt blue daylight bulb in a flood diffuser. This light gives a complementary cool cast to the warm shadow. Most of my work is done during the day, and the incandescent lighting is also affected by the existing natural light.

THE BASIC SKETCH

In beginning the portrait, I worked swiftly and directly with a #6 short haired bristle brush and raw umber. The umber was thinned a bit with water to control the brushability of the color, and was slightly darker than the background tone. My main objective at this point was to work with bold gestures, establishing the placement of the subject on the canvas, suggesting general shapes and their proportion to one another. The position of the facial features was indicated with soft washes, and the over-all composition of the portrait was established.

This portrait was a three-quarter view of the head, and the bent arm and position of the subject suggested a large diamond form, the essential shape of the composition. I continued the sketch by painting the shadow side of the face, still working with the thinned raw umber.

At this point, I believe it is very important for the artist not to become overly fascinated with the interesting details of the subject, but to concentrate on the essential task of establishing basic volumes of blocks and planes, and in this way establishing a solid foundation for subsequent work. (The cake should be baked before the frosting is applied.)

PAINTING IN THE LIGHT FLESH TONES

In this stage, the actual painting commenced. The palette was prepared by squeezing out the full range of colors on the glass surface, and some acrylic gel medium was poured into a painting cup. I prefer to work with the colors in tube consistency, and by mixing the flesh tones with the gel medium a uniform viscosity is maintained. I squinted my eyes as I observed the subject, which compressed the essential light planes, obscuring the fine details.

Again thinking in terms of large structural masses and shapes of light areas, I painted the light area of the head. I used a kind of scumbling action with the brush, which seemed to adapt itself well to painting with the plastics. With the addition of the gel medium, a partial blending was also accomplished.

DARK TONES AND DELINEATION OF DETAIL

In the next stage, the darker flesh tones were painted. A likeness of the model was developed through careful scrutiny of his features and careful delineation of the individual characteristics of these features. A background color was introduced, which brought a contrasting color to the edge of the head. This established a contrast in color and value, and defined the contour of the head. For the background, I used ultramarine blue with a touch of burnt sienna. For lighter tones, white was added. Continuing to think in terms of blocks and planes, I began to think of myself as literally "backing out" of the painting. The volumes, which were subsequently scumbled over the previously applied ones, were smaller, leading eventually to the point where the final details could be introduced.

INTERMEDIATE STAGES

At this time, both dark and light flesh tones were used alternately, and both flesh tones were mixed to produce a transition between the contrasting lights and darks. In a kind of semi-scumbling technique, warm areas of color were introduced over the cool shadow side of the face. Colors at this stage were thinned with the polymer medium, which made thinner glazes for warming or cooling areas of the head. As this stage progressed, the advantages of working with the acrylic paints were made clearly evident to me; areas could be scumbled with color almost immediately; glazes dried in minutes.

The hair was painted in, using titanium white, raw umber and an ultramarine blue. As this man's hair was silvery gray, I began by painting the

hair dark, and then "lifted" the light color out; that is to say, I "overpainted" with the colors mixed with more titanium white. I shifted to a fine pointed sable brush for the delineation of the soft, delicate texture of the hair.

CLOTHING

Dark and light tones of the clothing were painted with ultramarine blue and a touch of umber. By using raw sienna and white with this, I painted in the light areas of the sweater, and established the detail of the folds and creases. Instead of using black in my palette, I mixed a black consisting of ultramarine blue, naphthol ITR crimson and raw umber. This was used in the darker areas of the sweater and for accents on the head.

THE BACKGROUND

I decided to establish an "environment" for my subject, who, incidentally, is a deep sea diver. Light passages of cerulean blue, mixed with raw sienna and white, were scumbled in the background. Over this, thin passages of cerulean blue and acra violet were glazed. The colors were applied in a free manner, using more of a suggestive — rather than descriptive — technique.

FINISHING TOUCHES

As the painting neared its final stages, I began to use more transparent washes of color, using the polymer medium and colors for obtaining thin glazes. The painting's surface became lustrous; the clear quality of the plastic manifested a brilliance uncommon to other media. For the final details, I used a small #3 sable brush and painted in some areas of solid color; I emphasized the character lines of the model, accented the color of the eyes, and developed the final detail of the features.

Cadmium red light was used to paint the upper lip; cerulean blue for the iris of the eyes; black for the pupils and also for details on the eyes, eyebrows, ears, nose, and mouth. Pure white was used for the reflected light in the eyes and for the accent on the pipe.

HIGHLIGHT FLESH TONES

Once again, by squinting my eyes and observing the model, I looked for the flesh tone highlights. Raw sienna, naphthol ITR crimson, and cadmium red light were added in small quantities to titanium white, and the resultant light tints were placed on the forehead, nose, lower lip and cheek. These

highlight flesh tones were scumbled in opaquely and constituted the final details to be added to the portrait.

VARNISHING THE PORTRAIT

The acrylic colors dry to a semi-gloss finish, and no "hot spots" of individual colors seemed noticeable. The entire painting surface dried with a uniform sheen. However, I applied an acrylic varnish to my painting for two reasons: to create a matte surface quality, and to protect the painting surface. I used the matte acrylic varnish and applied two coats, thinning it with water, about 1:1. I applied the acrylic varnish with a two inch sign writer's brush. The medium was milky when applied, but dried to a clear, matte finish.

Rishell uses a plate glass palette, placed over a white Formica table. Liquitex acrylic colors are squeezed out along the top edge of the palette, with the remaining area left for color mixing. The putty knife is used for scraping dried color from the glass. The atomizer is filled with water and used to spray the lumps of color periodically to retard drying.

Linen canvas is stretched taut. The commercially prepared canvas is double primed with a latex primer. Rishell applies a thin coat of raw umber, diluted with water, to the canvas, toning the surface for his portrait. This middle tone acts as a color neutralizer, integrating both light and dark flesh tones as they are applied in subsequent painting.

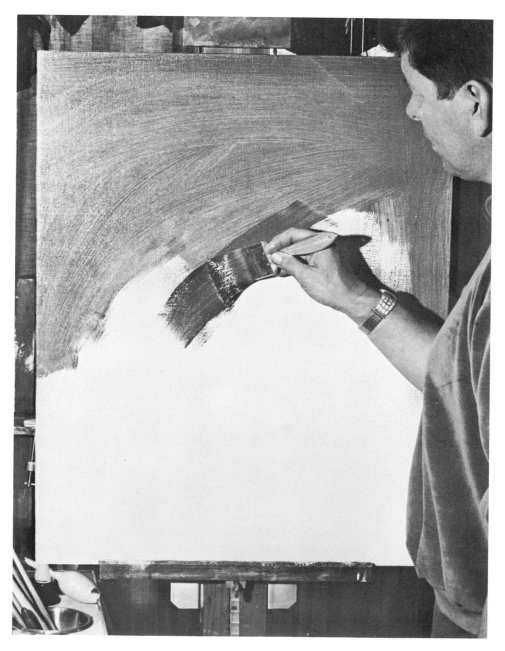

Rishell sketches directly on his canvas, without making previous drawings. He poses his model carefully and sets up studio lighting to establish light and dark patterns. Thinning raw umber with water in a disposable cup, he sketches with a bristle brush, establishing the gesture of the composition, the general placement of the subject on the canvas, and the relationship of negative and positive shapes. General position of facial features is indicated with the thin paint, and the shadow side of the head is painted in, completing the sketch.

Light flesh tones are introduced. Large areas and color masses are indicated, with no attempt to develop detail. The artist squints his eyes in observing his subject, thereby compressing areas of light and dark and making them readily discernible. For his light flesh tone palette, Rishell uses indo orange red and raw sienna, mixed with titanium white.

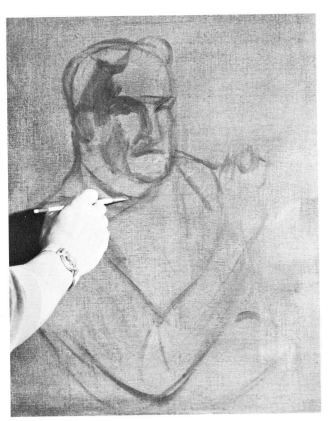

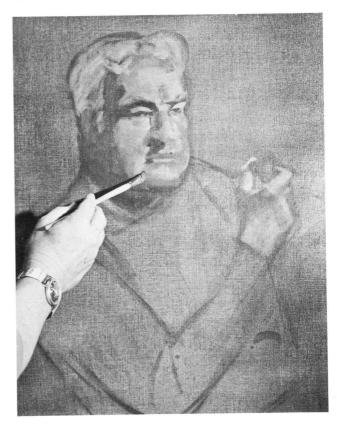

The background is painted with ultramarine blue and a touch of burnt sienna. Color is painted to the edge of the head, clarifying the outer contour and providing a value and color contrast against the flesh tones. The shadow area of the head is painted with the dark flesh tone colors. Facial details and characteristics are studied and indicated, using a bristle brush with a scumbling technique. Gel acrylic medium, added to the paint, maintains an even viscosity, slows the drying time of the colors to some extent, and allows a partial blending of colors.

Blocks and planes of the face are studied and painted; smaller areas of color are scumbled over the larger ones. The artist places intermediate masses of color over larger masses, eventually painting in the final accents of color. Working with both the light tones and the flesh tones of his palette, Rishell scumbles cool areas over warm and reverses the process as well. Warm red tones are scumbled into the dark areas, enriching the cool shadow tones. Hair is painted with dark color first, using umber with a touch of ultramarine blue; then he mixes white with umber and ultramarine blue and "lifts" a delicate silvery gray. For the hair, he uses a pointed sable brush and works with soft, short strokes.

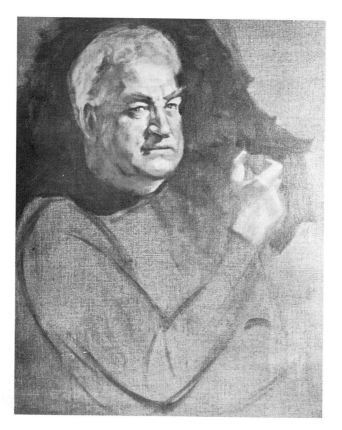

The light and dark passages of the clothing are studied and painted in ultramarine blue, mixed with a touch of burnt sienna. Raw sienna and white, mixed with this basic tone, produce lighter masses of color. Black is mixed by combining ultramarine blue, naphthol ITR crimson, and raw umber. This is mixed with the basic tone for darker shadow areas and delineation of folds and creases. He continues to work on the head by mixing dark and light flesh tones and obtaining intermediate tones, which are painted in to reduce sharp contrast between light and dark areas. Colors are mixed with polymer medium and thin glazes are used — along with semi-opaque scumbling — to refine the likeness.

The background is elaborated, giving the subject an environment. Scumbled areas of color, notably cerulean blue mixed with raw sienna and white, are painted in. Transparent areas of violet and cerulean blue are also painted to create a dramatic sky.

Using a pointed sable brush, the artist begins to paint final color accents. Fine lines and details are painted as the artist strives to capture the character of the subject. The soft sable brush is also used to elaborate the hair. Highlights of pure titanium white are placed on the eyes and pipe.

Continuing with the sable brush, Rishell applies a color accent of pure cadmium red light to the upper lip. With the sable brush, he continues to elaborate the drawing and the smaller passages of color.

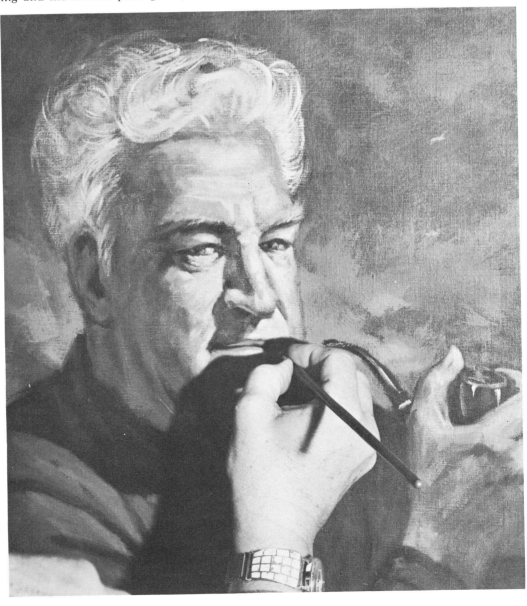

Squinting his eyes in observing his subject again, Rishell looks for the highlight flesh tones. Mixing flesh colors with white, he places the final opaque areas of color on the salient features of the portrait: the forehead, the high areas of the cheek bones, the lower lip, the salient plane of the nose, etc. The hand receives the same treatment. The painting is varnished as soon as it is dry. Using Liquitex matte medium, diluted with water, Rishell gives the painting two coats. The matte varnish serves two purposes; it gives the painting a flat surface quality and also serves to isolate the painted surface to protect the paint film. The portrait was completed in approximately three and one half hours.

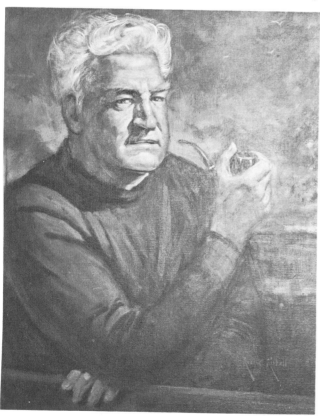 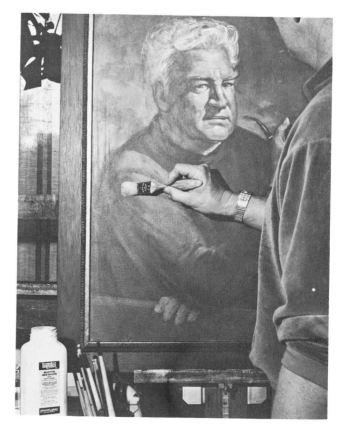

Man of the Sea *by Robert Rishell, acrylic on canvas, 24" x 30".*

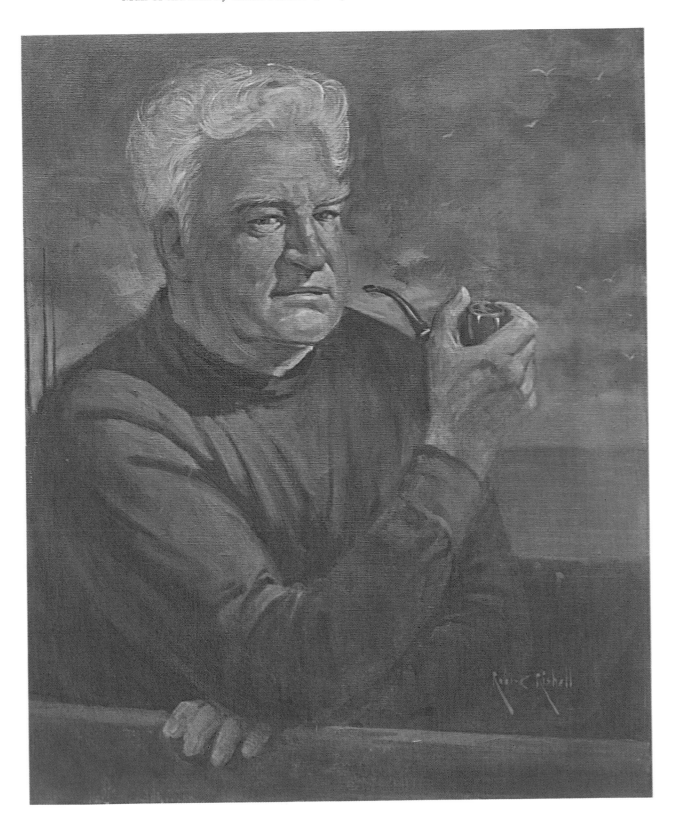

10
painting the figure

Jonathan Batchelor, of the San Francisco bay area, demonstrates his method of figure painting with an acrylic paint which he formulates himself.

I have prepared my own plastic paints for years by using an acrylic emulsion as the vehicle, mixed with dry pigments. Although it is now possible to obtain commercially prepared plastic paints, I find that my formulated plastic paints work very well, comparatively speaking, and I've grown accustomed to their working characteristics.

My paint formulation consists of only two ingredients: AC-34, the acrylic resin, and dry pigment. AC-34 is obtainable from the manufacturer, Rohm & Haas of Philadelphia. My grinding process, although somewhat crude, provides adequate results. I pour the acrylic emulsion into a tin can and then mix dry color with it. Using a long metal spatula, I grind the colors into the emulsion against the inside edge of the can. Although I have heard that some artists add a 5% solution of Tamol to aid the dispersion, I find that most pigments go into suspension quite readily, and very little grinding is necessary. Two to three minutes is all that is necessary in most cases.

The Sherwin-Williams Company manufactures universal tinting colors called Multi-Sperse, which I have also used with the AC-34 emulsion in making plastic paint. These tinting colors are already dispersed in a paste which facilitates mixing with the acrylic emulsion.

I keep the paints which I formulate in airtight glass bottles and add a few drops of water at times to make up for the water lost through evaporation. The plastic paints are durable and quite flexible for a variety of painting methods. They are water miscible and have a distinct advantage because they are quick drying.

My demonstration painting, entitled *Caroline*, was painted with the AC-34 formulated paints previously described. Artists who do not wish to formulate their own paints may still utilize the painting methods described in the text, using any of the commercially available acrylic paints.

PALETTE AND STUDIO ACCESSORIES

As a palette for my colors, I usually use a piece of tempered Masonite, which is dampened before applying the colors. An atomizer and a small glass jar filled with water are handy for keeping the colors fresh while the painting is in progress. Using these, I spray the palette from time to time to replace the water which the paint loses through evaporation. Metal foil over open jars of paint makes adequate temporary lids.

PREPARING THE CANVAS

I prefer to work on flexible canvas, rather than on Masonite, which is more rigid. The canvas responds to my brush, and offers the texture which I prefer. I prime the raw canvas with a single coat of flat latex primer. Any good industrial paint will do, but I prefer to use a latex primer because it bonds well with the subsequent painting and is water miscible. Also, the drying time is fast, and cleanup is facilitated.

PALETTE FOR FIGURE PAINTING

I used the following colors, plus white, in my demonstration figure painting: yellow ochre, cadmium yellow medium, cadmium red, burnt sienna, ultramarine blue, and green oxide.

The vehicle for these colors was straight AC-34, which I used with the dry pigments to obtain suitable brushability. In making ultramarine blue, I used Sherwin-Williams' ultramarine Multi-Sperse, which was mixed with the acrylic emulsion.

For glazing, I add water or straight AC-34 acrylic emulsion to the paints to produce thinner washes of color. By mixing the colors chosen from my palette, I obtain a wide range of intermediate colors. I keep straight AC-34 emulsion in a glass jar to use in thinning paints during the painting session.

BEGINNING THE FIGURE PAINTING

No preliminary sketches are made. I prefer to work directly with the brush, delineating general forms first, and then bringing in color. However, the preliminary step of establishing the pose of the model is essential in creat-

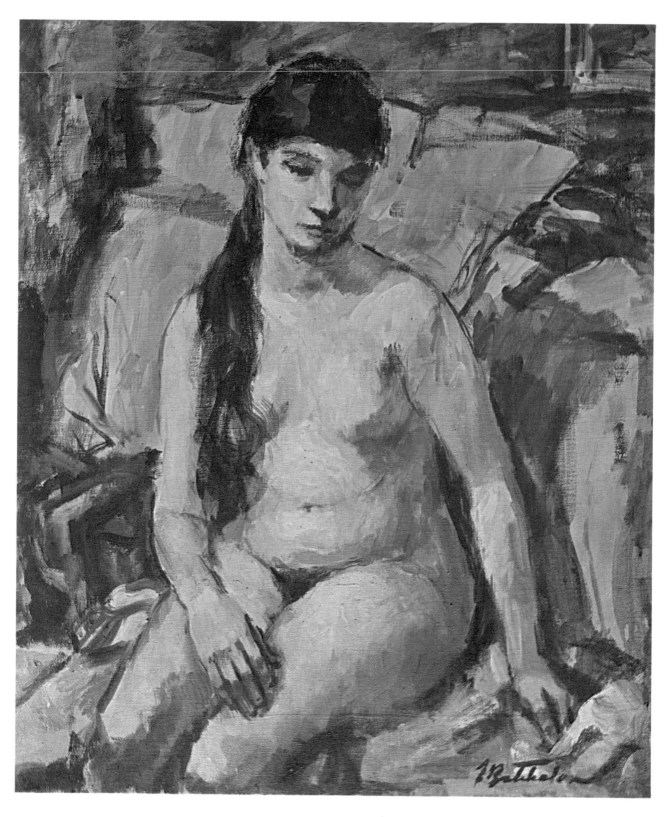

Caroline by Jonathan Batchelor, acrylic on canvas, 30" x 36".

ing a good figure painting. Once the model's pose is set, the composition of the painting is set and I am ready to begin. Studio light is fairly dim, with a large 100 watt floodlight placed at one side of the model to provide the key light.

GESTURE DRAWING

In beginning the figure painting, my approach is to make a gesture sketch on the canvas to establish the basic forms of the figure, and to establish the placement of the figure in relationship to the shape of the canvas. I work rapidly at this stage, mixing yellow ochre with the AC-34 medium, using a small bristle brush. The gesture drawing also suggests the fluidity of the pose, and I seek to keep the drawing simple, with large, sweeping, rhythmic lines.

DARK AND LIGHT FLESH TONES

In the next stage of my painting, I switch to a larger bristle brush and paint the dark and light tones of the figure. I close my eyes slightly in studying the model, to clearly establish the essential areas of light and dark. These areas are painted alternately, until the solidity of the figure is established. Scumbling the color, I make no attempt at finished detail. Only the structure of the light and dark masses is indicated at this point.

My palette for light flesh tones was yellow ochre, cadmium red, green oxide, and white. To the white, I add the warmer colors and a touch of the green.

My palette for dark flesh tone colors consisted of yellow ochre, green oxide, and burnt sienna.

INTERMEDIATE STEPS

The plastic paint dries quickly, and overpainting may commence as soon as the first paint film is dry. In the demonstration painting, I worked over dry paint, and in some instances into wet paint as well. As the painting continued, I applied smaller masses of color. Intermediate flesh tones were mixed and applied with short, scumbled brush strokes. The linear quality of the painting was not definitive; I kept it suggestive by painting lines which appeared and disappeared throughout the painting. I deliberately avoided painting excessively finished edges and forms, but worked with masses of color and tone to maintain a spontaneous quality.

FINISHING TOUCHES

As the painting progressed, the smaller areas of flesh tones, both light and dark, were applied. Eventually, the highlight areas of flesh tones were introduced. In pulling some areas together, AC-34 medium was mixed with the plastic paints, such as greens or siennas, to create thin glazes to warm or cool particular areas. In the shadow side of the figure, for example, I glazed with a thin wash of green. The background was scumbled in a suggestive manner, using yellow ochre, white, and ultramarine blue.

No varnishing was necessary because the painting dried with a uniform satin-like surface. The finished painting, *Caroline*, is 30" x 36".

After posing the model carefully, the artist begins by painting a gesture sketch, which establishes the general placement of the figure on the canvas and suggests the essential rhythm of the composition. Bold brush strokes suggest the essence of the pose, as the artist carefully avoids detail. Large areas of dark are also suggested.

Using bristle brushes, Batchelor scumbles light and dark flesh tones, alternately painting with both light and dark flesh tone colors. Light flesh colors include white, cadmium red, yellow ochre, and green oxide. Dark flesh colors include yellow ochre, green oxide, and burnt sienna.

Closing his eyes slightly to compress light and dark tonalities, Batchelor observes and paints the inter-relationships of shapes and the essential lights and darks. Using a bristle brush, he refines the color and shape of the hair, using a scumbling method with a brush heavily charged with paint.

During the intermediate stages of his work, the artist paints in the smaller masses of light and dark flesh tones. Here the artist paints a highlight area. Notice the character of Batchelor's short, scumbled brush strokes, which follow and emphasize the contours of the figure. Delicate lines are also drawn with the brush to reinforce passages of color.

Refining the painting, Batchelor paints in the smaller areas of color. Using the edge of his brush, he re-establishes and clarifies edges by drawing lines. Here a flesh tone highlight area is applied to the upper forearm, using white mixed with yellow ochre and cadmium red. The background is painted with ultramarine blue, yellow ochre, and white, suggesting the drapery.

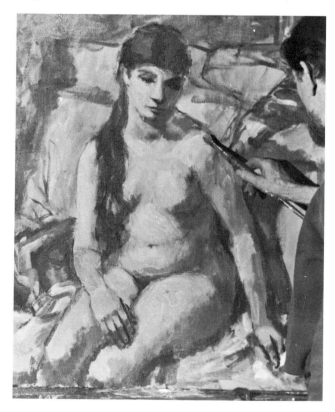

Thin glazes are applied to control areas of color and to adjust the tonality of light and dark flesh tones. Thin glazes of green are applied to the warm, dark side of the figure. Light and dark flesh tones are studied and painted on the hand. Features are clarified with smaller amounts of color, applied with a smaller bristle brush. In finishing the painting, Batchelor closes his eyes partially to observe the model once again, this time to study the key highlight areas, which he applies to salient parts of the figure, emphasizing the sculptural aspects of the painting. He maintains a "painterly" character in his work, never over-developing either figure or background. The background is clarified to some extent, yet is kept simple to avoid detracting from the central figure.

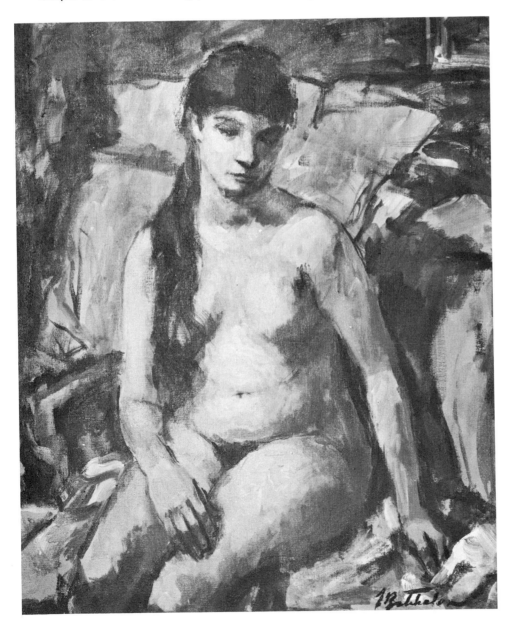

11
creating a painted relief

Luis Strempler of Mexico City demonstrates his use of acrylic paste and acrylic paint to achieve high relief paintings. The artist describes his technique.

For many years, I used only oils, watercolors, and other traditional media because I was reluctant to experiment with the newer synthetic materials. However, when I painted in oil and used heavy impastos, it seemed an eternity before the paint would dry. In 1956, I decided to try the plastic paints and used several of the water based vehicles to create heavy pastes. These materials dried quickly, taking only minutes instead of weeks. I found that in a day I could paint a picture using heavy impastos. Since I try to preserve a spontaneous quality in my work, this fast drying plastic medium suited my style perfectly.

I no longer work with formulations of my own, preferring to use the commercially prepared acrylic paste extenders, which I mix with fillers and paints and apply to a variety of rigid surfaces.

PREPARING A GROUND FOR A PAINTED RELIEF

Although canvas and other flexible supports may be used, I use a brutal attack when I paint and I prefer to work on the non-yielding, rigid surfaces of Masonite or plywood. Masonite is prepared in the following manner.

First, to avoid warping due to excess surface tension, I glue pine strips to the back of the Masonite panels. These strips are also screwed into position to make a perfectly stable support.

Second, although either side of the Masonite panel may be used, I prefer the rough side, which sometimes plays an important part in the final textures of my painted relief. This is painted with a coat of acrylic polymer medium—thinned slightly with water—which is then brushed over the entire surface. The medium is an excellent sealer and primer.

Third, when the coat of medium is dry to the touch, a coat of white acrylic paint is brushed over the surface. I use either a smooth or stipple technique.

The acrylic paint dries in a few minutes and the panel is ready for the first stage of my painting.

SKETCHING THE SUBJECT ON THE PANEL

Using charcoal, I sketch directly on the panel, using bold, free arm movements. In this demonstration, I am depicting *Pelea de Gallos* (Fighting Cocks). I sketch big swooping lines to emphasize the activity and drama of such an event. When I am satisfied with the line drawing, I paint over the lines with brown acrylic paint, thinned with water. The unwanted charcoal lines are wiped from the panel with a cloth. Then I proceed with the next step, which is to prepare the thick acrylic modeling pastes.

PREPARATION OF ACRYLIC MODELING PASTE

Acrylic paste extenders are mixed with marble dust or similar fillers to achieve a dough-like consistency.

Using an enamel or glass tray which serves as a palette, I mix the acrylic paste and marble dust with a spatula to create the heavy paste. In order to maintain cohesive strength, I add a small quantity of polymer medium to the mixture. This will keep the natural adhesiveness and flexibility of the modeling paste.

I also add small amounts of acrylic paint to the mixture to make up a palette of thick pastes in different colors. I am now ready for stage three.

APPLICATION OF COLORED MODELING PASTES

In stage three, I use the colored pastes to build up acrylic bas-relief forms which contrast clearly with the white painting surface.

I prefer to use my fingers to apply and manipulate the paste on the Masonite surface to achieve exactly the kind of bas-relief forms I desire. Because this paste does not level, but holds its shape, it lends itself readily to various techniques.

For making textures, I use forks, coarse brushes, combs, broken saw blades, and even coarsely textured cloth, which I press against the soft paste to produce a variety of surfaces.

I have found that it is wiser to build up the relief in several layers, allowing each to dry, rather than apply the paste too thickly in one operation. This gives me more control and insures against surface cracking. *Pelea de Gallos*, in its final stage, is approximately ¼" thick.

MAKING AND APPLYING THE ACRYLIC PASTE PAINT

When the basic modeling has been finished and the acrylic paste is dry, I continue the work by mixing a thinner paste with stronger colors. I omit the marble dust.

Using the porcelain palette again, I mix two ingredients with a spatula: acrylic paste extender and acrylic paint. These two materials are mixed to create a consistency similar to oil paint.

This finer paste paint I also apply with my fingers. After this finger painting procedure, I use a stiff bristle brush to comb the delicate texture of the roosters' feathers.

GLAZING

In the final painting operation, I apply many thin, transparent glazes, which work miracles in enriching the bas-relief. These glazes pool and collect in the recessed areas, enriching the forms and textures, and giving a rich, polychromatic effect to the work.

After preparing the thin washes by diluting acrylic paints with water, I apply them to the surface with a wide bristle brush. The first glaze will dry in a few minutes so that succeeding glazes may be added to produce brilliant, translucent passages.

I prefer to build a color by using glazes of different colors. For example, to produce a translucent orange, I begin by brushing on a coat of yellow, followed by a thin coat of red. Thalo blue glazed over yellow will yield beautiful translucent greens. By experimenting on small panels of Masonite, an artist can find endless possibilities for this type of painting.

VARNISHING

For the final gloss finish, I apply a coating of liquid acrylic plastic, called Luzitron. Luzitron (a product of Politec Company) is a clear plastic which is designed to impart a high gloss surface to plastic paintings, and to provide a strong, protective coating.

I spray the Luzitron (diluted with X-T Thinner, not water) over the entire surface with an atomizer. The varnish may also be brushed on if the painting surface is isolated first with a coat of polymer acrylic medium. This will keep the brush from picking up paint if the artist tends to scrub the surface when applying the varnish.

Strempler begins by sketching in a preliminary drawing with charcoal, using free, dynamic movements. When he is satisfied with the drawing, he paints over it with acrylic color, using a thin bristle brush and brown acrylic paint. When the line drawing is dry, the excess charcoal is wiped from the panel in preparation for stage two.

Using an enamel tray for a palette, Strempler prepares a thick modeling paste for his initial bas relief build-up. Marble dust is added to acrylic paste to produce a dough-like consistency. A small amount of polymer medium is added to the mixture to increase cohesive strength. Acrylic paint is also added to the mixture for the final preparation of the modeling paste.

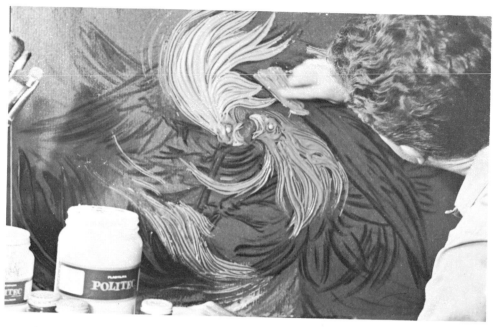

Using such tools as spatulas, palette knives, stiff bristle brushes, forks, and fingers, Strempler applies the heavy modeling paste to the Masonite panel. He sculpts the paste to the desired forms and textures. The paste is allowed to dry before he continues to the next step.

For the fourth stage of his painting, Strempler prepares a finer modeling paste, using acrylic paint and acrylic paste. He mixes many colors in this fashion, making up a palette of colors that are used for the final refinement of the bas relief. Marble dust is eliminated as a thickener, producing a colored paste which is not as heavy as the first mixture and which resembles the consistency of oil paint.

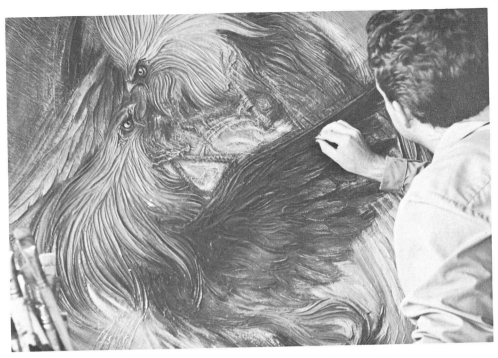

Strempler applies the thinner colored paste with his fingers. He squeezes out a delicate ridge of paint and builds the final surface of his bas relief. Using a wide bristle brush, he creates the delicate texture of the feathers.

The final stage of Strempler's work is continued after the bas relief modeling is completely dry. Here the artist is shown applying thin glazes of Politec acrylic paint. The paint has been thinned with water and glazes are applied, one over the other, to achieve thin, transparent colors which enrich the painted surface.

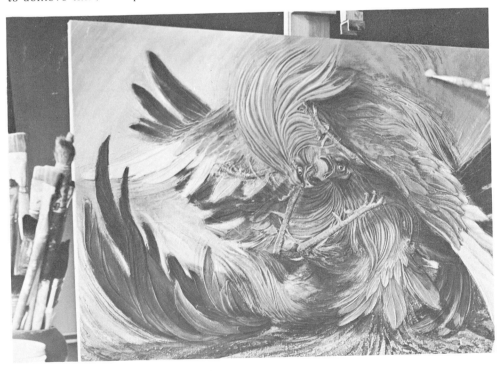

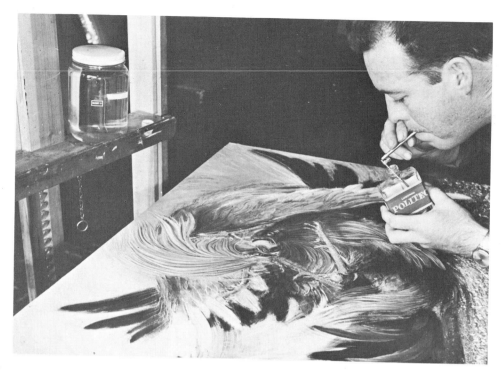

Strempler finishes his painting by applying a protective coating of Politec Luzitron varnish, using an atomizer. Unlike oil paints that dry by oxidation, acrylic paints dry by evaporation, so that the final varnish may be applied minutes after the painting is finished, not months later.

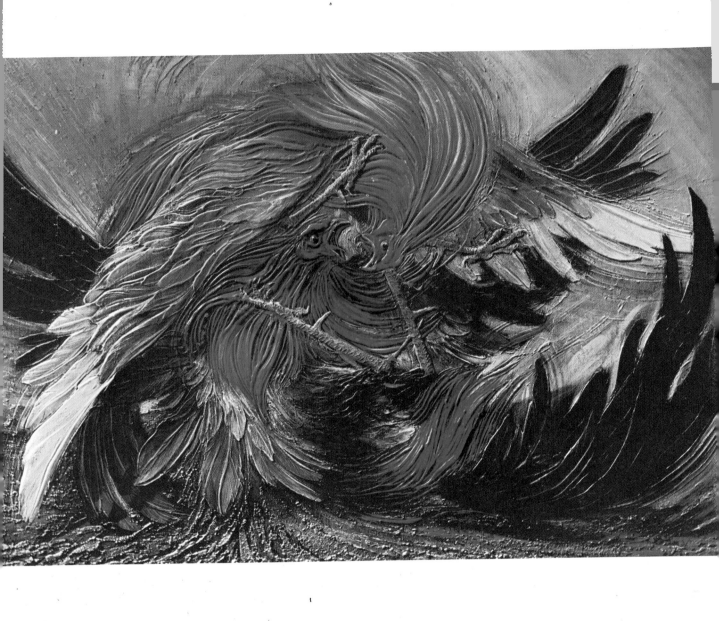

Pelea de Gallos by Luis Strempler, acrylic on Masonite, 24"x34".

12
creating a collage

Greek artist Jean Varda, who lives in Sausalito, California, uses plastic mediums and paints for attaching and decorating his cloth collages.

Collage is the delightful art of cutting and pasting. I have been fashioning my subjects with papers, cardboards, and fabrics, since 1942. In earlier works, I used wood, glass, and sea shells, in addition to the other materials mentioned. In recent years, however, my principal medium has been fabric of brilliant colors, textures, and shades.

My purpose in making collages is to denounce the morbid, lackluster black of some contemporary painters. My collages are testimonies of the joy of life. With rich colors, bold textures, and daring, the contemporary artist should create an atmosphere of optimism and joy for the spectator. I remember the words of Manuel Mavroulas, my early teacher, who told me when I was a child in Greece: "A work of art should vie with the splendor of the birds and the opulence of the flower, and surpass them both."

The plastic paints and plastic mediums have made it easier for me to carry out my work, because of the quick drying nature and the inherent tenacity of the adhesive polymer mediums, which I use for attaching fabrics and cloth. I also rely upon the quick drying brilliance of the colors which I use for making accents on the completed fabric collages.

BEGINNING A CLOTH COLLAGE

My work begins with a search for materials. Fabrics of rich colors and textures are the essential element of my work. These I find in yardage shops,

and many times they are brought to me by friends who share my love of unusual materials.

CUTTING AND ARRANGING THE CLOTH

The actual process of making a collage begins with an arrangement of many fabrics on a large plywood surface. This arrangement is later transferred and pasted to a second piece of plywood which is similar in size, and prepared with a background.

In the demonstration sequence of *Fishes*, I used two pieces of quarter-inch plywood, cut to 32" x 48". I placed the two plywood sheets side by side on a large work table. A large piece of thin fabric was used as a background for the eventual collage, and this was glued down on one of the plywood surfaces with polyvinyl acetate glue (Elmer's Glue or polymer medium). The glue is painted onto the back of the fabric, which is then pressed firmly to the plywood surface.

Turning to the second piece of plywood, I began to cut and arrange pieces of fabric to develop the composition of the collage. Pieces of cloth were moved about, arranged and re-arranged. Brilliant colored fabrics work *against* and *with* other brilliant colors; textures work with other textures; and values of both are manipulated until a satisfactory composition is achieved.

TRANSFERRING AND PASTING THE FABRICS

When I am satisfied with the final composition of the collage arrangement, I begin the next stage of the work, which is to transfer and paste each piece of material to the prepared plywood surface. Each piece of cloth material is carefully picked up from the surface arrangement; glue is painted on the back side of the material, and then it is pressed onto the final surface. The white glue or polymer medium is used for this adhering process. This procedure is continued until all of the elements have been transferred and pasted to the final surface.

FINISHING TOUCHES WITH PLASTIC PAINT

In completing the collage, I use plastic paints for accents, and for controlling weak color or value contrasts. For accents, I apply the paint thickly with a bristle brush, emphasizing such details as eyes and contour lines. Some painted texture is also added in the form of spots of color. Plastic paints may also be diluted with water to serve as a dye, and some areas were treated in this way, emphasizing color contrast.

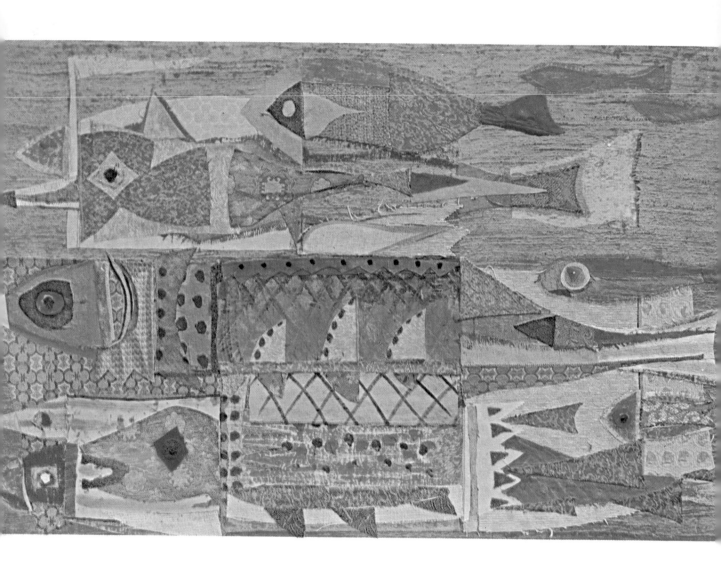

Fishes by Jean Varda, collage on plywood, 32"x48".

Collage artist Jean Varda has turned to the exclusive use of richly colored fabrics. Here, in the first stages of his work, he begins cutting the material into a variety of shapes for his collage entitled Fishes.

Each piece of fabric is placed and arranged on the plywood surface to the right. Cutting and arranging is continued until the artist is satisfied with the final composition of the collage. On the left, Varda is shown in the process of preparing the surface which eventually receives the collage. A piece of ¼″ plywood, cut to the identical size as the plywood on the right, is prepared by gluing a large piece of fabric to its surface. This serves as the background for the collage. Polyvinyl acetate glue is used as the adhesive.

The artist carefully lifts each piece of material and brushes white polyvinyl acetate glue on to the back of each section. The fabrics are in this way transferred from the arrangement surface to the final collage surface.

The fabrics have been carefully transferred and pasted to the final surface with the white glue adhesive. Allowed to dry for a few hours, the collage is ready for the final accents of plastic paint.

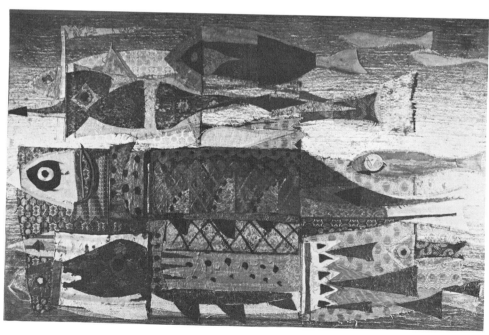

For accenting such details as eyes and contour lines, Varda applies thick paint with a small bristle brush. To control color contrast, he dilutes plastic paint with water to serve as a dye and brushes thin paint over the porous material. In some cases, he also overpaints with thicker paint, using a scumbling method of applying the heavier paint over larger areas. In addition to the fabrics, Varda uses small pieces of fluorescent plastic for details such as the eyes of the fish, complementing the richly textured fabrics.

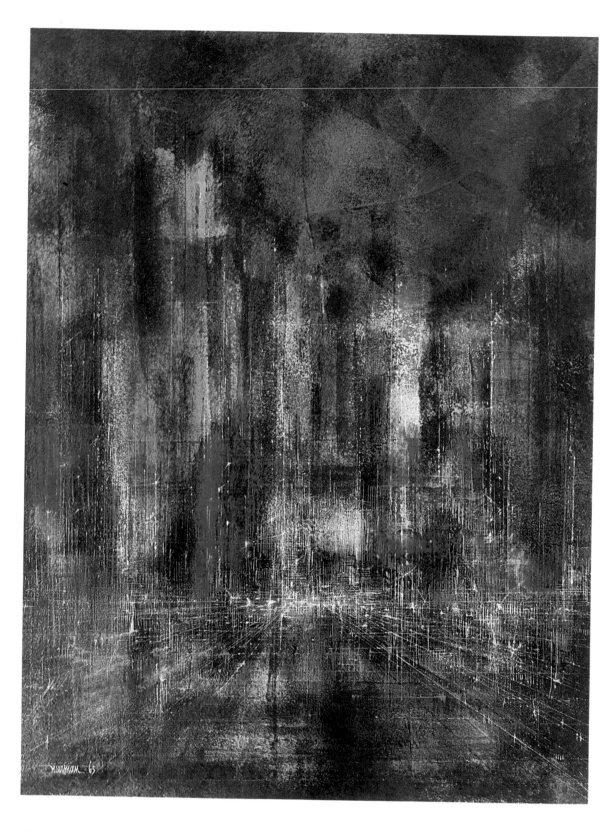

City at Night by Leonardo Nierman, acrylic lacquer on Masonite, 24" x 32".

13
painting with acrylic lacquers

Leonardo Nierman of Mexico City, until recently used Pyroxylin (lacquers) exclusively for his work. He has turned to using the new acrylic lacquers and demonstrates his method of painting with them.

Since 1959, acrylic lacquers have been used in the automotive industry, and at the present time this paint is used to finish and refinish approximately one half of America's automobiles. There are two basic types of industrial lacquers: acrylic lacquers and acrylic nitrocellulose lacquers.

In formulating acrylic lacquers, the basic acrylic resin is combined with a plasticizer for modification of film properties. Small amounts of cellulose esters may be present as pigment dispersion aids. This is a patented process of DuPont.

In formulating the acrylic nitrocellulose type of acrylic lacquers, an acrylic resin is used, plus another resin, usually nitrocellulose. The second resin is added to accelerate hardening, to increase resistance to automotive fluids, and to improve adhesion to substrata. The resins which are used to formulate the acrylic lacquers (described in the preceding paragraph) are generally hard and do not require the addition of nitrocellulose. Conversely, resins used in formulating the acrylic nitrocellulose type are somewhat softer in film-producing characteristics, without the addition of the modifying nitrocellulose resins.

Any multi-purpose lacquer thinner that is used with regular automotive lacquer works well as a solvent for either acrylic or acrylic nitrocellulose lacquers. Surfaces of acrylic lacquer are remarkable for their gloss and gloss retention qualities.

I enjoy working with the acrylic lacquers as a painting medium because of their brilliance and gloss, their fast drying characteristics, and their versatility in handling. The particular type of acrylic lacquers that I use are of the acrylic nitrocellulose group, and are formulated for me in Mexico City. However, these types of lacquers are widely distributed in the United States and are available from most paint stores.

The artist should be cautioned to provide adequate ventilation when working with these paints. Even with proper precautions, the fumes may affect some people who are particularly sensitive. In my studio in Mexico City, I work daily with these paints and I keep a large balcony door open for proper ventilation. In addition, I have installed three extractor fans to absorb and expel the vapors caused by the paints and solvent.

STUDIO ACCESSORIES FOR PAINTING WITH ACRYLIC LACQUERS

I use the following colors in my palette: cadmium yellow, cadmium orange light, cadmium orange deep, deep violet, light violet, phthalocyanine blue, ultramarine blue, green, black, gold, pink, and white.

In addition to the colors above, I use transparent acrylic lacquer, which is mixed with the colors to obtain glazes. I use Sherwin-Williams' best grade of lacquer thinner for thinning the acrylic lacquers and also for general cleanup. For a palette, I use a piece of plate glass.

PREPARING THE SUPPORT

In painting *City at Night*, I worked on the smooth side of tempered Masonite. No sanding or preliminary priming is necessary.

BEGINNING THE PAINTING

The painting was inspired by a recent visit to New York. I wanted to express, in a subjective manner, my feelings about this great city; I tried to create the concept of a man-made complex of giant and intricate structures, bristling with light and excitement. My first step was to make a drawing of vertical and horizontal lines directly on the Masonite panel. For this I used black and white grease pencils. The drawing was fairly simple, and was used to create a foundation for the subsequent painting. No other sketches

were made. The Blaisdell type of pencil makes clean, sharp lines which do not interfere with the subsequent coats of paint.

INTRODUCING THE ACRYLIC LACQUERS

After the general composition has been established, colors were loosely spotted over the unprimed Masonite surface. I used a fan shaped bristle brush in applying the acrylic lacquers. I applied yellow, orange, green, and violet in selected color areas, following the rhythm of the preliminary drawing.

STIPPLING

In the next stage, I continued with the fan shaped bristle brush, this time stippling colors over the entire surface of the Masonite. In this stage, the combined effect of the line drawing and the color spotting helped to establish the impression of blocks of light and clarified the concept of *City at Night*. Brilliant particles of broken color were applied at this stage, giving the panel an extremely rich surface. Yellows, light oranges, pinks, light blues, and light greens were applied. The painting was then allowed to dry in anticipation of the next stage. Acrylic lacquer dries quickly, usually in less than an hour, and advanced stages may continue quickly.

PERSPECTIVE DRAWING

Returning to the use of the dark and light grease pencils, I reinforced the horizontal and vertical structural lines. I also emphasized the three dimensional aspect of the painting by drawing perspective lines which established the horizon, and gave the painting a more dynamic quality.

MASKING AND PAINTING

In the next stage I began a systematic darkening of the painting. I used a sheet of paper to act as a temporary masking device, while I stippled dark transparent color onto the surface. For this I used black acrylic lacquer predominantly, which had been thinned with clear lacquer. This transparent black was used over a great deal of the painting, giving it a "night" characteristic. Other colors used for darkening the painting were greens, golds, and blues. These colors were also mixed with clear acrylic lacquer to obtain transparent glazes.

Leonardo Nierman begins his acrylic lacquer painting by sketching with black and white grease pencils on a smooth, unprimed Masonite panel. His painting, City at Night, begins with horizontal and vertical structural lines, drawn with the aid of a T-square. Painting tools include clear acrylic lacquer, which is used for making transparent colors; lacquer thinner for cleaning brushes and for thinning paint; a fan-shaped bristle brush for stippling color; and a painting knife for "printing" highlights.

In the second stage of his painting, Nierman applies color in a loose manner. With the fan-shaped bristle brush, heavy applications of acrylic lacquer are dragged over the painting surface, creating movements of color. Although acrylic lacquers may be intermixed for obtaining a variety of colors, Nierman purchases a large number of cans of prepared color, and uses the lacquer straight.

INTRODUCING HIGHLIGHTS

Now, seeking to create the shimmering quality of a labyrinth of city lights, I used a painting knife and applied colors with the edge of the knife. Acrylic lacquers were picked up from the glass palette and "printed" onto the panel with the long edge of the knife, using parallel strokes. A great number of highlights were "printed" in this manner. The perspective lines served as a general guide and I used the same colors which I used previously in the spotting stage. A bristle brush was used over the color, softening it, and diffusing it somewhat in different directions. In this way, an effect of glittering lights was created. The final painting is 24" x 32".

Light and dark volumes of color are stippled with the fan-shaped bristle brush. The entire surface of the untempered Masonite panel is stippled with color, developing an atmosphere of brilliant structural forms.

Nierman uses the white grease pencil to clarify shapes of buildings and to develop horizon and perspective lines. Pencil lines disappear under subsequent coats of acrylic lacquer.

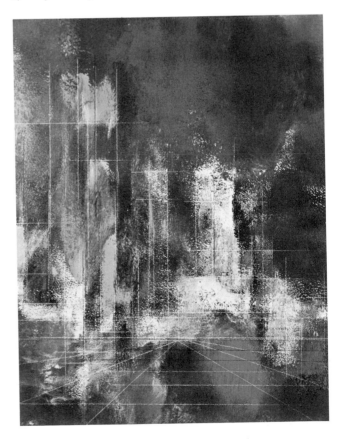

Systematic darkening of the painting begins by using transparent black acrylic lacquer, applied with the fan-shaped bristle brush. Nierman uses a paper shield to emphasize edges. He goes over the entire painting with transparent black, greens, golds, and blues, and completes the darkening of the painting. The night time mood of the picture is now intensified. In the next stage, highlights will be added.

 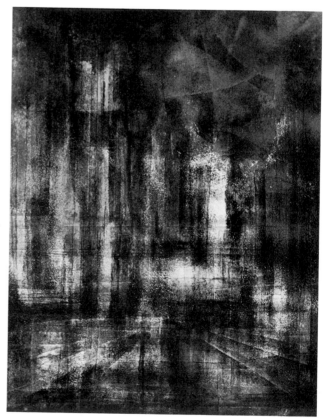

Highlights of brilliant color are applied with the painting knife in parallel strokes. A labyrinth of printed lines suggests the lights of New York. Nierman uses the combination of the painting knife and the fan-shaped bristle brush to suggest the quality of glittering lights. Applying acrylic lacquer with the edge of the painting knife, he dissolves the sharp edge by using the brush to gently push the wet paint in a variety of ways, creating the quality of brilliant lights on a rain-swept evening.

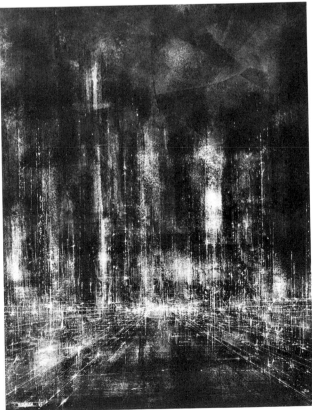

187

DIRECTORY OF SUPPLIERS

Note: Some of the manufacturers may sell only in large orders. In this case, contact a local jobber or chemical supply house.

Material	Source
Acetone	Paint store.
Acrylic emulsion.	Rohm and Haas Company. Independence Mall West, Philadelphia 5, Pennsylvania 19105. Canadian distributor: Crystal Glass and Plastics, Ltd., 130 Queens Quay East, Toronto, Ontario, Canada.
Alcohol, denatured	Paint store.
Alcohol, butylic	Chemical supply house.
Aqua-Tec	Bocour Artists Colors, Inc. 552 West 52 Street, New York, New York 10019, or art supply store.
Art fabric	Minnesota Mining and Manufacturing Company, 2501 Hudson Road, St. Paul, Minnesota 55119, or art supply store.
Asbestos	Building supply store.
Bentone 38	Union Carbide Corporation, Chemicals Division, 270 Park Avenue, New York, New York 10017, or chemical supply house.
Brushes, for plastic paints	A. Langnickel, Inc., 115 West 31 Street, New York, New York 10001, or art supply store.
Butanol	Chemical supply house.
Butyl acetate	Union Carbide Corporation, Chemicals Division, 270 Park Avenue, New York, New York 10017, or chemical supply house.
Carbosil	Chemical supply house.
Carbitol	Union Carbide Corporation, Chemicals Division, 270 Park Avenue, New York, New York 10017, or chemical supply house.
Celite #281	Johns Manville Company, 270 Madison Avenue, New York, New York 10016, or building supply house.
Celotex	Building supply house.
China clay (ASP 400)	Chemical supply house.
Cobalt octoate	Chemical supply house.
Craftint (Un-Art-Co)	Craftint Manufacturing Company, 18501 Euclid Avenue, Cleveland, Ohio 45212, or art supply store.
Cryla colors	George Rowney and Company Limited, 10/11 Percy Street, London W1, England. U.S. distributor: Morilla Company, Inc., 43-01 21 Street, Long Island City, New York 11101.
Dana colors (Acrycolors)	Dana Colors, Inc., 1833 Egbert Avenue, San Francisco, California 94124.
Dry pigment	American Hoechst Corporation, Carbic Color Division, 270 Sheffield Street, Mountainside, New Jersey 07091, or art supply store.
Duco lacquer (pyroxylin)	Automobile paint store.
Hemp, cut	Building supply store.
Hydrochloric acid	Hardware store or chemical supply house.
Hydrated lime	Building supply house.
Hyplar colors and mediums	M. Grumbacher, Inc., 460 West 34 Street, New York, New York 10001, or art supply store.
Liquitex colors and mediums	Permanent Pigments, Inc., 2700 Highland Avenue, Cincinnati, Ohio 45212, or art supply store.
Magna colors and mediums	Bocour Artists Colors Inc., 552 West 52 Street, New York, New York 10019, or art supply store.
Marble dust	Building supply store.
Masonite	Building supply store or lumber yard.
Metallic powders	Metals Disintegrating Company, Inc. Elizabeth, New Jersey, or art supply store.
Methyl isobutyl ketone	Chemical supply house.
New Masters colors and mediums	California Products Corporation, New Masters Fine Arts Division, 169 Waverly Street, Cambridge, Massachusetts 02139, or art supply store.
Politec acrylic colors and mediums	The Politec Company, Tigre 24, Mexico 12, D.F. U.S. distributor: The Politec Company, 425 14th Street, San Francisco, California 94103.
Polyart colors and mediums	Polyart Company, 1199 East 12 Street, Oakland, California 94606.
Polyvinyl acetate	Reichhold Chemicals, Inc., RCI Building, 525 North Broadway, White Plains, New York 10602. Borden Company, Chemical Division, Peabody, Massachusetts 01961.
Portland cement	Building supply store.
Reeves polymer colors and mediums	Reeves and Sons Limited, Lincoln Road, Enfield, Middlesex, England. Canadian distributor: Reeves and Sons (Canada) Limited, 16 Apex Road, Toronto 19, Canada.
Rhoplex AC-33, AC-34	Rohm and Haas Company, Independence Mall West, Philadelphia, Pennsylvania 19105.
Shiva colors and mediums	Shiva Artists Colors, Shiva-Rhodes Building, 10th and Monroe Streets, Paducah, Kentucky 42001, or art supply store.
Toluol	Chemical supply house.
Vinyl acetate (AYAF, AYAT)	Union Carbide Corporation, Chemicals Division, 270 Park Avenue, New York, New York 10017.
Vinyl chloride acetate (VMCH, VYHH)	Union Carbide Corporation, Chemicals Division, 270 Park Avenue, New York, New York 10017.
Wallpol	Reichhold Chemicals, Inc., RCI Building, 525 North Broadway, White Plains, New York 10602
Weber latex polymer paints	F. Weber Company, 1220 Buttonwood Street, Philadelphia, Pennsylvania 19123, or art supply store.

BIBLIOGRAPHY

Chaet, Bernard, *Artists at Work*, Cambridge, Massachusetts, Webb Books.

Doerner, Max, *The Materials of the Artist*, New York, Harcourt, Brace and World.

Gettens, Rutherford, and George Stout, *Painting Materials, A Short Encyclopedia*, Princeton, New Jersey, Van Nostrand.

Gutiérrez, José, *From Fresco to Plastics*, Ottawa, The National Gallery of Art.

Herberts, Kurt, *Complete Book of Artists' Techniques*, New York, Praeger.

Horn, Milton, *Acrylic Resins*, New York, Reinhold.

Jensen, Lawrence N., *Synthetic Painting Media*, Englewood Cliffs, New Jersey, Prentice-Hall.

Mayer, Ralph, *The Artist's Handbook*, New York, Viking.

Newman, Thelma R., *Plastics as an Art Form*, Philadelphia, Chilton.

Reichhold Chemical Corporation, *Polyester Plastics* (technical bulletin).

Rohm & Haas Company, *AC-33* (technical bulletin).

Simonds, Herbert R., *Source Book of the New Plastics*, New York, Reinhold.

Taubes, Frederic, *Painting Materials and Techniques*, New York, Watson-Guptill.

Vasari, Giorgio, *Vasari on Technique*, New York, Dover.

Woody, Russell O., *Painting with Synthetic Media*, New York, Reinhold.

INDEX

Acetic acid, 33
Acetone, 20
Acrycolor, 111
Acrylic resins, 46-48, 62, 75, 79, 181; chemical ingredients, 46-47; manufacturing, 47; painting surfaces, 47-48; painting techniques, 48; solvents, 47; working characteristics, 46
Acryloid, 20, 46, 47
Alcohol, denatured, 20, 37, 38, 43; unsaturated, 33
Alkalinity, 64, 65, 71; test for, 77
Alla prima, 18, 44, 103, 120
Alumina, 70, 71
Aluminum oxide, 70
Aqua-Tec, 80-82; painting with, 82; products, 80
Arenal, 52
Art Fabric, 117-118
Assemblage, 20; see also Collage

Barium sulphate, 74
Basques, 52
Batchelor, Jonathan, demonstration by, 158-165
Belkin, Arnold, 46; illus. by, 57
Benton, Thomas Hart, illus. by, 84-85
Berdesio, 52
Betts, Edward, illus. by, 108
Binder, 17
Bocour Artists Colors, 80, 92
Bocour, Leonard, 24, 26, 27; see also Magna
Borden Company, 33
Brushes, 18, 114, 145; care of, 115
Butonal, 37

Cadmium-barium, 71
Cadmium lithopones, 71
Cadmium selenide, 67
Cadmium sulphide, 67, 74
Cadmium-sulpho-selenide, 74
California Products Corporation, 93
Camarena, Jorge Gonzales, illus. by, 81
Canvas, 41, 44, 49, 59, 99, 102; preparing, 138, 159; toning, 146
Carbitol, 37
Carbonic acid, 63
Cardboard, 38, 41, 117
Casein, 26, 58, 59, 99, 100, 110
Castor oil, 55
Celite, 34, 37-38, 42, 55, 58, 113, 123
Celotex, 38, 41, 47, 53, 55, 59
Characteristics of plastic media, 18-20
Chromium oxide, 71
Cleaning plastic paintings, 124
Cobalt oxide, 70
Coiner, Charles, illus. by, 101
Collage, 20, 80, 87, 90, 96, 99, 100, 103, 123; demonstrated, 174-179
Colville, Alex, illus. by, 88
Commercially made paints, 49, 79-111
Copper phthalocyanine, 70, 71
Cornwell, Dean, 24
Covering characteristics, 17
Craftint Manufacturing Company, 110
Cryla Acrylics, 82-86; painting with, 86; products, 83-86

Dana Colors, Inc., 111
Dioxazine carbasole, 68
Drying characteristics, 16, 17
Duco lacquers, 52-55
Durability, 16, 17
DuPont, E.I., 181

Elsocht, Robert, 115; demonstration by, 137-143

Emulsified polyvinyl acetate, 30, 31-36; chemical properties, 33; painting surfaces, 34; technique, 34; working characteristics, 33
Emulsifying agent, 21
Estrada, Neil, 33, 34
Ethyl silicate, 24, 30, 42-46, 58-59, 62; chemical properties, 42-43; manufacturing, 43; painting techniques, 43-46; working characteristics, 42

Figure painting, demonstrated, 158-165
Fixative, 120
Final coat, 56, 57, 58
Flesh tones, 145, 147, 148, 161, 162
Fluorescent colors, 131
Frankenthaler, Helen, 26
Fresco, 15, 16, 18, 65, 71; restoring, 125; secco, 58, 63, 127

Gasser, Henry, illus. by, 76
Gel, 87, 89, 91
George Rowney and Company, Limited, 82
Gerszo, Gunther, illus. by, 37
Gesso, 18, 59, 62, 79, 82, 87, 89, 90, 94, 96, 98, 104-106, 107-110, 115, 117
Gibson, Don, 33; see also Polyart
Gibson Paint Company, 99
Glazing, 53, 65, 89, 122, 168
Glycol, 99, 114, 120
Glycolin, 115; see also Glycol
Gouache methods, 122-123
Grumbacher, M., Inc., 86
Gutiérrez, José, 18, 24, 27, 30, 52; illus. by, 105; see also Politec

Hard edge techniques, 123
Hayes, Richard, illus. by, 72
Hoechst Company, 68, 70
Home-made plastic paints, 30-55
Hydrochloric acid, 43
Hyplar, 86-89; painting with, 87-88; products, 86-87

Impasto, 18, 86, 89, 93, 94, 100, 104, 106, 107, 114, 122, 123, 166

Johns Manville Company, 34
Jonson, Raymond, 118
Joysmith, Toby, illus. by, 45

Kaish, Morton, illus. by, 25
Kozlow, Richard, illus. by, 109

Lacquers, 59, 62; demonstrated, 181-187; Duco, 52-55; Pyroxylin, 24
Lacquer thinners, 52, 53
Land, Ernest, illus. by, 95
Landscape painting, demonstrated, 137-143
Langnickel, Inc., A, 114
Lawter Chemical Company, 75
Levison, Henry, 24, 26, 27; see also Permanent Pigments
Lime, 63
Linoxyn, 16
Linseed oil, 16
Liquitex, 26, 89-92, 144; painting with, 91-92; products, 90-91
Louis, Morris, 26; illus. by, 32
Lucite, 80, 89
Luzitron, 99, 168; Thinner X-T, 98, 99; see also Politec

Magna, 26, 27, 79, 92-93; painting with, 93; products, 92-93
Making plastic paints, 30-55
Markos, Lajos, illus. by, 50
Marshall, Fred B., illus. by, 39

Martinez, Norberto, 46
Masonite, 34, 38, 41, 44, 47, 49, 53, 55, 59, 62, 99, 100, 102, 103, 107, 117, 130, 159, 166-167, 168, 182, 183
Mavroulas, Manuel, 174
Mayer, Ralph, 64
Merida, Carlos, illus. by, 69
Metal, 41, 47, 59, 102, 107, 118
Metals Disintegrating Company, 77
Methyl Isobutyl Ketone, 40-41
Minnesota Mining and Manufacturing Company, 117
Modeling paste, 79, 87, 96, 106, 167; colored, 167-168; -extender, 87, 89, 91; see also Paste-extenders; Molding paste
Molding paste, 82; see also Modeling paste; Paste-extenders
Mosaics, 99, 124
Motherwell, Robert, 26
Multi-Sperse, 158, 159
Murals, 16, 17, 20, 24, 30, 40, 42-46, 52, 56-63

Naphthol, 68
National Polytechnic Institute, 13, 44, 97
New Masters, 93-96, 115; painting with, 96; products, 94-96
Nicholas, Tom, illus. by, 66
Nierman, Leonardo, demonstration by, 181-187
Nitrocellulose, 181; see also Pyroxylin
Noland, Kenneth, 26

O'Gorman, Juan, 46
Oil painting, 15-16, 18, 58, 59, 62, 93, 99, 100, 110, 128, 166
Oleo acrylic, 113
Orozco, José Clemente, 24, 40, 44; illus. by, 60
Overpainting methods, 122

Palette knife, 18, 115, 137
Palettes, 118, 145, 159; preparing, 138
Papier maché, 87, 97, 100, 102
Paste, 115; see also Modeling paste-extenders; Molding paste; Paste-extenders
Paste-extenders, 59, 87, 100, 122, 123, 124, 130, 138, 139; see also Paste; Modeling paste-extenders; Molding paste
Permanent Pigments, Inc., 26, 68, 89; see also Liquitex
Petersen, Roland, illus. by, 4
Phosphoric acid, 70
Picasso, Pablo, 16
Pigments, 64-76; fluorescent, 75, 131; metallic powder, 75-76; requirements for, 64-65
Plaster of Paris, 59
Plaster walls, 38, 47, 59, 96, 107, 117
Plastilita, 59, 98, 99, 130; see also Politec
Plexiglas, 80, 87
Plywood, 34, 38, 47, 53, 55, 175
Politec, 26, 96-99, 115, 128, 130, 131, 168; painting with, 98-99; products, 97-98; see also Luzitron, Plastilita
Politec Company, 96
Pollock, Jackson, 26, 52; illus. by, 14
Polyacrylic esters, 48-49; chemical properties, 48-49; manufacturing, 49; painting surfaces, 49; technique, 49; working characteristics, 48
Polyart, 99-102, 138; Clear, 34; products of, 99-100
Polymer, 20, 75; defined, 21-22
Polytechnic Institute, 26; see also National Polytechnic Institute
Porter, Fairfield, illus. by, 19
Portrait painting, demonstrated, 144-158
Potassium, 42
Priming, 83, 103, 115-117, 130, 145
Pyroxylin, 52-55, 58; chemical properties, 53; lacquers, 24; painting surfaces, 53; working characteristics, 52

Reeves, 102-104; painting with, 103-104; products, 102-103
Reeves and Sons Limited, 102

Reichhold Chemicals, Inc., 33, 34
Relief painting, demonstrated, 166-173
Rembrandt Acryl Colors, 110
Remover, 100, 106
Retarder, 100, 115
Rhoplex, 20, 49
Rishell, Robert, demonstration by, 144-158
Rivera, Orozco, 46
Rohm and Haas, 17, 20, 22, 48, 49, 158; see also Acryloid; Rhoplex
Rohm, Otto, 46
Rothko, Mark, 26
Roukes, Nicholas, illus. by, 78
Rutile; see Titanium dioxide

Saran Wrap, 86, 98, 118
Scratch coat, 56, 57, 58
Sculpture, painting over, 124
Scumbling, 82, 103, 122, 130, 137
Sgrafitto technique, 137
Shaw, Kendall, illus. by, 73
Sherwin-Williams Paint Company, 24, 158, 159, 182
Shiva, 104-106; painting with, 106; products, 104-106
Siqueiros, David Alfaro, 24, 40, 42, 46, 52; preface by, 8
Sodium silicate, 42
Still life painting demonstrated, 128-136
Stippling, 167, 183
Strempler, Luis, demonstration by, 166-173
Strisik, Paul, illus. by, 51
Styrofoam, 100

Tabuena, Romeo, demonstration by, 128-136
Talens and Sons, Inc., 110
Tamayo, Rufino, 24; illus. by, 28-29
Tamol, 158
Tempera, 18, 41, 59, 62, 99, 100, 128
Textures, 123
Titanium dioxide, 65
Toluene, 20, 46, 47, 48, 98, 115; Xylol-, 48
Tools, 115
Turpenoid, 107

Un-Art-Co, 110
Union Carbide Corporation, 21, 24, 36, 40

Van Eyck brothers, 15
Varda, Jean, demonstration by, 174-179
Varnish, 40, 41, 47, 58, 63, 82, 83, 87, 90, 91, 93, 103, 124
Varnishing, 118-120, 149, 162, 168-169
Varnish-sealer, 59, 63, 97-98, 131; -medium, 63
Vinyl Chloride, 30, 40-42, 62; chemical properties, 40; manufacturing, 41; painting surfaces, 41; solvents, 40-41; working characteristics, 40
Vinylite, 24, 30, 36-40, 58, 75; chemical properties, 36, 37; manufacturing instructions, 37; painting surfaces, 37; working characteristics, 36

Wallpol, 33, 34, 36
Watercolor, 18, 99, 117, 102, 120-122
Weber, 106-110, 120; painting with, 110; products, 106-110
Weber Company, F., 106
White glue; see Emulsified polyvinyl acetate
Working characteristics, of acrylic resins, 46; of emulsified polyvinyl acetate, 33; of ethyl silicate, 42; of polyacrylic esters, 48; of Pyroxylin, 52; of vinyl chloride, 40; of Vinylite, 36

Xylol, 20, 46, 47, 48, 98, 115; -Toluene, 48

Zerbe, Karl, illus. by, 23

Edited by Donald Holden
Designed by Wm. Harris
Photocomposition in ten point Melior by Noera-Rayns Studio, Inc.
Black and white offset by Affiliated Lithographers, Inc.
Color offset and binding by The Haddon Craftsmen, Inc.